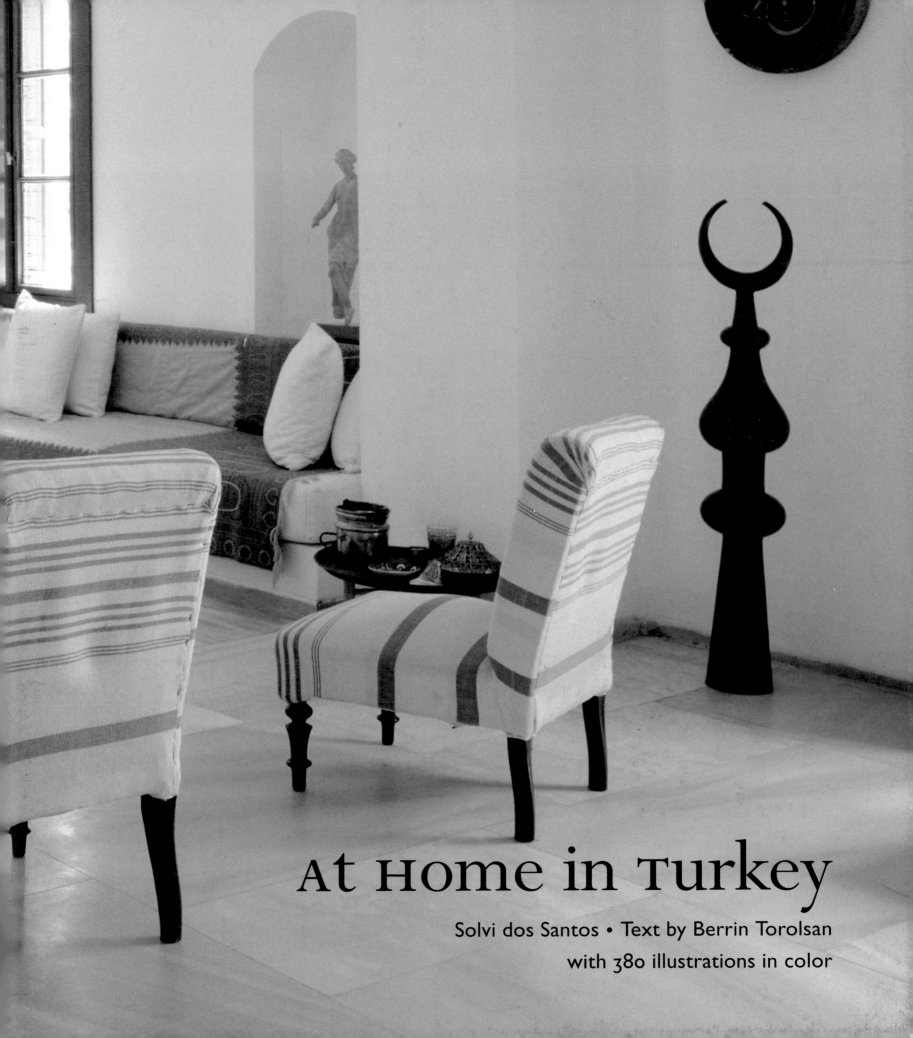

at home in Turkey

Solvi dos Santos • Text by Berrin Torolsan

with 380 illustrations in color

spring

12

Kıbrıslı Family
A PALATIAL YALI ON THE BOSPHORUS
16

Rahmi Koç
A CLASSICAL BOSPHORUS YALI
22

Sefer Çağlar
A CONTEMPORARY APARTMENT IN PERA
30

Kavur Family
A WOODEN MANSION ON THE PRINCES ISLANDS
36

Emel Kurhan
A THEATRICAL PIED-À-TERRE IN HARBIYE
42

Gönül Paksoy
A DESIGNER'S PENTHOUSE
IN NIŞANTAŞI
46

Ramazan Üren
AN AVANT-GARDE ISTANBUL LOFT
52

summer

58

Komili Family
A MAJESTIC MONASTERY ON THE AEGEAN ISLAND
OF CUNDA
62

Erdal and Betül Sayıl
A MINIATURE HARBOUR HOUSE AT AYVALIK
70

Selden Emre
A GRAND TOWNHOUSE ON CUNDA ISLAND
76

Zeynep Öziş
A STONE HOUSE IN ALAÇATI, ÇEŞME
84

Rifat Özbek
A DESIGNER'S HILLTOP HOUSE IN YALIKAVAK,
BODRUM
88

Mica Ertegün
AN ELEGANT HAVEN IN BODRUM
96

Sema Menteşeoğlu
A LAKESIDE BOHEMIAN HOUSE IN KÖYCEĞIZ
104

Mehmet and Emine Öğün
A COASTAL COTTAGE IN TORBA, BODRUM
112

Autumn
116

Reşit and Şebnem Soley
A vintner's home on the island of bozcaada,
near troy
120

Zeynelabidin Öztürk
A secluded stone house in mardin
126

Jacques Avizou
A cave house in cappadocia
132

İlker Şevketbeyoğlu
A tea planter's stone mansion in the
çağlayan valley, fındıklı
138

The Gökçüoğlu Konak
A traditional ottoman house in safranbolu
144

Mustafa and Caroline Koç
A sophisticated chalet in the bolu mountains
148

Hakan Ezer
A sumptuous apartment in teşvikiye
154

winter
160

Kemal Torun
A rustic wooden chalet in veliköy, şavşat
164

Rıfat Edin
A bohemian apartment in ortaköy on
the bosphorus
168

Zeki and Catherine Özdoğan
A painterly pied-à-terre in galata
174

Orhan Pamuk
A writer's retreat in cihangir
178

Serdar Gülgün
An ottoman-style apartment in teşvikiye
182

contact details
190
Acknowledgments
192

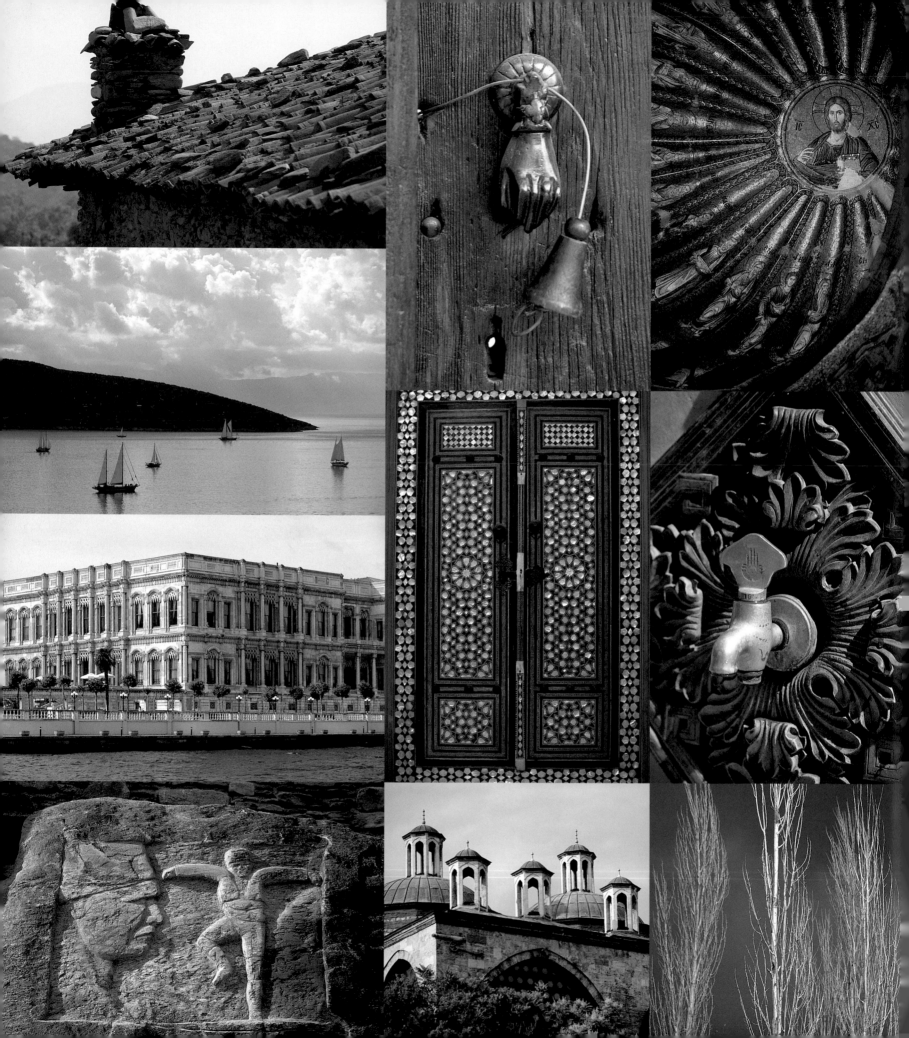

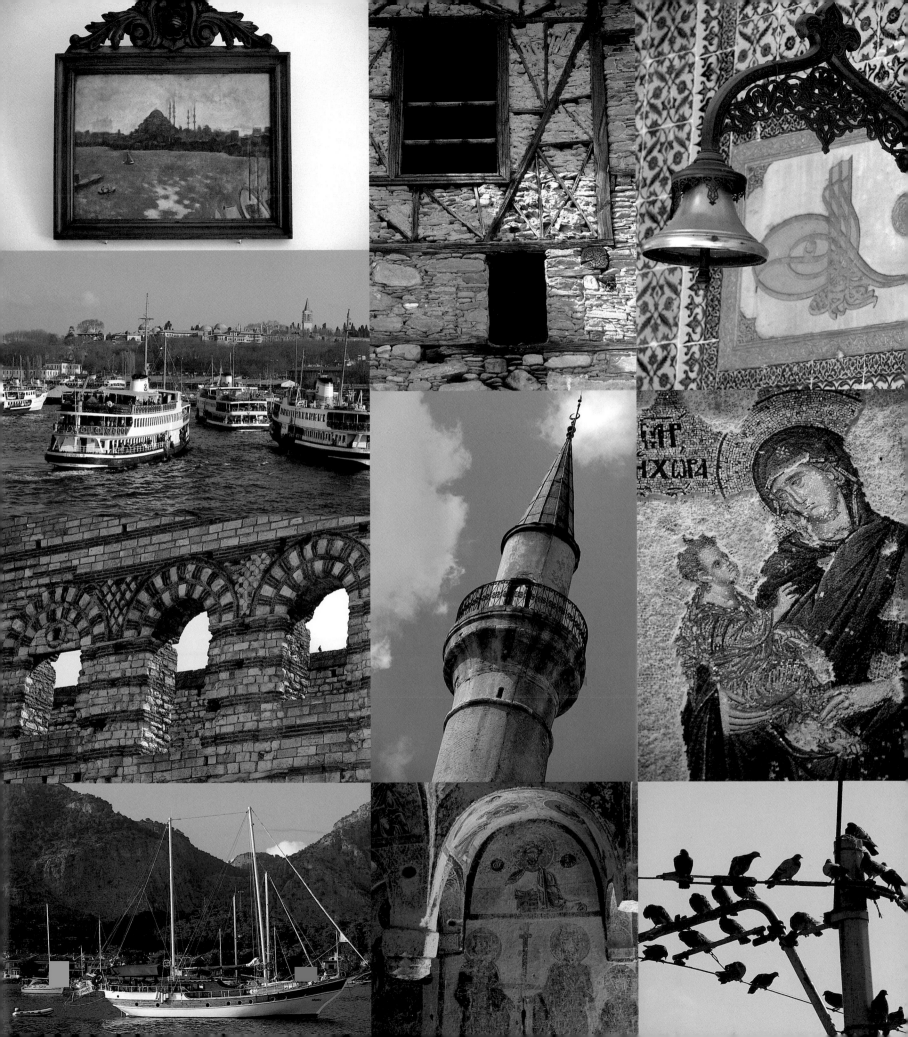

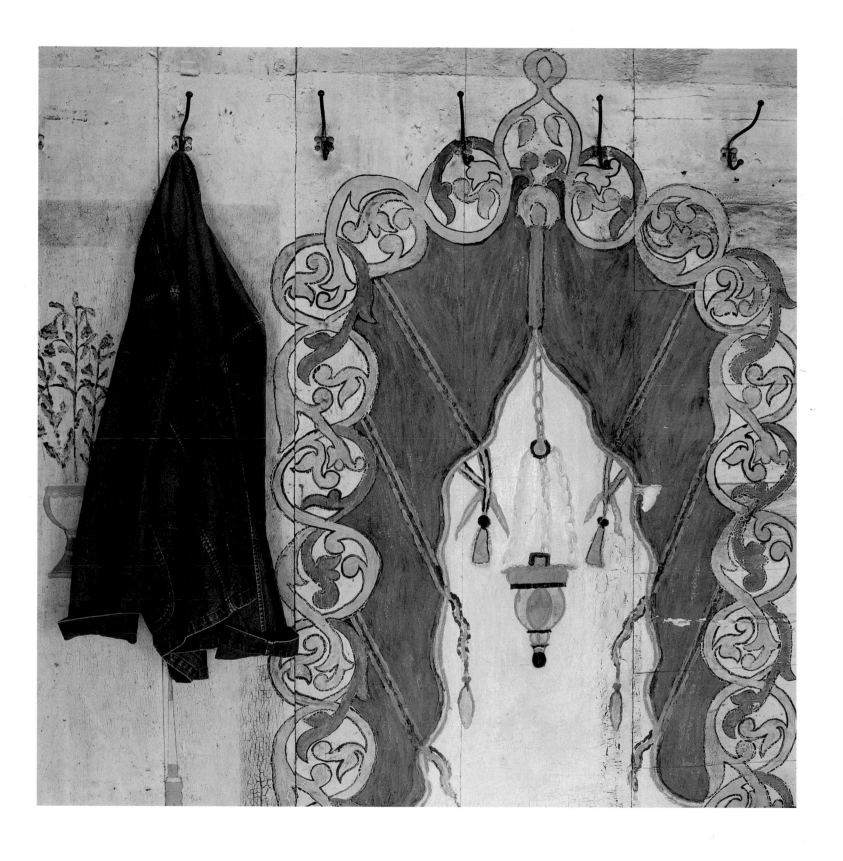

introduction

THE HISTORY OF TURKEY, as this extraordinary land is now called, dates back over ten millennia. The territories of which it is formed have nurtured and protected, or provided a home for, many civilizations. Turkey's diverse culture, which emerged as a result of migrations from Mesopotamia and the Caucasus, was developed by the first literate societies and reached maturity with the Hittites, the first civilization of the region. Later, many glorious empires – Persian, Alexandrian, Greek, Roman, Seljuk, Byzantine and Ottoman – flourished along with other different cultures and civilizations. Even though all of them have long since disappeared, the treasures they left behind have survived. Today, this unique land that has brought many civilizations together offers freedom of religion and conscience to those who live as one nation in the Republic of Turkey.

A mural depicting a tent doorway with hanging lamp in the Şevketbeyoğlu Mansion, one of the many magnificent mansions in Turkey's Black Sea Mountains (opposite).

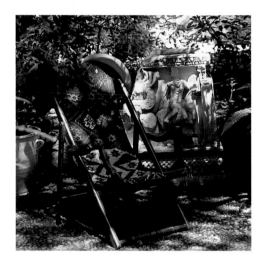

Turkey has always been in the spotlight in the global arena and has appeared in many guises at different times in her history: sometimes alone, sometimes trying to help her disaster-stricken neighbours, sometimes as a nation of intellectuals, sometimes as an unjustly accused defendant on trial, sometimes as a true friend trying to make peace between opposing parties, sometimes as a strong rival, sometimes as an enchantress who captivates with her history, culture and natural beauty. Even though there are so many faces, she has aroused one common feeling in those who have happened to know her: a true passion beyond words. Those who are born in this land spend a lifetime with an inexpressible passion for her. Even if out of sight, she will never stay out of mind.

Ancient patterns with a modern twist (from top): marble mosaic inspired by marbled paper; a kilim deckchair next to an ancient sculpture; gilded rococo moulding and refined calligraphy on the walls of an Ottoman palace.

This book offers a pleasant surprise, a discovery. It contains not only fascinating photographs of Turkish houses, which illustrate the lifestyles of different regions and cultures, but also their stories. Some of these homes have been hosts to special people, listened to important conversations or participated in historic events, while others have stayed secluded and are now shared for the first time in this book. You will find the same warmth you feel as you turn the pages within the hearts of people you meet in Turkey. There will always be a Turk who will be willing to share this joy with you over a cup of coffee, remembering the past and celebrating the present.

Esen Talu

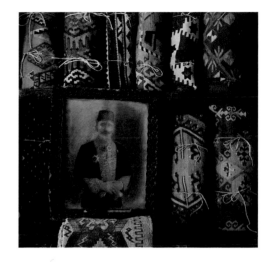

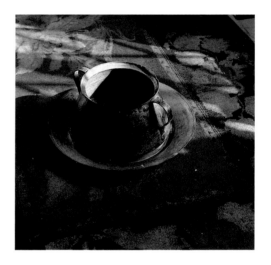

More is more: (from top) a gentleman in a fez and kilims galore at Erkal Aksoy's A la Turca Kilims in Çukurcuma, Istanbul's antiques district; Anatolian copperware; fin-de-siècle aladdin's cave designed by Hakan Erez.

spring

This is the season when both shores of the Bosphorus are enveloped in a cloud of blue wisteria, a spectacle soon followed by Judas trees that set the wooded hills of Asia and Europe ablaze. This was when, in the first warm days of spring, the wooden summerhouses of the last century, with latticework balconies and delicate cornices that made them resemble exotic birdcages, opened their shutters once more to the cool sea breezes. In the old days, their occupants used to send their love letters in a secret language of flowers, picking their words carefully from the profusion that appeared of its own accord in their gardens or the surrounding meadows.

Spring flowers are dearly loved by Turks. Bouquets of roses, hyacinths, carnations, pointed Istanbul tulips and peonies are reproduced in tiles, carpets, embroideries and textiles. Today, during the annual tulip festival, millions of tulips are planted in parks, squares, even along the roadside, to create a fanfare of colour.

This is the season when people picnic beneath blossoming fruit trees or take day trips on the ferries zigzagging between the shores of the Bosphorus and out to the Princes Islands. Cafés and parks fill up with young and old enjoying the first rays of sunshine, and dedicated fishermen line the shores and the bridges to catch the first of the migrating fish. As the days grow longer, the spring light becomes more brilliant, reviving everything indoors and out with its magic touch.

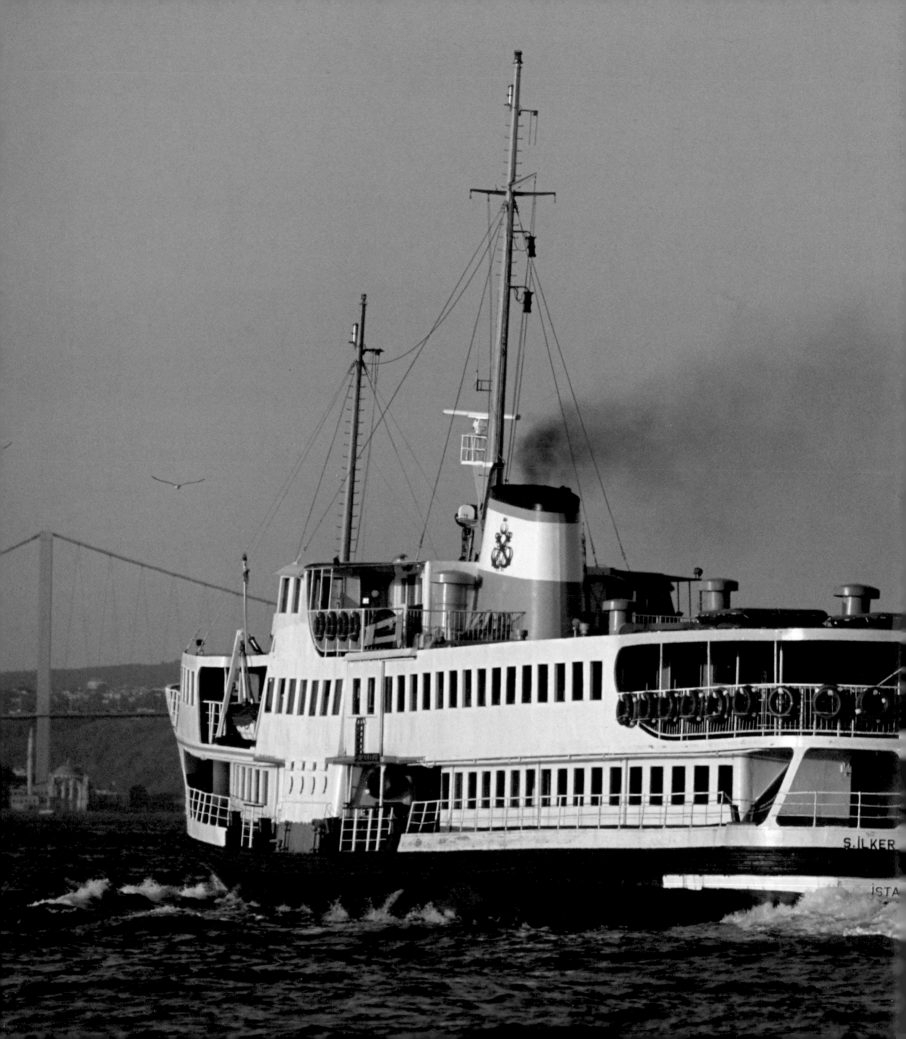

Kıbrıslı Family
a palatial yalı on the bosphorus

The palatial Kıbrıslı Yalı and the deep blue waters of the Bosphorus (above, left). The orangery has traditional pebble paving in a sunburst design (above, centre). Palm trees, cedars and peonies frame a spectacular view of the Bosphorus (above, right). Sea urchin shells in fleeting shades of rose and ivory (below), part of the collection of Selim Dirvana, Mihda Bilgişin's father.

The stunningly luminous Salon Rose (opposite) looks out both on to the Bosphorus and into a leafy garden. The gilded French furniture, like the stucco moulding of the frieze, was all the rage in Kıbrıslı Mehmet Emin Pasha's time: the mid-19th century was a period when the West was in vogue, and armchairs and free-standing settees replaced the sedirs and divans that once lined the walls. These elegant chairs must have been sat on by many distinguished guests, and witnessed many a memorable soirée.

The Kıbrıslı Yalı is the most romantic of all the surviving yalıs, or waterside mansions, that once lined the Bosphorus. Painted white, it stands out against a steep, dark hillside of cypresses, umbrella pines and Judas trees on the Asian shore of Istanbul, its elegant, noble features and slightly imperfect symmetry mirrored in the deep blue waters. It is a joy to behold as you approach from the sea. Today, one wing of this wooden magnificent mansion is home to Mihda Bilgişin, the great-great-granddaughter of Kıbrıslı Mehmet Emin Pasha, one of the Ottoman Empire's most able statesmen. The yalı was built in 1770 and in the decades that followed it changed hands several

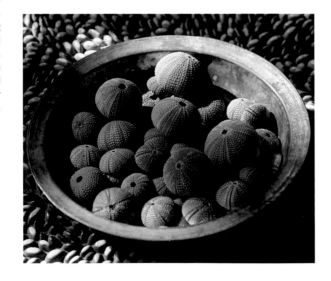

times before Kıbrıslı Mehmet Emin Pasha bought it in 1840 as a wedding gift for his wife.

The house is divided into three self-contained dwellings; the middle one is two storeys high and is flanked by two single-storey wings which once served as separate quarters for women and men, the harem and the selamlık. Each has a central hall leading from the front door on the garden side, with a plain-columned portico, to the sea entrance on the water's edge, where French windows open onto a breathtaking view. On either side of the grand marble-flagged hall, or sofa, doors lead off to rooms in each of the four corners. In Mihda's wing the hall has a vaulted ceiling of beautiful floral murals, of the kind one might see in Paris. It was largely thanks to Mihda's father, Selim Dirvana, that the yalı survived the 20th century. In the 1950s he struggled heroically to find the funds to maintain the building and preserve its original Ottoman features, and not to sell it for irresistible sums despite pressure from relatives. It was also Selim, an archaeologist by training, who rediscovered the magnificent peony murals on the ceiling of the marble hall and insisted on keeping the traditional garden design.

Mihda was born and grew up here, surrounded by distinguished guests, artists and diplomats, the friends

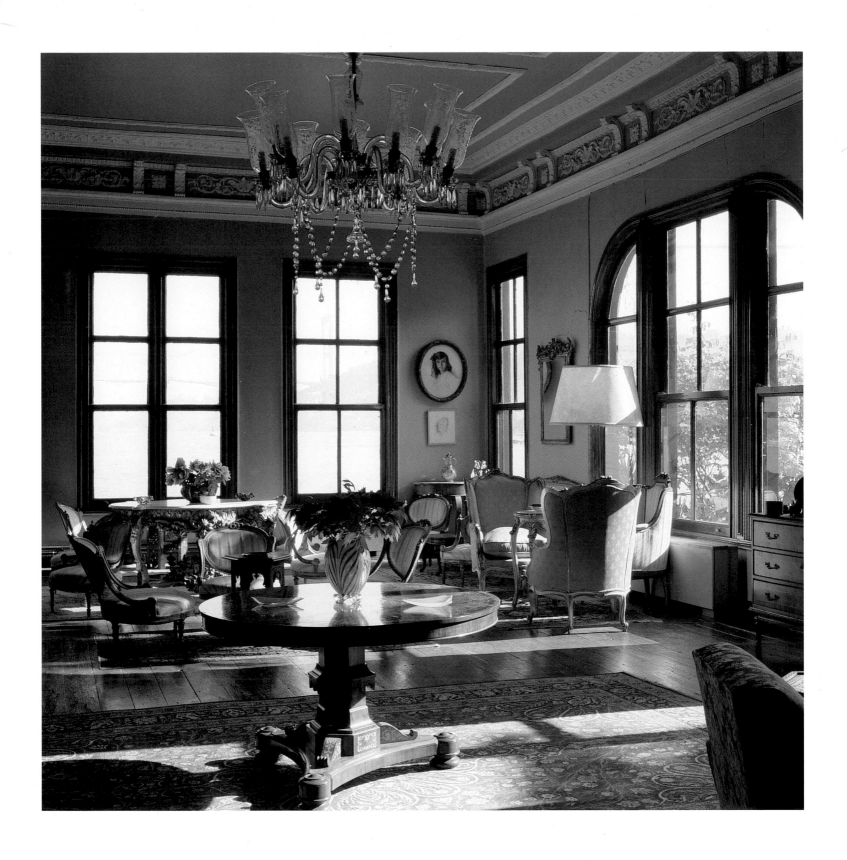

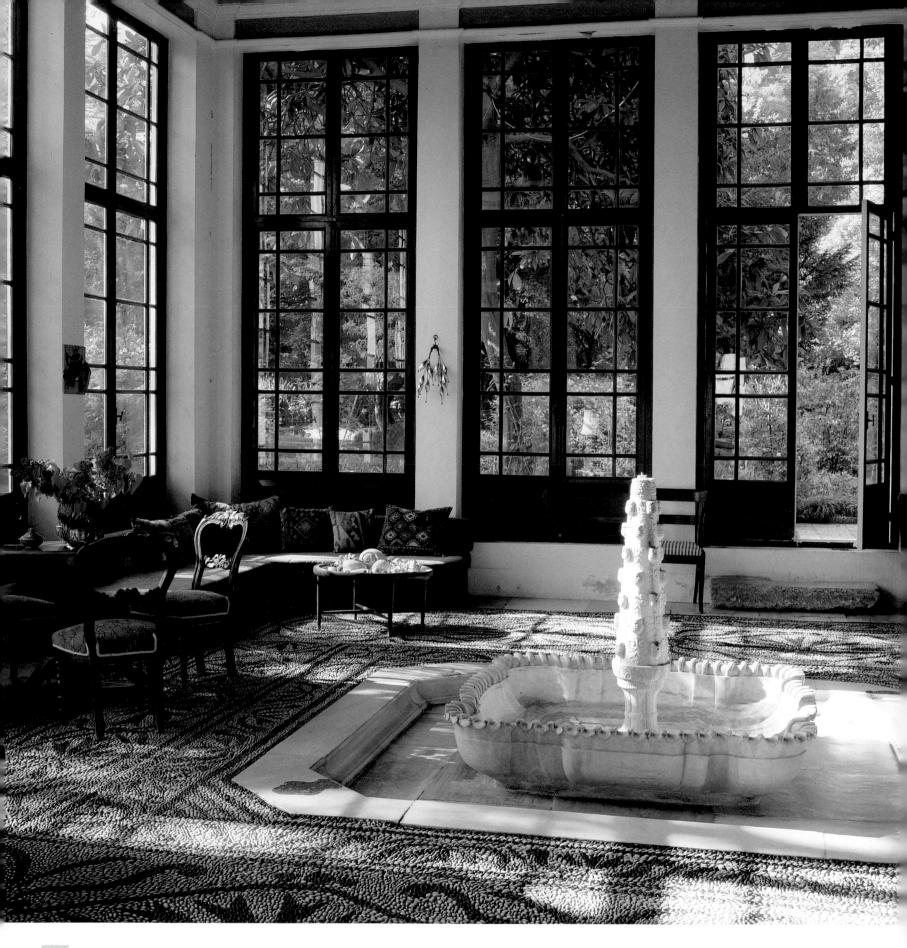

of her parents and grandparents. Anyone who was anyone visiting Istanbul would have passed through the house, from young King Faisal of Iraq to Rudolf Nureyev, Henry Kissinger, Paloma Picasso and Catherine Deneuve. Neighbouring children used to come to play, and stay, in the *yalı*, swimming in the Bosphorus. 'I was very privileged to live with three generations of my family under the same roof,' Alev, her eldest daughter, says. 'When I was young, I don't remember sitting down to eat with fewer than 20 people round the table.' Her mother would create the most wonderful lunches and dinners, and organize memorable soirées and parties.

Like all the historic waterside mansions and palaces of the Bosphorus, the Kıbrıslı Yalı used to have a sea entrance as grand, if not grander, than the land entrance. Travel was faster by water and infinitely more efficient. In the 18th and 19th centuries guests of honour would have been borne here on slender *caiques*; some were simple, others splendidly carved.

Originally the *yalı* was intended as a summerhouse, but Mihda and her husband, Ilkay, now live in it all the year round. Alev lives with her family in an old mansion in a corner of the extensive garden restored for her by the architect Sedad Hakkı Eldem. Although the parklands behind the house have long

since passed out of the family's hands, the *yalı* still stands in a fine garden.

The house is a living family home where heirlooms mingle with everyday practical items. Mihda's African violets arranged on huge Ottoman copper trays create pools of colour next to the faded lithographs of the Bosphorus. Mihda likes to call the rooms by their colours, rather than their functions. Under the murals of pink peonies in the spacious pink marble hall is a billiard table; next to it sits the grandchildren's full-size dinghy, its sails still up. And on a wall of the Turquoise Room hangs a portrait of Kıbrıslı Mehmet Emin Pasha in full regalia. Selim's colourful shell collection is treasured alongside Mihda's precious Beykoz glass collection in a delicate French vitrine. Tabletops are invisible under dozens of family photographs, generation upon generation clustered together.

The vaulted ceiling (above, left)
of the marble hall is decorated
with beautiful floral murals depicting
peonies. An imperial decree, or
firman, and an antique silk textile
hanging above a daybed and a
Thonet hat stand in the hall (above,
right). The central hall (right)
stretches the depth of the
entire house.

One of the most delightful corners
of the house (opposite): a carved
turban stand glints above an old-
fashioned *sedir* on a raised platform.

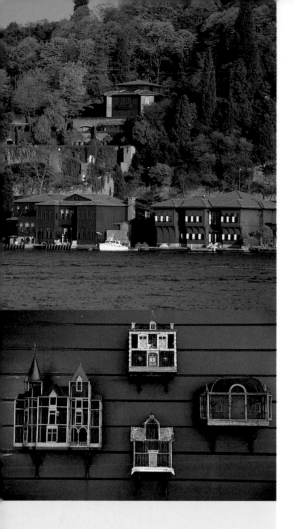

Rahmi Koç
A classical Bosphorus yalı

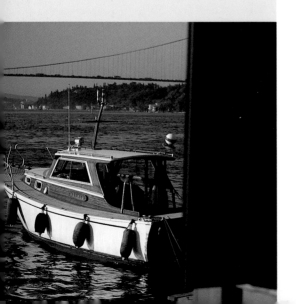

A few doors downstream from the Kıbrıslı Yalı is one of the rarest examples of classical 18th-century Ottoman Bosphorus architecture, the wooden waterside mansion of Count Ostrorog in Kandilli, on the Asian shore. The exterior of the yalı is a deep oxblood, too deep to be simply red, lovelier than burgundy. Known in Turkish as aşı boya, the traditional paint of the Bosphorus is prepared from a special recipe of earth pigments and terebinth, designed to protect the wood from the elements and the sea air.

Ever since the Polish aristocrat Count Ostrorog bought the yalı in the late 19th century, it has been known by his name. Learned in Islamic law, he was a legal adviser to the government and assumed important duties in the administration of the Ottoman Empire in its last years. His Istanbul-born son Jean, a cultured, flamboyant figure, inherited the house, living there according to friends, 'like a Turkish pasha'. When his renowned generosity combined with the hospitality of Ishka, his elegant countess, their doors were always open to friends from every walk of life, foreign and Turkish alike. The French poets Pierre Loti and Claude Farrère, the violinist Jacques Thibaud and pianist Alfred Cortot, the Turkish painter Abidin Dino, the music producer Arif Mardin, President Georges Pompidou, and the novelist Nancy Mitford, were but a few of them.

Today the yalı is home to another extraordinary person, Rahmi M. Koç, Turkey's leading industrialist. When the building started sliding into the sea, its timber construction worm-eaten, its roof leaking, Rahmi, an adopted child of the Bosphorus who had lived for many years in another yalı upstream, leapt gallantly to the rescue. A relentless collector, his interest in the yalı was largely sentimental. Painstaking conservation work of museum standard began under the expert direction of Dr Bülent Bulgurlu.

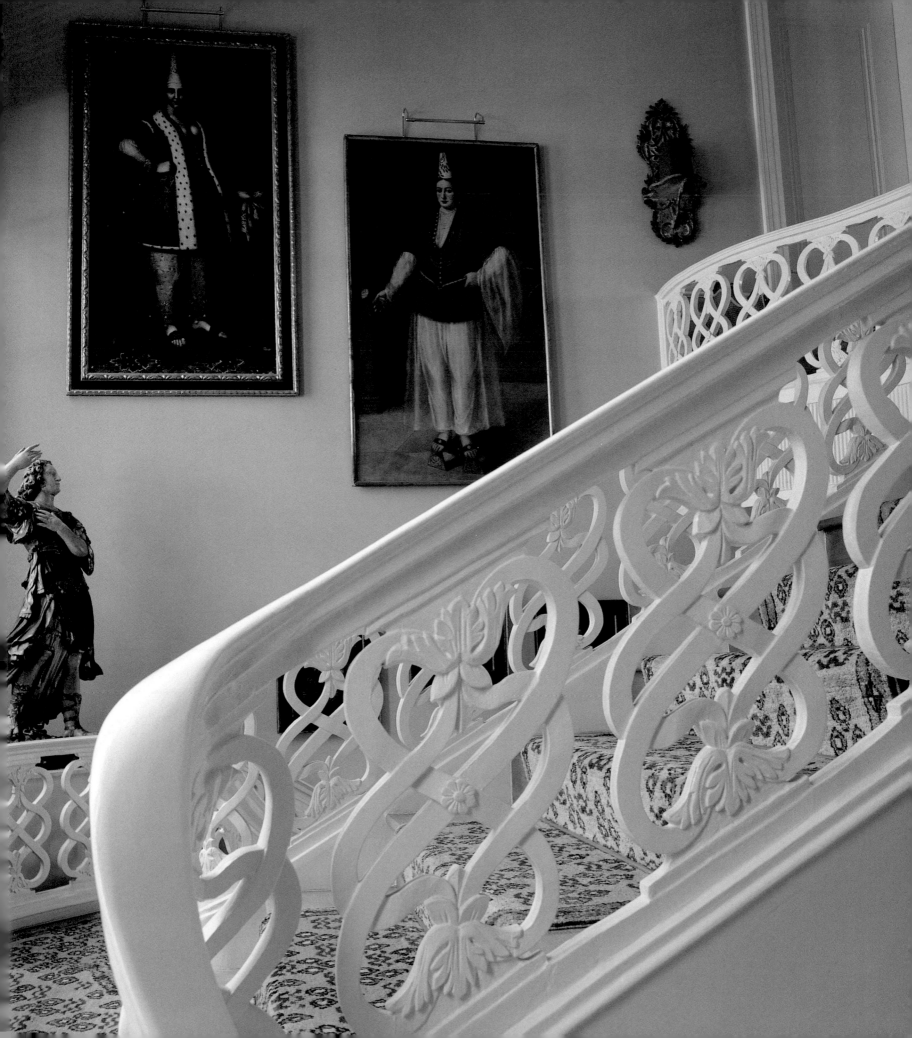

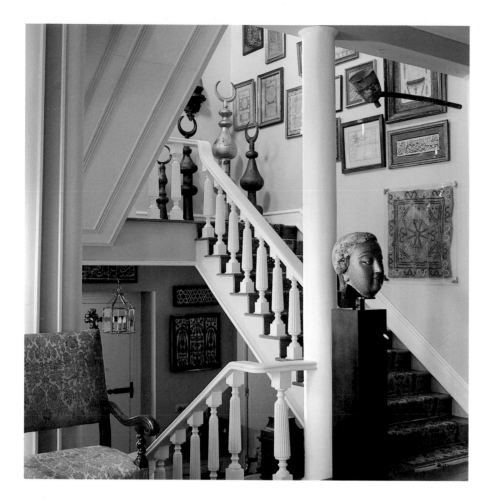

table for twelve filling the space, though, as Rahmi says, 'eight is a decent number – you can have a conversation', adding that he no longer enjoys large anonymous gatherings. The ceiling is crowned by an opulent wooden centrepiece of finely carved fruit. On the walls hang a pair of exquisite Luigi Mayer panoramas in watercolour and gouache of Scutari in the early 19th century. In one of them sits the artist himself, a sketchbook in hand, looking towards the old city while his servant tends to the horses and a caravan of camels winds its way through fruit orchards below. The seaside room across the hall was known as Pierre Loti's room. It was here that the Turcophile poet would stay on his frequent visits, sitting cross-legged on the *sedir*, composing his verses and watching the blue waters of the Bosphorus. Today, it is Rahmi's study, where he can work in peace on Sundays on company matters and his many museum projects, surrounded by shelves of curiosities – marble busts of Roman consuls and senators, a Mycenaean helmet, giant bronze taps next to vessels of infinitely delicate antique glass. Next to his desk sits a tidy row of briefcases collected over the years.

The stairs leading up to the library (above) are hung with glazed tiles from Iznik, Damascus and Tabriz, a rare *susani* textile and exquisite Ottoman calligraphy. *Alems* – crescent-moon finials – guard the landing. The tall windows of the peacock-tail staircase (right) face the garden and the east. Every morning the light of the rising sun paints the interior of the house a glowing pink.

What makes the house so important are its proportions. It is the very epitome of classical Ottoman architecture with the minimum of fuss outside. A wooden house, like most Ottoman vernacular buildings in the past, it was built not so much by architects as by trained master carpenters, *kalfa* as they were known, who worked like cabinet-makers. The main building is symmetrical. A hall in the centre stretches the depth of the house, from the glazed front door on the garden side to the sea entrance on the water's edge. On either side of this hall, or *sofa*, doors lead off symmetrically to rooms in each of the four corners. The garden room on the left has been transformed into a spacious kitchen, where a chef cooks *pilavs*, *böreks* and *dolmas* – classic Turkish home cooking. The seaside room next to it serves as a dining room for small informal dinners 'as in the days of the Count and Countess', the original

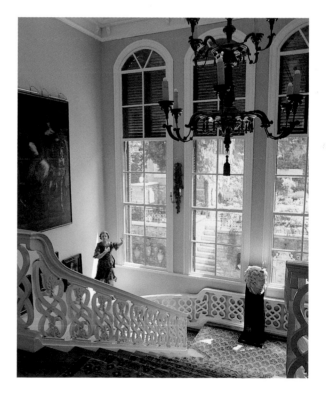

The central marble hallway leads to what is known as a peacock tail: a double flight of stairs that opens up to another wider flight on the next floor. A magnificent carved wooden balustrade twists elegantly into a stairwell of high arched windows. The upstairs reception room has a row of tall windows that face the sea. A grand piano stands next to the windows: very much part of the house in the Ostrorogs' day, it is still finely tuned. Rahmi has kept it exactly where it always stood. Behind family photographs on the piano, Loti stares out dreamily from a silver-framed sepia photograph. On the wall behind him hang 18th-century imaginary portraits of Ottoman courtiers by anonymous European artists – perhaps a fine joke by Rahmi, who as it happens is not only musically talented, but also an able caricaturist who used to enjoy drawing mischievous cartoons of friends after dinner parties. The Roman busts, antique masks, blackamoors and portraits are all evidence of his interest in faces and expressions, their witty juxtaposition reflecting his sense of humour.

The four corner rooms on this floor, with their finely carved wooden ceilings, are bedrooms. They have been tastefully decorated with the help of Barbara Ther, a dear old friend of Rahmi's, and embellished with precious objets d'art and paintings, fine drawings and watercolours by western Orientalist artists. Both downstairs and upstairs the rooms are painted in a pastel shade of blue-green grey known in Turkish as 'limon küfü' or lime mould, which contrasts with the white doors and cornices. This shade, always popular in the past with the Turks, flatters the carved polychrome and gilded Ottoman antique furniture, known as *Edirnekârî*, and the paintings, particularly the two sizeable gouaches of Moorish Andalusia.

Adjoining the main house is another building, once a separate annexe serving as the *selamlık*, or men's quarters and reception room – added, art historians believe, at a later period, but now seamlessly integrated. Its raised hall, reached by a short flight of steps, sits on a stone basement that was once the

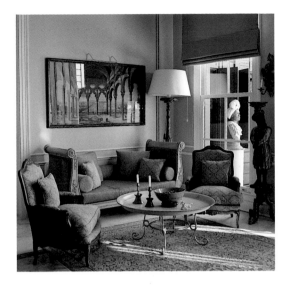

At the sea entrance to the marble hall, guests are greeted by a pair of blackamoors. A Moorish landscape hangs above an elegant giltwood daybed with scroll ends (left). The gilt Ottoman turban stands either side of the Venetian mirror (below) are of a rare and valuable type known as *Edirnekârî*, as is the elaborate sofa beneath. It came from an old Turkish mansion and was a housewarming present.

The marble hall (above) with the study beyond. The arched giltwood mirror is 18th century. The marble bust on the painted chest of drawers is late Roman. The study (opposite), once the French writer Pierre Loti's room, now peopled with Roman senators and consuls and other curiosities. One can almost smell the fragrant Cuban cigars from the comfortable leather chesterfields.

boathouse for the *caiques*. Facing the garden is what was known even in the Ostrorogs' day as the Chinese Room – the Count's brother had brought Chinese porcelain back from his travels in Asia. Rahmi, sensitive to the spirit of the house, kept it this way, dedicating it to his own astounding collection of terracotta Chinese figurines, their wooden arms and clothes long gone. In this room coral red dominates.

The *selamlık* leads to other delightful corners where one can sit, such as the arched platform, which the household call the 'eyvan', overlooking the sea. Traditional *sedirs* piled with cushions surround a low round table with a gilded box in the shape of a pumpkin in the middle. On the walls hang imperial *firmans*, or decrees, and a silk brocade kaftan. Another corner, with Iznik tiles, opens into the garden, in which Ottoman fountains, terracotta vessels and a menagerie of antique marble horses and lions stand among the hydrangeas and box parterres.

In a library upstairs which opens onto a rooftop terrace, Rahmi keeps the Count's portrait and handsomely bound copies of Hammer's *History of the Ottoman Empire* and Scott's *Waverley Novels*. The master bedroom is upstairs in the main building with a view of the castle of Rumelihisar opposite and surrounded by a courtly assembly of Renaissance portraits. A passage leads through a very nautical bathroom into an impressive dressing room which catches the morning sun. The wardrobe doors are hung with cartoons of 19th-century gentlemen drawn by Spy for *Vanity Fair*. There is ample storage for Rahmi's 130 pairs of shoes and rainbow of 340 ties: nothing reflects better the master's style and wit. Here the ever-energetic patron of the arts, protector of architectural heritage and pioneer of private museums meditates each morning: 'The only way is to separate one's outer and inner worlds,' he says.

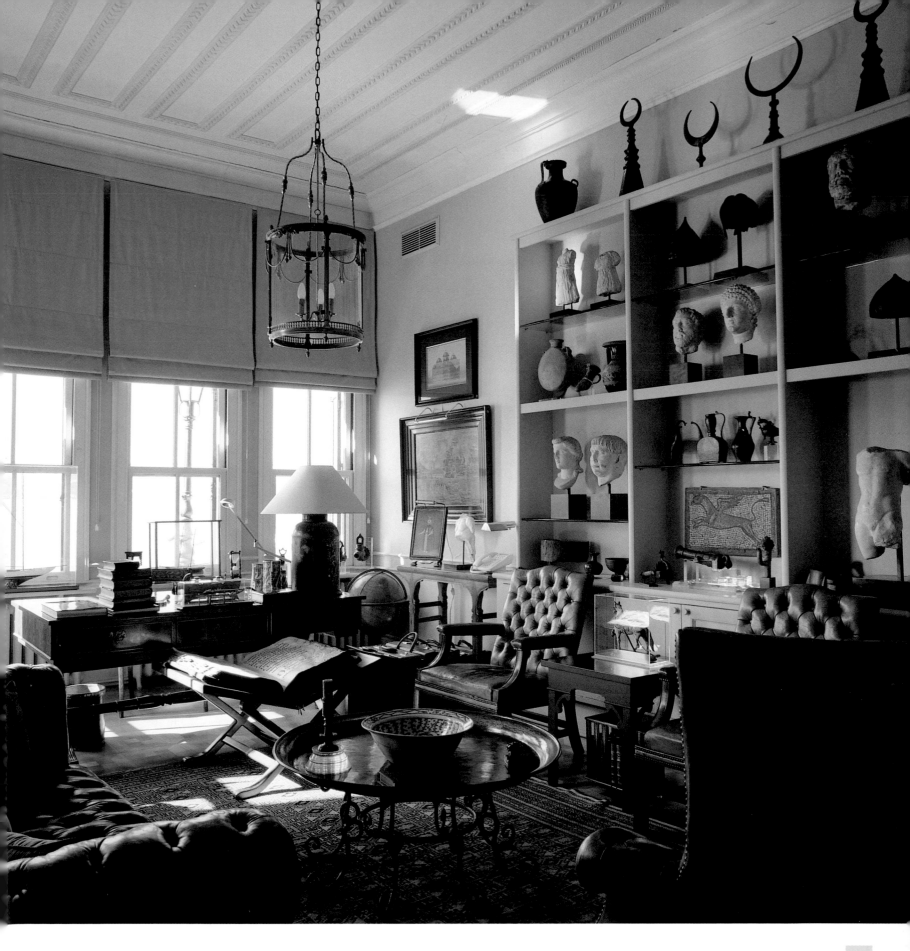

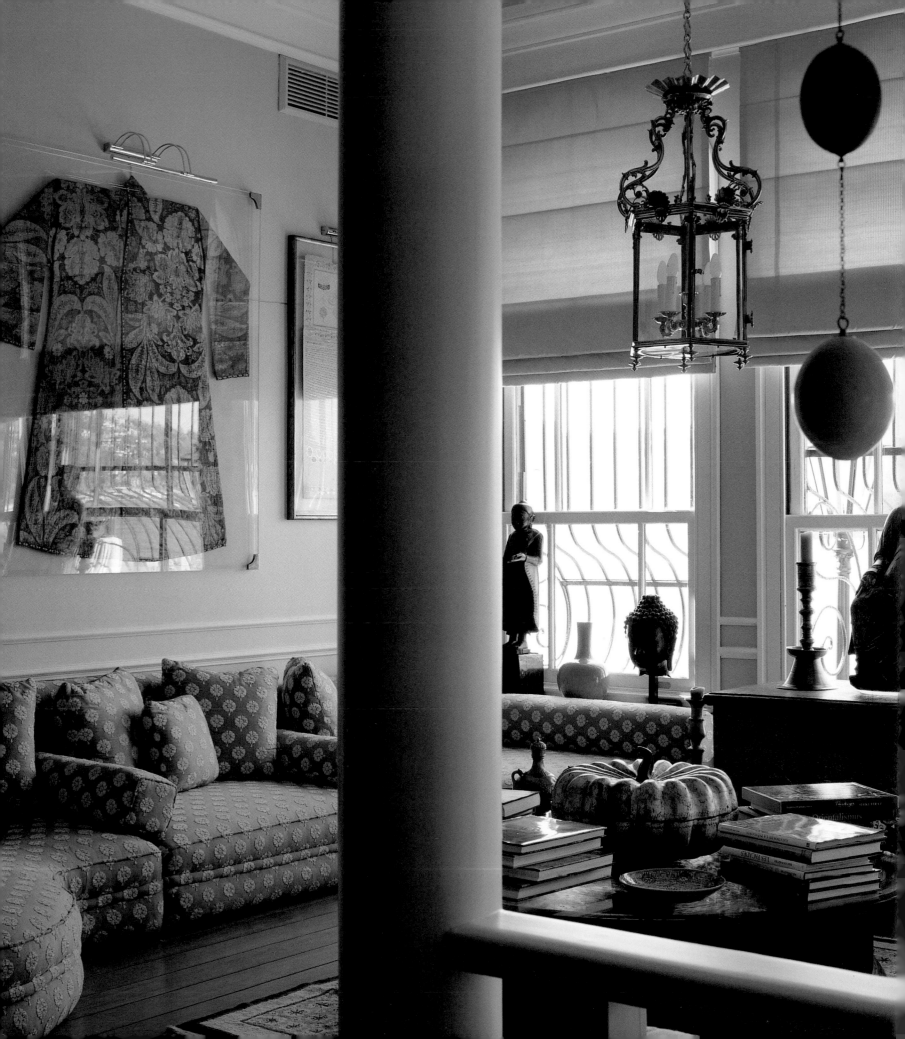

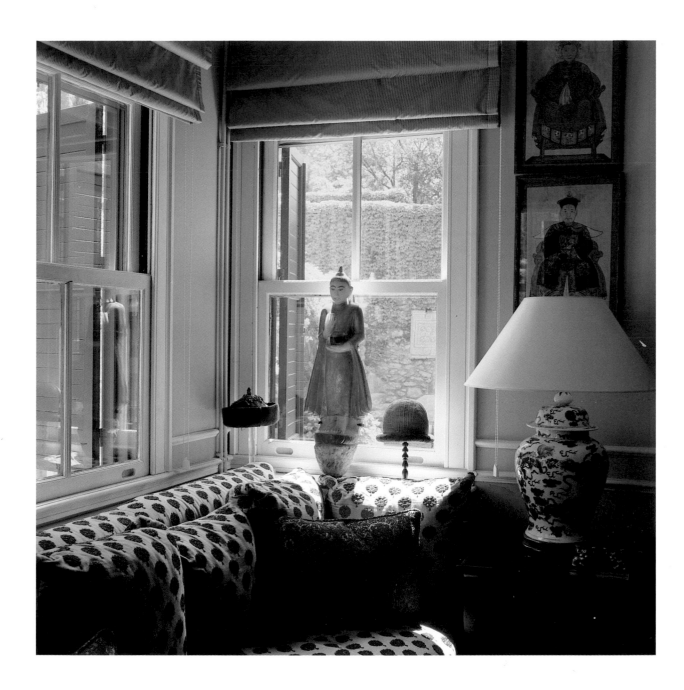

The raised sitting room known as the 'eyvan' (left). Low sofas recall the classical deep Ottoman divan piled with cushions to lean back on. The silk brocade kaftan is from Baluchistan. A gilded pumpkin box sits in the middle of the low tray table. The Buddha is flanked by Ottoman candlesticks. East again meets East in the Chinese room (above), with Ottoman patterns on the sofa fabric, Chinese emperors on the walls, another Buddha in the window, and a blue-and-white porcelain lamp.

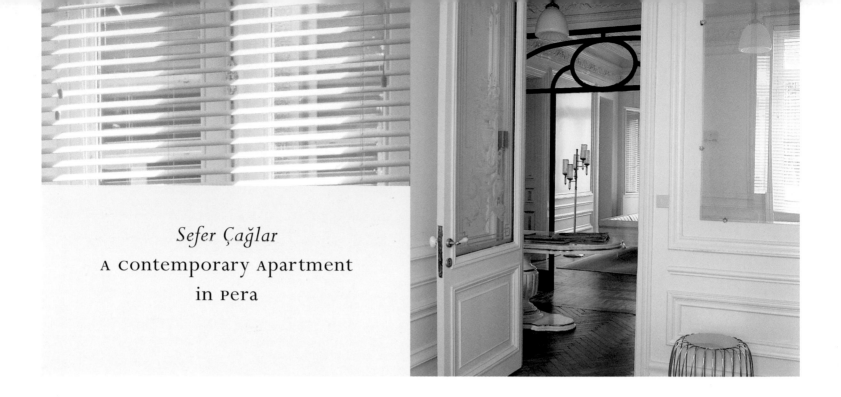

Sefer Çağlar
A Contemporary Apartment in Pera

Light filters through the Venetian blinds of Sefer Çağlar's apartment (above, left). Looking through the bedroom door into the hall: the elegant black wrought-iron partition between the entrance and the living room is modern, but its curved forms are timeless (above, right).

Above the long narrow wooden dining table and the designer chairs hangs Sefer's black 'Octopus' pendant lamp (opposite); it has adjustable arms and adds a sculptural touch. Odd silver and glass objects bought in junk and antiques shops adorn the room. The panelled wall on the left opens at a touch to reveal the kitchen.

Today's Istiklâl Caddesi, in the district of Pera, was the grandest thoroughfare in Istanbul in the 1900s. Known as the Grand' Rue de Pera, it was where the foreign embassies, the Galatasaray Lycée and the beautiful Gothic Catholic church of Saint Antoine could be found. Flanked by elegant arcades, opulent department stores, fashionable cafés, theatres and music halls, it was also where the elite of late Ottoman Istanbul had their winter residences.

But two world wars and historic upheavals stripped the district of its swagger. In the 1920s, with the founding of the new Turkish Republic, the embassies decamped to the new capital, Ankara. Pera – or Beyoğlu, as it was now more commonly called – was no longer a respectable place to live. But things have changed again. Construction on Istiklal is now rigorously controlled, the promenade has been closed to traffic and many of the old buildings have changed hands and are being renovated. In the past ten years, Istanbul's young intellectuals and connoisseurs have developed a keen interest in these buildings and their faded grandeur.

The successful young interior designer Sefer Çağlar is one of them. He not only chose to live in a fin-de-

siècle apartment here, but with the architect Seyhan Özdemir, his business partner and a former school-friend, he has become one of the people responsible for reviving these run-down gems. Sefer and Seyhan own the Istanbul design company Autoban, a multi-disciplinary design practice, founded in 2003, which instantly caught attention by winning Britain's Blueprints for Quirky Design award. Now they have joined forces with the Spanish-Portuguese firm De La Espada to enable Autoban's designs to reach shops in London, New York and Los Angeles.

The flat Sefer bought occupies the whole floor of a reasonably modest block in a side street off Istiklâl. He has renovated it, turning it into a comfortable home. The additions accumulated over a century by numerous occupants with differing tastes were carefully peeled away to bring out – in some cases, literally excavate – the original architectural details. The elegant panelled doors with their original engraved crystal panes and the luxurious oak parquet flooring were sanded, cleaned, repaired, painted and polished to regain their original lustre. The floor plan has altered, but the impressive plaster cornices and ornate ceilings have been kept intact. Intricate

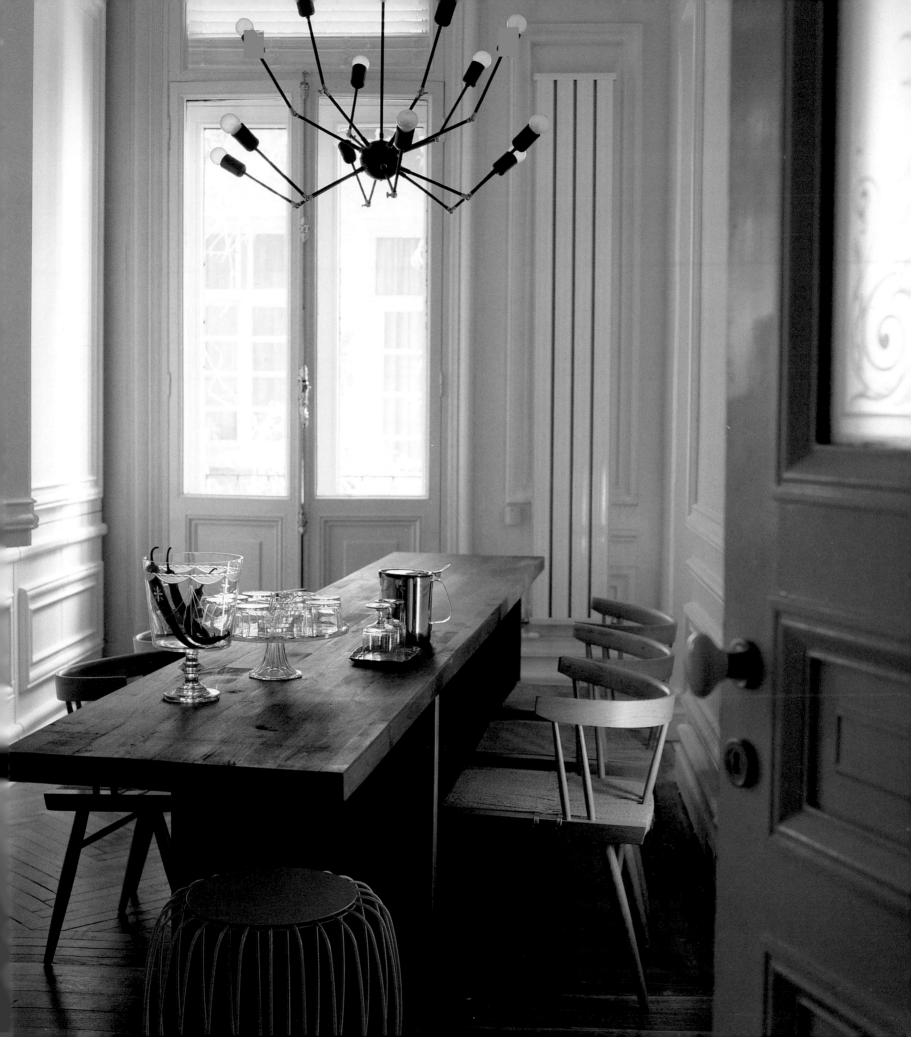

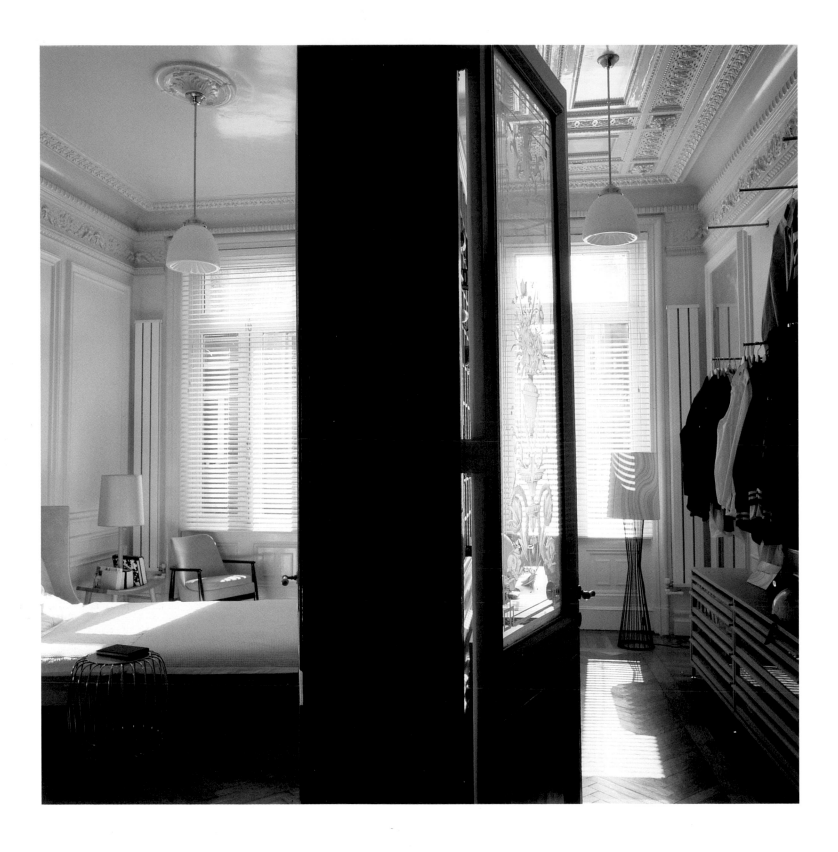

mouldings have been picked out in gloss paint to contrast with the matt walls, all off-white. When the walls were being stripped, Sefer was thrilled to find traces of the old panelling in one corner and he then replicated the design on the other walls. Without anything to distract the eye, the clean, bare walls and high ceilings are the perfect setting for Sefer and Seyhan's gently quirky, slightly tongue-in-cheek furniture and lighting.

Their first successful project was the 'Spider' lamp, a circle of curved rods radiating from a central mirrored bulb, which is in perfect harmony here with the intricate ceiling decoration of the living room. There are two generous 'Box' sofas with 1950s modernist lines, 2006 creations, and a pair of white 'Ladder' bookcases, designed the year before, lean at an angle against the white walls and form a clever contrast with the period style of the building. The faint beam of colour from Sefer's tube lights is the finishing touch, breathing new life into a minimalist off-white space. 'The aesthetic is derived from the chaos of modern Istanbul,' Sefer explained to Nick Vinson from the *Financial Times*, who picked their 'Tulip' lamp as one of the ten key objects at London's 2007 Design Festival. The result manages to be both edgy and serene.

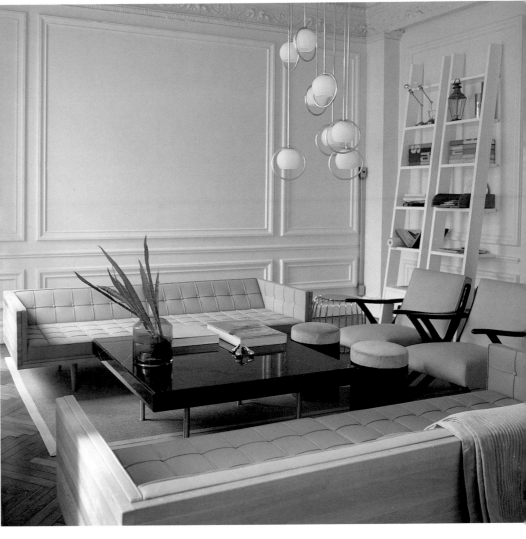

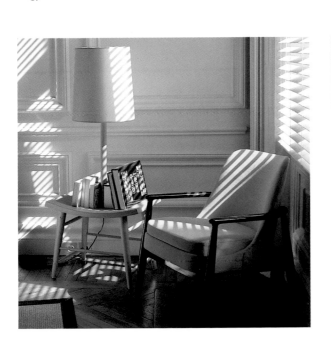

The living room with 'Box' sofas and a pair of 'Ladder' bookcases, both Autoban designs (above). Beams of sunlight create patterns in a corner of the bedroom (far left). In the dining room a glimpse of the fitted kitchen, where mirror tiles create optical depth behind the panelling (near left).

The designer's high-ceilinged bedroom and walk-in wardrobe (opposite) with, in the corner, Autoban's recent 'Tulip' lamp consisting of delicate black metal rods topped by a stylish white lampshade.

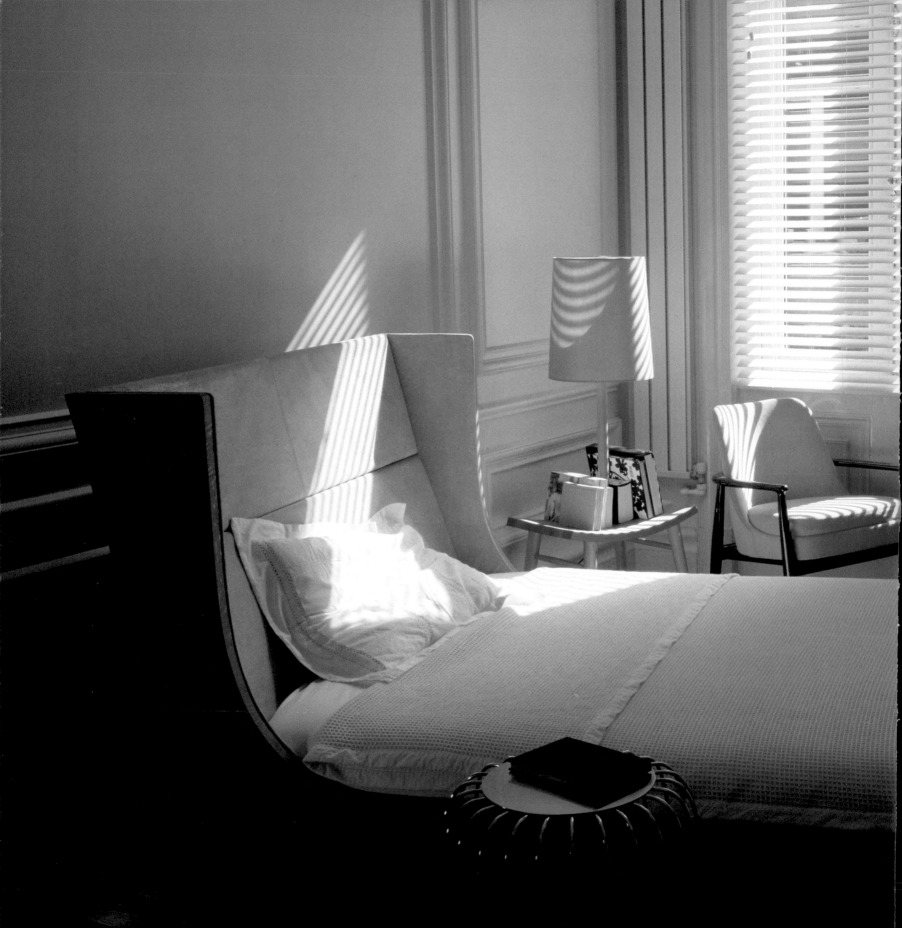

The interior designer's bedroom (left); the doorknob and the crystal pane engraved with floral sprays and scrolling leaves are original. The 'Bergère' bed is an Autoban design, built by De La Espada. The beige suede upholstery of the bedhead, the oak 'Book Lamp' on the bedside table, the mustard easy chair and the brass 'Pumpkin' stool, one of Autoban's early designs, make for a cool but intimate interior. The blinds create graphic patterns of light.

Kavur Family
A wooden mansion
on the princes islands

In the 19th century, cast-iron structures like this (above, left) were shipped down the Danube from Vienna to be reassembled in situ. This one was installed on top of the well in the garden and is known as the well house. The façade of John Pasha's *köşk*, a cascade of eclectic decorative elements (above, right). A horse carriage or *fayton* (right) is the only transport on the meandering lanes of Büyükada, shaded with old planes and pines.

The timber mansion seen from the garden (opposite). The bedrooms on the upper floor enjoy breathtaking views of the Sea of Marmara and the Asian shore beyond.

A cluster of islands in the Sea of Marmara close to Istanbul, the Princes Islands took their name from the Byzantine princes and princesses exiled there over a millennium ago. Today fresh breezes, blue waters, shady streets, horse-drawn carriages (there are no cars), handsome mansions and villas, and beautiful gardens make them an ideal escape.

On Büyükada, the largest of the islands, the *köşk* of 'John' Pasha, an Ottoman gentleman of Italian-Greek origin who introduced the steamboat service to the island, was commissioned in 1880. The exterior is an exuberant concoction of architectural styles – Empire pediments, tall Loire château towers, baroque pilasters and volutes, neo-classical columns and balustrades.

A rococo-inspired marble staircase forms the entrance to the house. For more than half a century John's *köşk* – its square roof towers and monumental silhouette visible from the distance as the ferry approaches the quay – has been the summer home of the Kavur family. They have only recently handed it on to Lucien Arkas, scion of an old Izmir shipping family.

Nilgün Kavur describes how summers were spent there: 'On the first day of May cleaning ladies opened up the house, polishing the parquet, airing and cleaning all three storeys from basement to attic – it would take three weeks.' First to arrive was the grandmother, 'the Great Hanım', followed by her brother, 'Great Uncle', and his wife and son, and finally, as soon as school had broken up, Nilgün and Hakan with their two children. 'Every member of the family moved into their own particular bedroom, taking on exactly where they had left off the year before.'

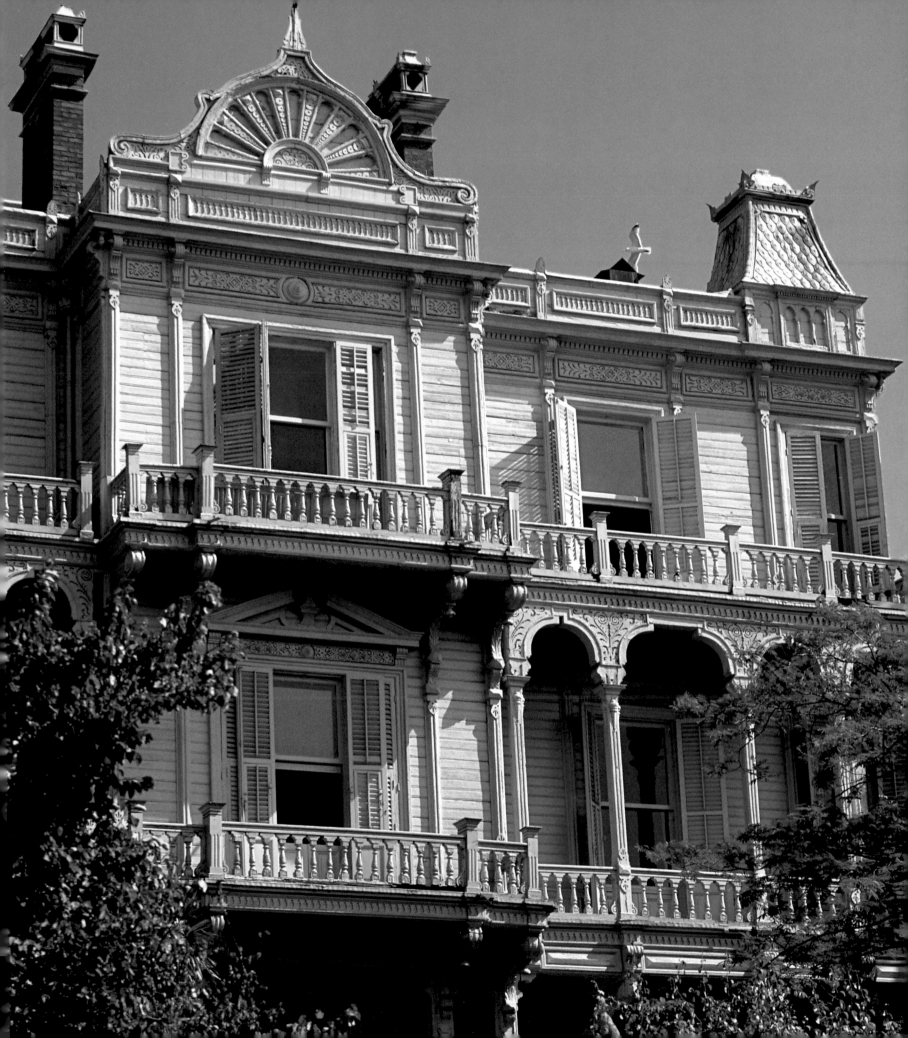

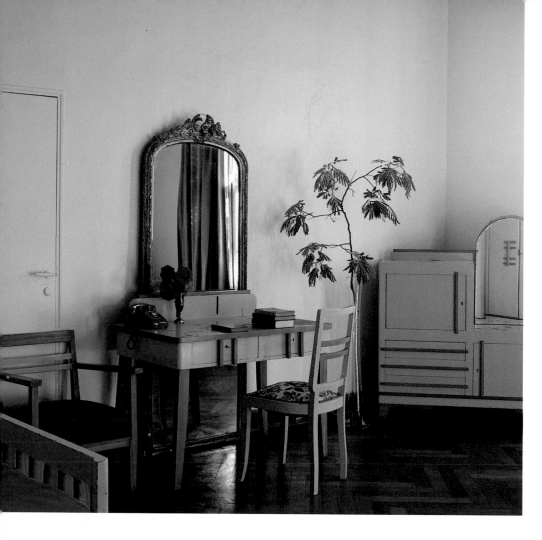

All three generations of Kavurs enjoyed the *köşk's* playful architectural details, the sumptuous stained-glass windows in the main bathroom, the painted and stencilled ceilings with their seascapes of steamships in the bedrooms, the creaking oak parquet floors, the extensive kitchen and the Bavarian dining room, which still has a button on the floor for the mistress of the house to summon the butler.

A corner of one of the bedrooms upstairs (above), furnished plainly with post-war family furniture and a gilded mirror.

The spacious kitchen on the ground floor with original flagging and plate rack (opposite). The old wood-burning stoves have been replaced today with modern gas ovens. The door leads to a little veranda and the garden with its lily ponds.

Nilgün remembers 22 June 1994 particularly well: her wedding day, celebrated with a candle-lit party for 150 in the three sumptuous salons and the garden outside. 'The room my husband Hakan was born in was given to us,' she recalls. 'It later became my daughter's room. Our two children are the third generation born and brought up in this *köşk*.' She also remembers how it needed some maintenance when she arrived as a young bride: 'The balconies were so

fragile we didn't dare allow guests to step out on our wedding day.' The young groom took on the task and commissioned 'artistic carpenters'. After two and a half years of painstaking work, the house was as it had been in his childhood.

The interior of the *köşk* reveals an absence of fireplaces, and the round holes in the walls for stove pipes are a reminder that it was heated by coal- or wood-burning stoves, the height of modernity, at the beginning of the 20th century. Also absent is the traditional Turkish floor plan. A narrow hallway with panelled walls leads to the drawing room, in fact a suite of three spacious salons taking up the entire width of the house is linked with open arches. The ceiling repeats the honeycomb stucco of the octagonal medallions in the hall, each framing a decorative painting. Nilgün describes how much they cherished the house, respecting its faded elegance and never trying to modernize it. The Kavurs avoided hanging paintings, leaving the walls uncluttered so as not to compete with the richly decorated ceiling and cornices. A variety of lampshades create pools of light to read by in the evening and there are comfortable sofas, armchairs and mahogany furniture from the 1940s, covered in printed linen with patterns of garden flowers, to sit in.

The extensive garden leads down in terraces towards the sea, ending at a gardener's house, a greenhouse and an orangery. Beyond the greenhouses can be seen the red tiles of a neighbouring mansion down by the sea – the house where Leon Trotsky and his wife lived during their exile in Turkey in the early 1930s. Trotsky fished and swam, and wrote his treatise on communism. It was possibly the happiest time of his life.

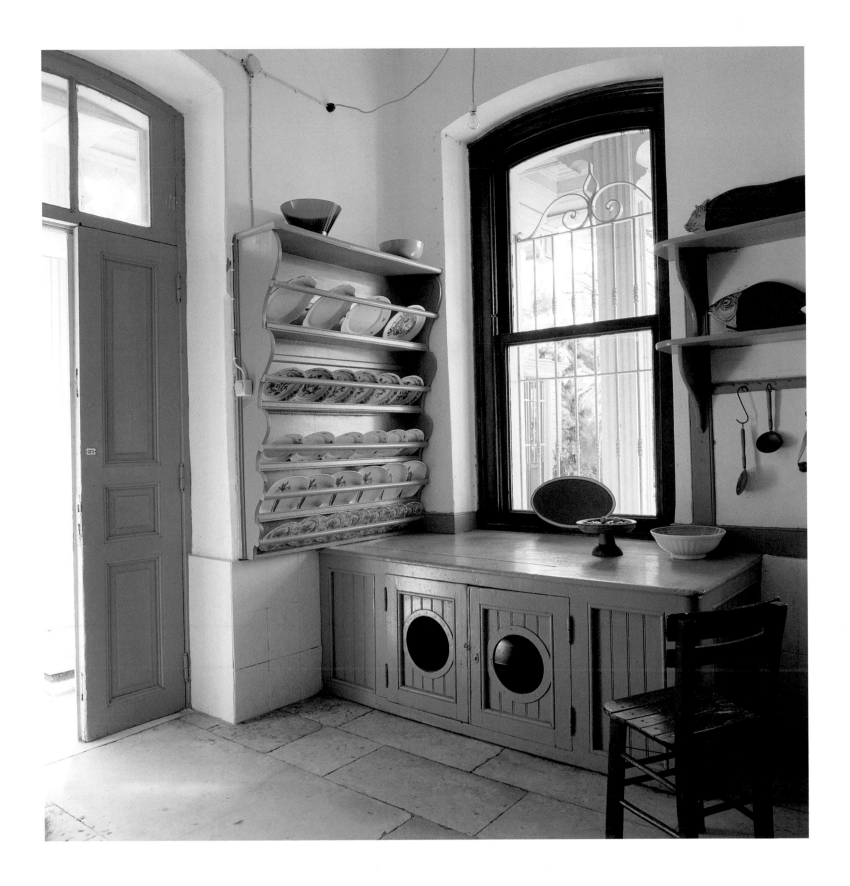

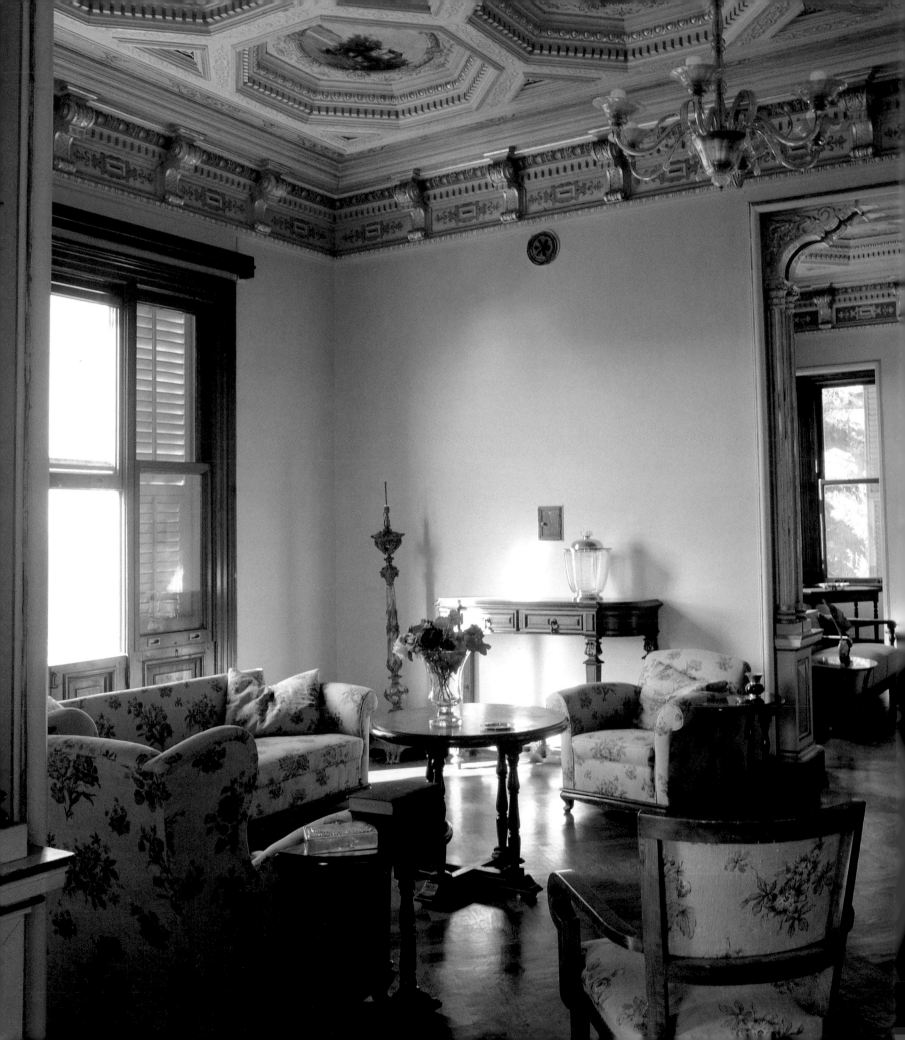

Designed for entertaining: the drawing room consists of a suite of reception rooms with opulent ceilings running from one end of John Pasha's house to the other. Today, flowers from the garden and the faded elegance of old family furniture give it a relaxed air (left). One of the painted bedroom ceilings has an Art Nouveau brass chandelier and glass shades in the form of tulips (above, right). In the drawing room, gilded octagonal mouldings frame paintings of panoramic views and ancient monuments (right).

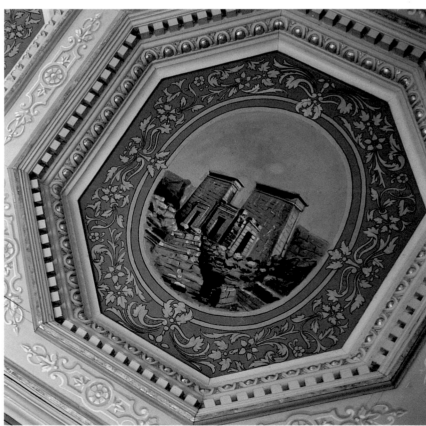

Emel Kurhan
A theatrical pied-à-terre in Harbiye

The garden has become a leafy playroom for Emel Kurhan: a tranquil corner with pots of succulent Crassula shrubs (above, left). The ceramic jug was brought back from Algeria and the necklace with Marilyn Monroe's lips is a design from Yazbukey, Emel's company. Family heirlooms against the backdrop of a brick wall (left). A framed family embroidery next to a toy squirrel made by Emel from scraps of denim for the Turkish jeans company Mavi (bottom).

In front of the brick wall (opposite), which shields Emel's bed, is a delicate French secretaire and a Venetian mirror, inherited from her family, and a gouache portrait of Princess Josephine-Charlotte of Belgium, a present from a friend. The armchair in the background is her grandfather's and the Chinese screen belonged to her parents.

Dividing her time between Istanbul and Paris, Emel Kurhan is a very successful young designer. Her father was a diplomat and she and her elder sister had a thoroughly international upbringing. After graduating from the prestigious avant-garde Studio Berçot fashion school in Paris, they both worked for several years at various fashion houses in France. Following the premature death of their parents, they decided to stay on in Paris and create something 'new and surprising', as Emel puts it.

'Our very first design was made from scraps of leather, because they cost nothing,' she says. 'As an experiment we left a few pieces in some boutiques in London.' The Kurhan sisters were amazed when the Icelandic singer Björk, famous for her eccentric style, bought the entire stock. Instantly famous, they decided to form a Paris-based company, Yazbukey, named after Emel's sister (it means 'summer princess'). Their jewelry is now well established, displayed alongside Manolo Blahnik shoes and John Galliano handbags in international stores such as Maria Luisa in Paris and Kabiri in London.

Emel is very attached to Istanbul – she has many childhood memories of carefree summer holidays spent on the island of Büyükada and of her grandparents' house above the Bosphorus in Beşiktaş. 'I come here whenever I can,' she says. 'Production costs are cheaper here than in France or Italy, but that is only an excuse to come to Istanbul.' By chance, she also found herself a tiny pied-à-terre where she could create a 'den' and a 'secret garden'. 'One day, two and half years ago, I was passing by with a friend and we noticed a sign. I wanted to see the place. It was below street level, next to the concierge's flat, and looked really awful, but somehow I liked the place.'

The flat was in the basement of a 1960s concrete block in the Harbiye district, not far from Taksim

This necklace, from Yazbukey (below, left), is one of Emel's favourite designs. A frog ring from the new animal collection (below, centre). The twin chihuahuas – one Emel's, the other her sister's – are treated like family (below, right).

Emel's romantic ancestor, the Khedive, in a fez, hangs in a more formal corner (opposite).

Square. Emel bought it and renovation started. It was to take a year: first they reclaimed the small walled garden at the back. It was the size of a ping pong table and over the years it had turned into a rubbish tip. Then, with the help of her friends and their parents, Emel reorganized the flat, eliminating the few existing walls to create an open, 'doorless space' – even the bathroom is without a door. The rectangular floor plan culminates in the small garden at the far end. There is an open kitchen in the corner next to the entrance, installed with a ready-made unit from Ikea – which 'fitted like a glove'. The rest is a living, resting and working area. The bed in the corner by the garden is shielded on one side by an elegant screen brought back by Emel's parents after a posting in the Far East. A free-standing brick wall at the end of the bed creates a semi-enclosed space, separated from the living area. With clever planning, the maximum space has been obtained from a limited area.

For Emel, the flat, where she lives alone with Kumpir, her silky chihuahua, gives her independence and peace. 'I feel as though time stops when I creep in here, leaving the outside world behind. It is quiet,

hidden and protected.' The garden is important to her and has been transformed into a leafy playroom filled with evergreens, rambling roses and pot plants. The interior, with its white walls and contrasting exposed brickwork, was inspired by American musicals of the 1940s and 1950s staged in the back streets of New York. Full-size original posters of such classics as *Singin' in the Rain* and *The Wizard of Oz* hang alongside photographs of childhood heroes such as Humphrey Bogart, Bette Davis and David Niven. They are all freely arranged with her family photographs and pictures, including an oil portrait of her great-great-grandfather Ibrahim Pasha, who died young and was the only son of a famous Khedive of Egypt. In Emel's flat French armchairs and her mother's secretaire sit happily alongside wire chairs and a garden table with aluminium legs. Porcelain lampstands and crystal vases are at home with colourful plastic toys and polyester animals.

A potpourri of styles, tools and toys, old and new, antique and kitsch, functional and decorative, serious and fun, fills Emel's bijou flat. The result is refreshing and playful, just like her designs.

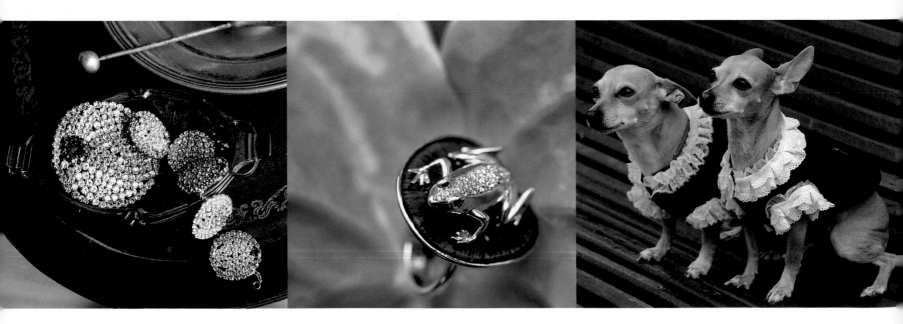

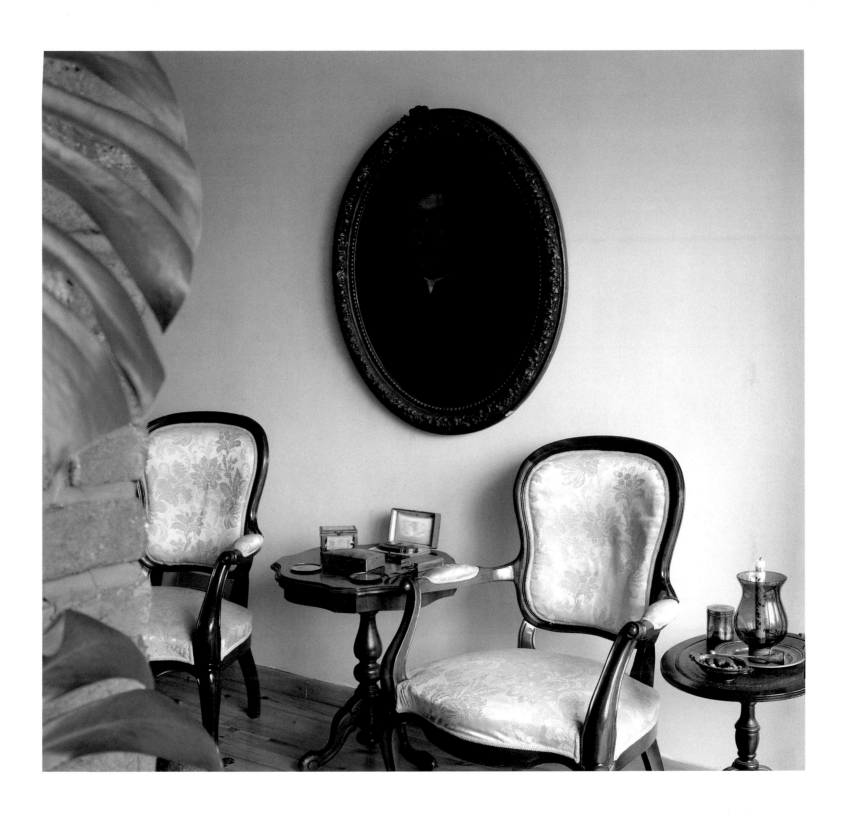

Gönül Paksoy
A Designer's Penthouse
in Nişantaşı

In Gönül Paksoy's dining room (above, left) a home-made table is surrounded by matching chairs bought at different times and places. The walls are adorned with fragments of Roman mosaics depicting pomegranates, ducks and scenes of nature. Gönül discovered them at the very last moment before they were smuggled out of the country. Now they have been rescued, restored and listed by the authorities. The rooftop terrace garden with its lemon, pomegranate, apple and citron trees (above, right). The trimmed globe topiary is a juniper. Late Roman marble capitals serve as low tables. The garden furniture is from 'semi-antique' dealers and flea markets. A pair of tarnished bronze vessels on the landing (right), one with a handle, the other without, dating back to 1000 BC.

Upstairs (opposite), Gönül's desk in front of shelves lined with prehistoric ceramic bowls, Roman bronze trefoil-mouthed jugs, copper ewers, Ottoman *hamam* bowls – all neatly labelled.

Collector, artist, designer and food writer, Gönül Paksoy possesses many gifts. She has always worked hard and been determined to create wonderfully original objects. As Kenzo, one of her many celebrity admirers, said of her, 'How is it possible that Gönül is not more famous than myself?'

The eldest of six brothers and sisters, Gönül was raised in a *konak*, or mansion, in Adana. Her grandmother taught her how to be creative when cooking and she developed a taste for the finer things in life from her mother, who always placed a vase with a single white rose on the breakfast table. At university she trained as a chemical engineer and her thesis was on dyes. Her professor advised her: 'Always start at the beginning.' This is how her lifelong passion for natural dyes and prehistoric objects began.

In her duplex penthouse in a modern block in Nişantaşı, a smart quarter of Istanbul, Gönül treasures her priceless collection of listed archaeological objects, all found in Turkey. A collector for almost 25 years, she says she does not acquire them as an investment, but sees them rather as a universal heritage which she is trying to save for future

generations. She rescued many of them before they could be smuggled abroad. 'I consider myself so lucky to live in a country with an infinite cultural wealth.'

The whitewashed walls of her flat are the ideal setting for all her timeless beauties: not only the precious collection of ceramic pots, bronzes and marbles, but also her own textiles. In Gönül's spacious living room the large sofa and two armchairs which she designed have covers made, like the curtains, from fabrics that she had specially woven from natural fibres. The cushions are made up of antique 'but not museum-quality' materials which she has dipped in a dark shade of dye so that all the

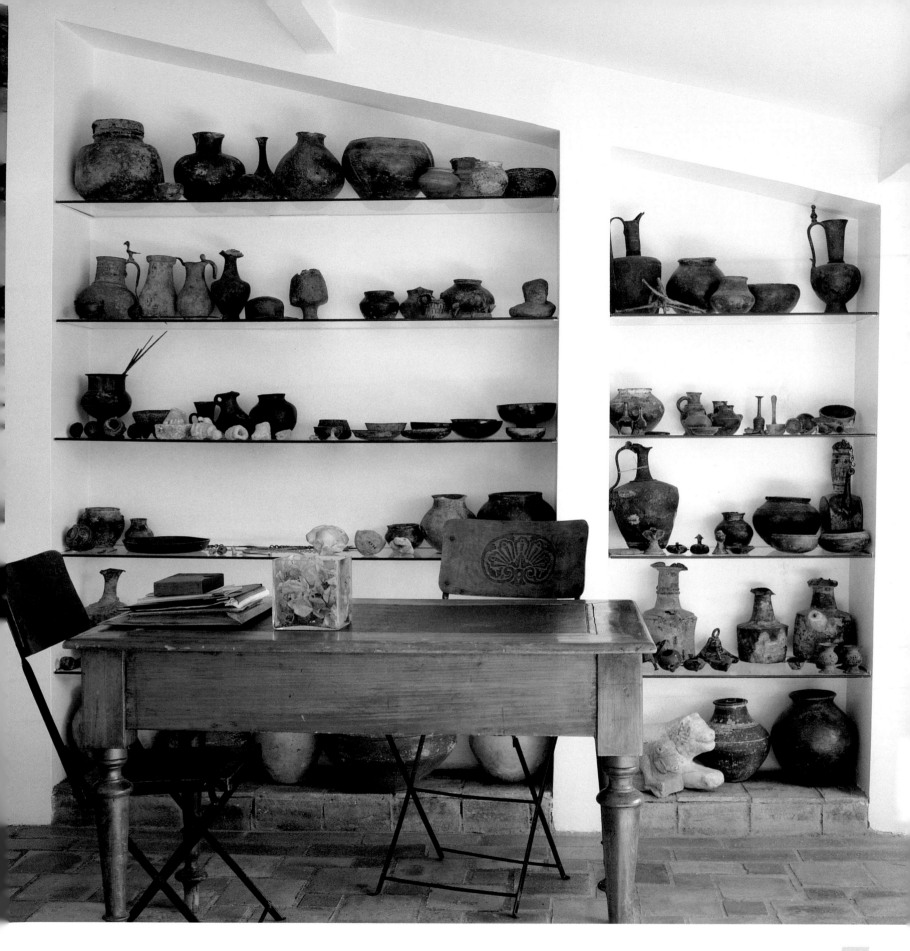

A picture-perfect Ottoman boy's waistcoat, or *yelek*, hangs above a 12th-century Seljuk pestle and mortar and two smaller mortars – possibly used for medicinal purposes (left). The deep sofa in the living room (right) is Gönül's design and the table her brother's. Cushions and curtains, including the curtain rail, are all dyed and made by Gönül. The austere composition is completed with marble fragments on the wall and a glowing copper-coloured kaftan, possibly made for a clergyman. The two ceramic pots, far right, date from 2000 BC.

colours have an equal value. The resulting muted tones – as if 'seen through a dark veil' – reflect the shades of the burnished pots and tarnished bronzes. A chintz kaftan on a stand in the corner, which Gönül said appealed to her because of its warm copper colour, complements two enormous earthenware pots dating from 2000 BC and fragments of Roman mosaic in the adjoining dining area.

A hall and a corridor paved with fired-earth tiles takes one to the open-plan kitchen, the bedroom and en-suite dressing room. Gönül planned the kitchen, where she enjoys experimenting with new flavours, herself. White, practical and contemporary, it has ample storage for her collections of fine porcelain tableware and her extensive 1902 Christofle silverware. In this highly equipped kitchen, her most indispensable tool is a mandolin grater. Having published two cookery books, she says: 'Though I don't do it professionally, I try to create tastes which are unforgettable. They are based on the flavours of my childhood, the taste of Anatolia.'

Her bedroom at the back of the flat is neat and tidy to the point of sparseness: a bed, an old chaise longue and a bedside table – all covered in dark silky materials. The wardrobes in her dressing room

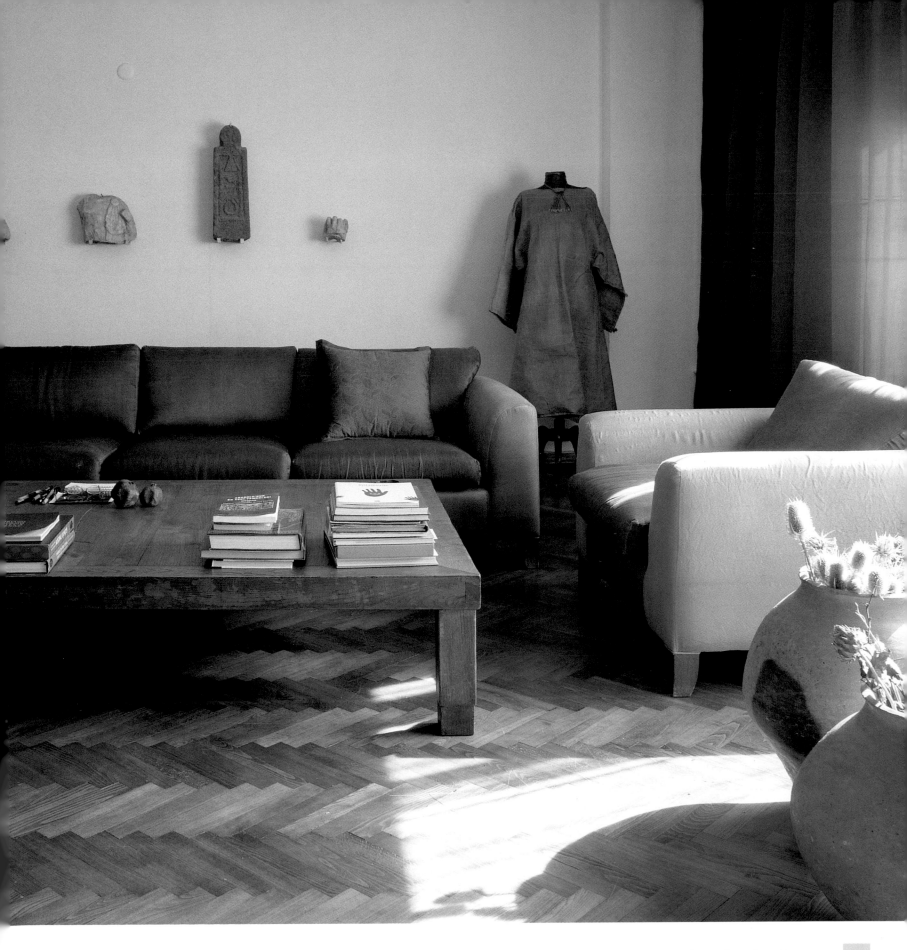

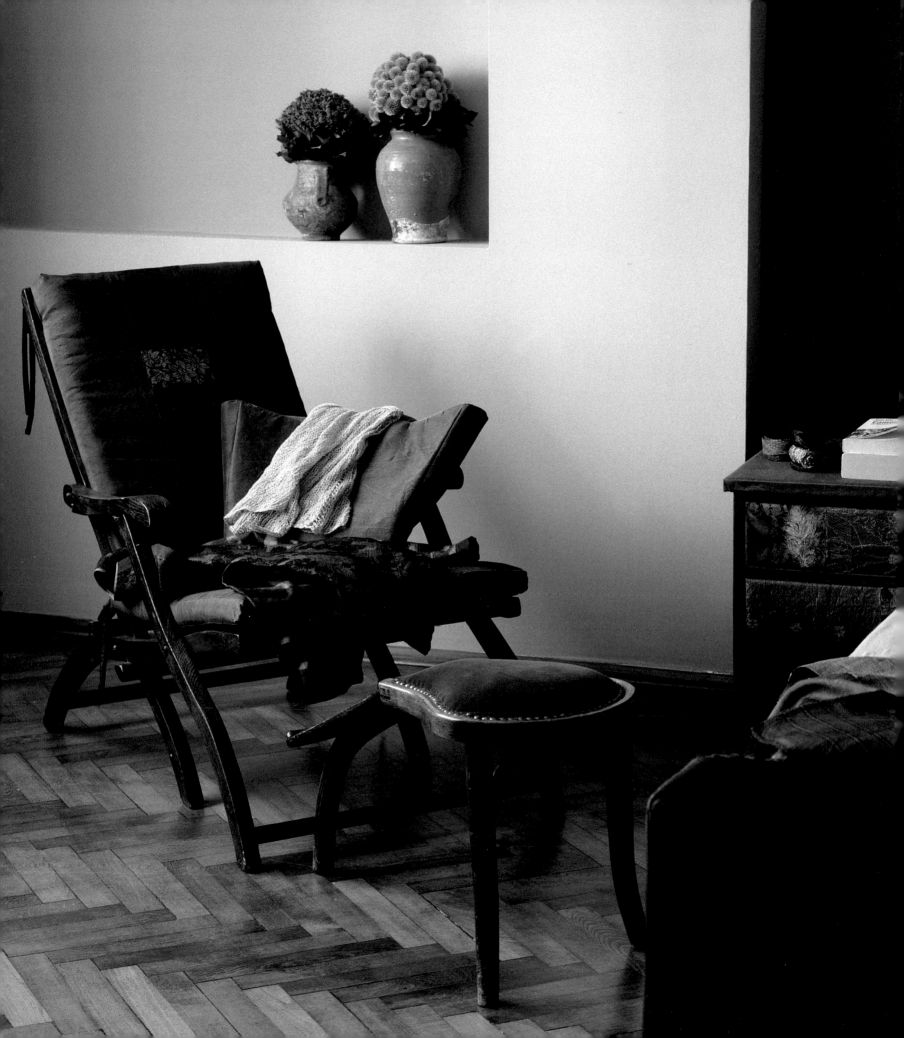

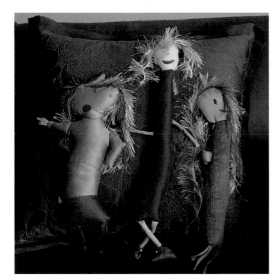

disappear behind wall-to-wall mirrors, which give an effect of infinite space. Two turquoise Iznik vases and a pair of fuchsia satin slippers on the floor are the only bright tones on this Rothkoesque canvas.

Upstairs on the roof Gönül has created a small studio with two leafy terraces front and back. Here she not only grows her herbs, but enjoys a bumper harvest of lemons, apples and mulberries from trees planted in containers. Gönül spends her mornings here, in silent reverie, watching over her garden. Her evenings are spent in solitude, drawing models for her elegant outfits and jewelry, designing furniture and writing her books. Gönül's costume designs are simple – inspired, she says, by the 'plainness and subdued colours' of the habits that Sufi dervishes used to wear. 'They are not only ergonomic,' she explains, 'but there is also a mathematical balance in their design – so that not an inch of material goes to waste. Their simplicity has reached a level of perfection.' Gönül's home is a reflection of similar principles at work.

Gönül's bedroom (left): the bedside table and the high bedhead, both covered in silk, are Gönül's designs. The old chaise longue and the Thonet shoe-shop assistant's chair were bought in flea markets and dressed by Gönül. The two turquoise glazed vases in the niche are 12th-century Seljuk. Rag dolls from Gönül's extensive collection (above). The characters are drawn by her three- and five-year-old nephews, then created and stuffed in her workshop from offcuts and trimmings. After that the children name them. In 2002 ninety such dolls were exhibited. The 'spoilt girl' is on the left, next to the 'model' and the 'floppy bird-man'. The bedside table (right) with deep red velvety feet is covered in a patchwork of old brocades and antique fabrics.

Ramazan Üren
An Avant-Garde
Istanbul Loft

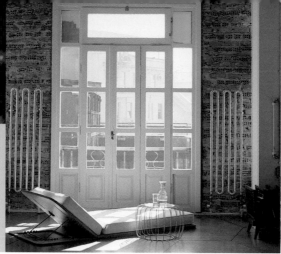

The printed felt used to upholster Ramazan Üren's 'Bergère' chair (above, left). The tall terrace doors with their coloured panes and sun-drenched floor-level chaise longue (above, right).

The seating is a motley collection: designer pieces, such as the Bertoia wire-mesh chair, finds from secondhand shops, and pieces from Ramazan's many cafés and restaurants, all somehow fitting together (opposite). Sun pouring through the coloured panes of the windows lights up the scene.

Ramazan Üren, a free-verse poet, a graphic designer, a would-be motorbike mechanic and the owner of The House Café, a chain of hip café-restaurants in Istanbul, lives in the Mısırlı Apartmanı, or Egyptian Apartments, in the Pera district of Istanbul. The palatial building was originally commissioned by the Egyptian prince Abbas Halim Pasha as a winter residence for his extended family and retinue.

The architect Aznavur started building the Mısırlı in May 1910. For a flavour of the pomp and grandeur of the project, one need look no further than the finial that tops the marble balustrade at the foot of the stairs: a globe with the continents carved in relief on its surface. On his death the prince's heirs converted the palazzo into flats and added two more storeys. It has recently been modernized and the roof top is now occupied by a fashionable bar-restaurant with fabulous views of the Bosphorus. Ramazan's flat, on the second floor, was for years used as a canteen by the staff of a nearby bank. It had been gutted and the partitions between the rooms removed. One wall was covered with white tiles.

The fact that the flat had no view did not bother him. 'I always find views uninteresting in a house,' he says. Ramazan, one of nine, was born in a beautiful sand-coloured farmhouse in Adıyaman, in arid southeast Turkey. 'It was really a group of houses around a courtyard looking inwards,' he explains.

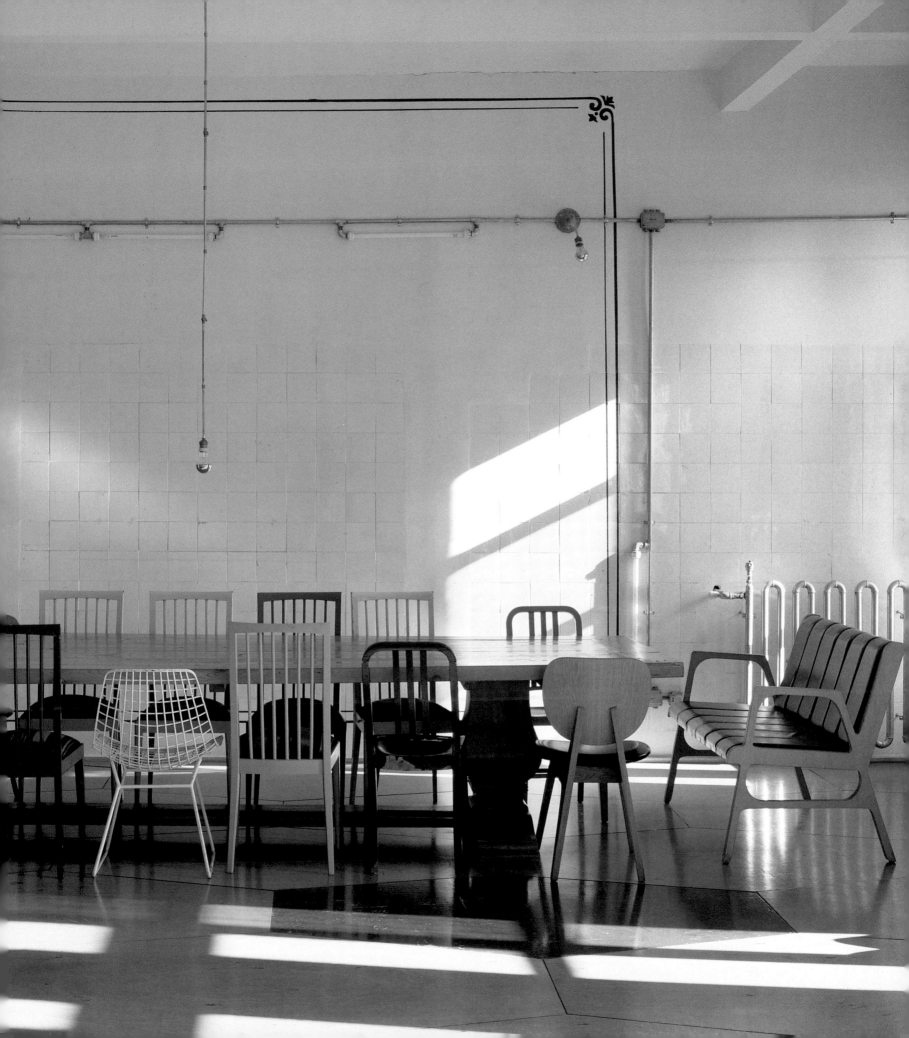

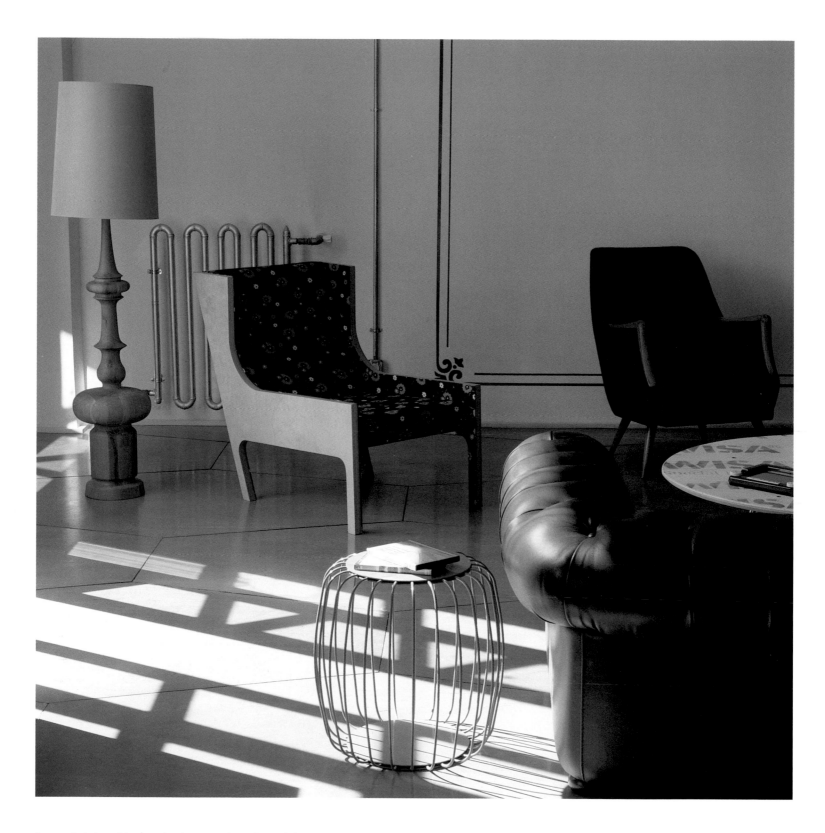

Ramazan's designer friends at Autoban created this 'Bergère' chair upholstered in printed felt. Behind it stands their ever-popular 'King' lamp. In the foreground, next to the chesterfield, their verdigris 'Pumpkin' stool catches the light.

But he did like the flat's high ceilings and tall windows, as well as the fact that it had a metropolitan edginess. When he consulted his friends Seyhan Özdemir and Sefer Çağlar – who designed his chain of restaurants and founded the award-winning design studio Autoban – they felt the same. The space is minimalist, but is always changing and is somewhere Ramazan can experiment with design ideas, as well as being an excellent photography studio. He himself is full of energy and obsessive: the moment you step inside the flat you are welcomed by his motorbike, two bicycles and 50 pairs of trainers neatly lined up. The platform bed is raised on stilts which provide useful space to hang 50 or so leather jackets.

The living space has a luxurious dark green leather chesterfield. Colourful objects give a lift to the Spartan décor. The secondhand armchairs are upholstered in bright fabrics. The arrangement is teasing and constantly changing. The plaster on the front walls has been peeled away to expose the brickwork, which contrasts starkly with the delicacy of the door, with its white frame and fragile coloured panes. The ceiling has been left unpainted in parts, showing earlier signs of damp and previous layers of paint. The designers regard it as honesty not to cover up functional elements such as cables and pipes: their own 'Spider' lamps are installed in the ceiling with all their fittings exposed; industrial valves and pipes serve as taps and plumbing.

A long dining table, its paint worn off, is surrounded by random chairs, vintage classics put next to odd chairs found in secondhand shops. In the spacious open-plan space there is a small free-standing kitchen, 'which easily caters for 150 people,' says Ramazan.

All in all, the room is like a free-verse poem, its disparate elements arranged with laid-back sophistication.

In an otherwise avant-garde setting, the bathroom (top) is surprisingly conventional apart from the intimidatingly futuristic shower. The marble walls, whitewashed ceiling and traditional *kurna* washbasin are all inspired by the Turkish *hamam*. The stencilled paintwork (above) on the wall contrasts with the industrial valves and plumbing.

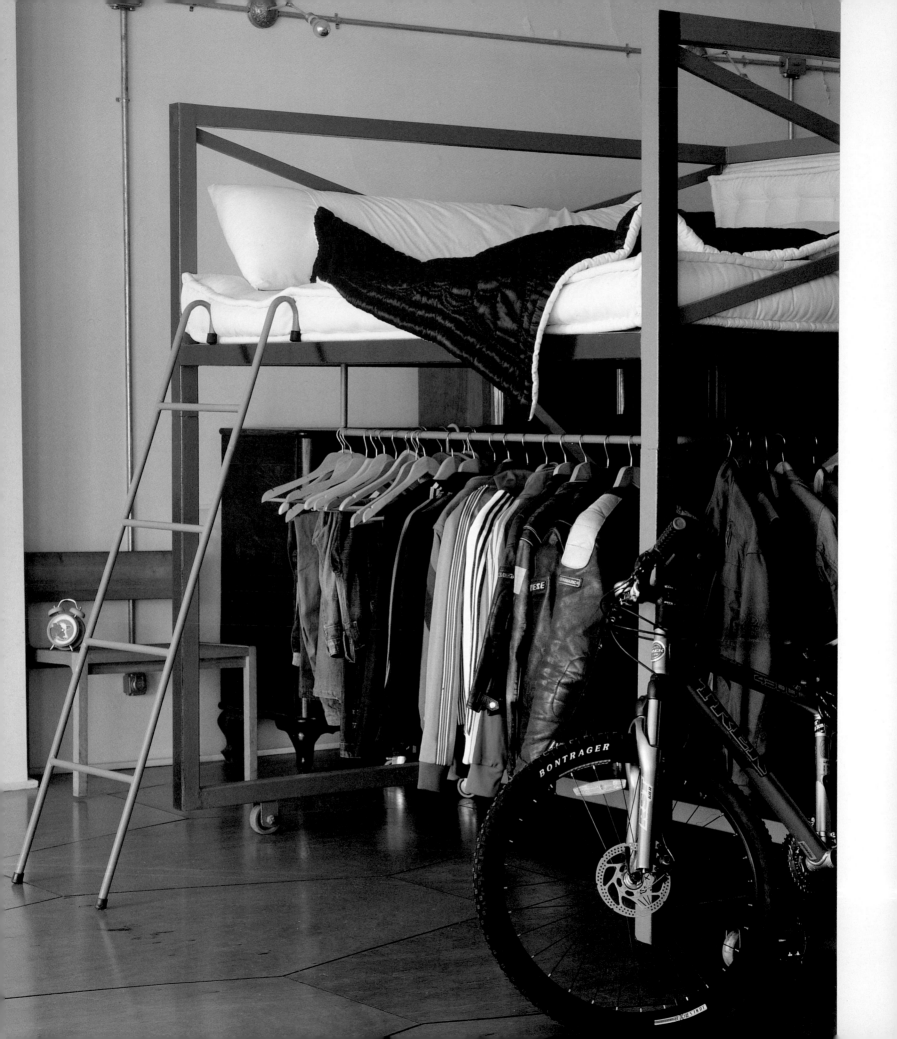

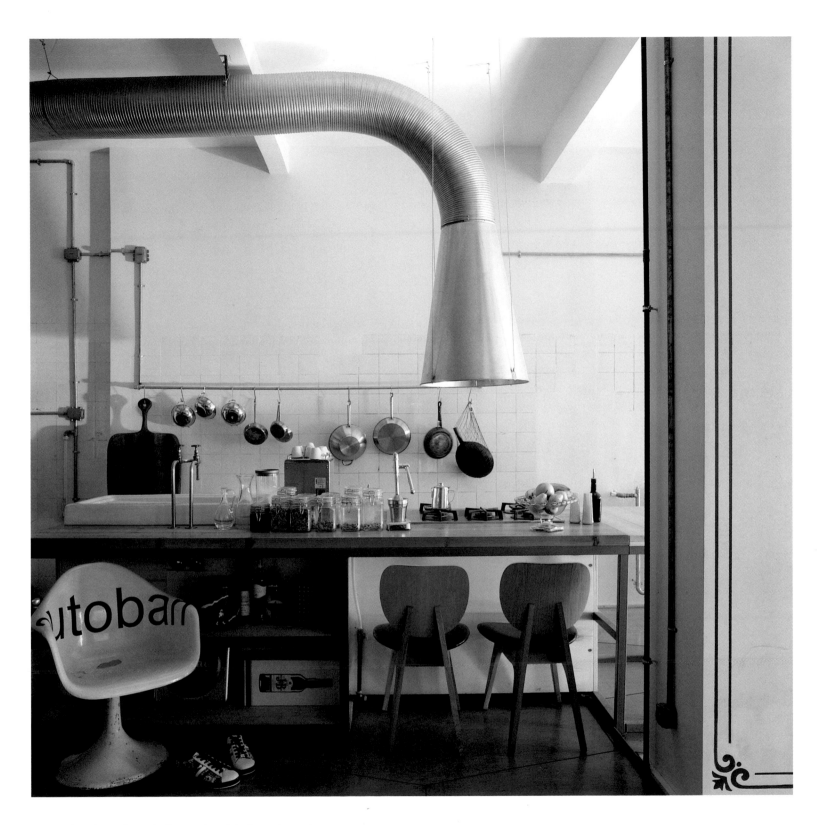

The mobile bed, raised on stilts (opposite), with leather jackets and mountain bike below, and an alarm clock well out of reach. Only a slender ladder separates the world of dreams from the man of action. In the open-plan space (above), there is a free-standing kitchen range with spectacular ventilation. It easily caters for 150, according to Ramazan Üren.

summer

In Turkey this is the season of serene skies, jasmine-scented starry nights, at times pleasantly warm, at times less pleasantly hot, the season to plunge into the waters that surround the country's shores. The indigo Mediterranean, the turquoise Aegean, the sky-blue Marmara, the grey-blue Bosphorus and the dark lapis lazuli Black Sea – it is a world transformed by the changing light to an inexhaustible palette of blues.

Summer retreats on Turkey's shores are hidden in the dappled shade of courtyards, gardens, olive groves and pine forests. Some of them are grand, others modest, but all enjoy the serenity that only water can bring. Cool tiles, printed cotton, linen and limewashed interiors all capture a fresh, tranquil mood and make these hideaways irresistible.

This is the season of simple pleasures – the flap of sails unfurled in the wind, the distant sound of a passing gulet, a horizon dotted with islands, a full moon reflected in black waters, long siestas in the afternoon listening to the serenade of the cicadas, a little gentle herb gardening, watching out for the local fisherman with his catch of the day, the sight of mountains of watermelons arriving from the country, the enjoyment of juicy peaches, fragrant apricots and figs oozing with honey.

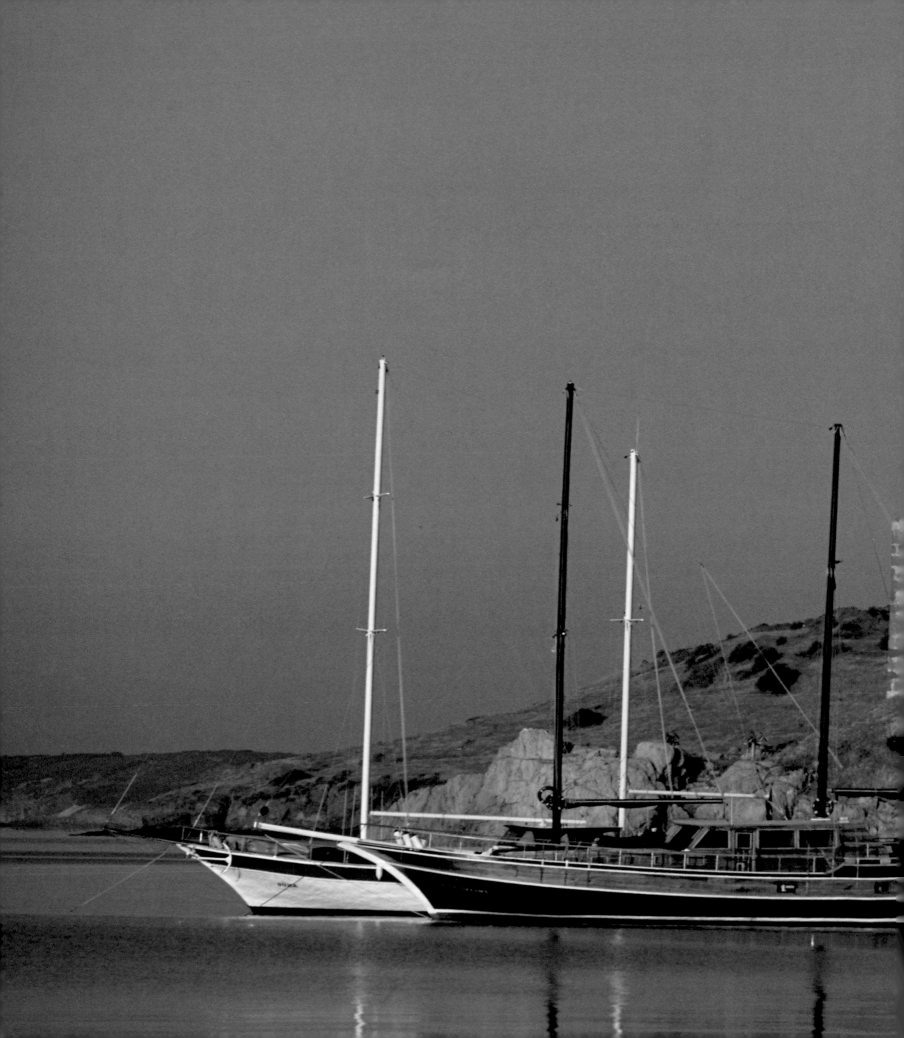

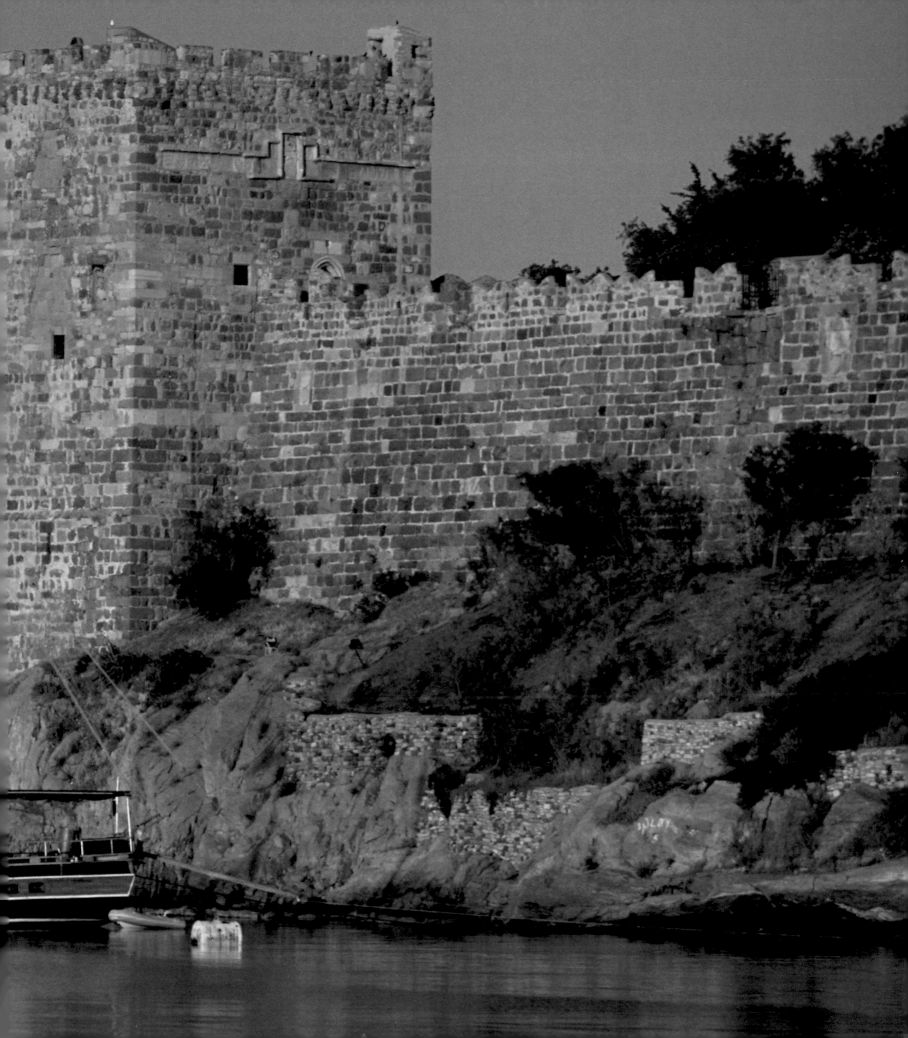

Komili Family
A majestic monastery
on the Aegean island
of cunda

The impressive former monastery of Leka Panaya, Mary the Saviour, rises above an ocean of olive trees. A long brick-red dust road winding through the groves leads to the country home of Alev and Halis Komili and their daughter Arzu, one of eight monasteries on the fertile island of Cunda in the Aegean. In 1820 the Metropolitan of Izmir reputedly sold it for 1800 kuruş (pennies) to one Dionisius, who rented out the rooms to families in the summer months. When the Komilis bought the property, it was a complete ruin, 'just four walls', as Alev puts it. After lengthy research and visits to other monasteries in Turkey and on the Greek islands of Lesbos, Rhodes and Chios, the restoration began under the supervision of the Turkish architect Ümit Serdaroğlu, also responsible for restoring the ruins of ancient Assos. It took ten years to bring the monastery to today's excellent state, the building work finally being completed in 1997. Its massive stone walls now resemble a fortified keep.

Facing the archipelago of Ayvalık and the island of Lesbos across the narrow Dalyan strait, the location is particularly meaningful for Halis. His family traces its history back to the village of Komi, in the mountains of Lesbos, or Midilli as it is known in Turkey. It was there, in the 16th century, that the Sultan granted his family their lands. For centuries the Komilis have produced olive oil, supplying the Ottoman palace with their fragrant Midilli soaps. By 1878, they had established a company with what was then one of the first modern trademarks to be registered in the Ottoman Empire. Komili (which means 'from Komi') is still one of the leading brands of Turkish olive oil, even though ownership has passed on. Obliged to leave their beloved island during the enforced population exchanges of 1922, the Komilis settled in Ayvalık on the Turkish mainland, next to Cunda.

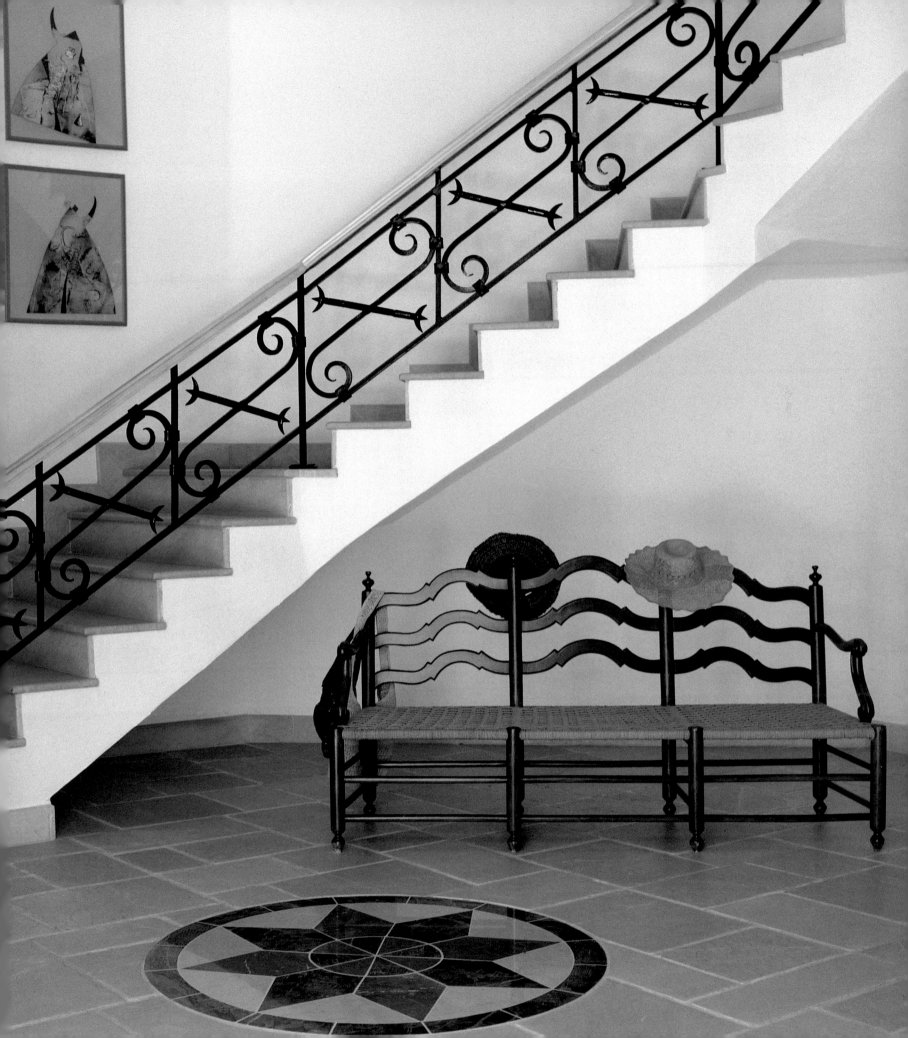

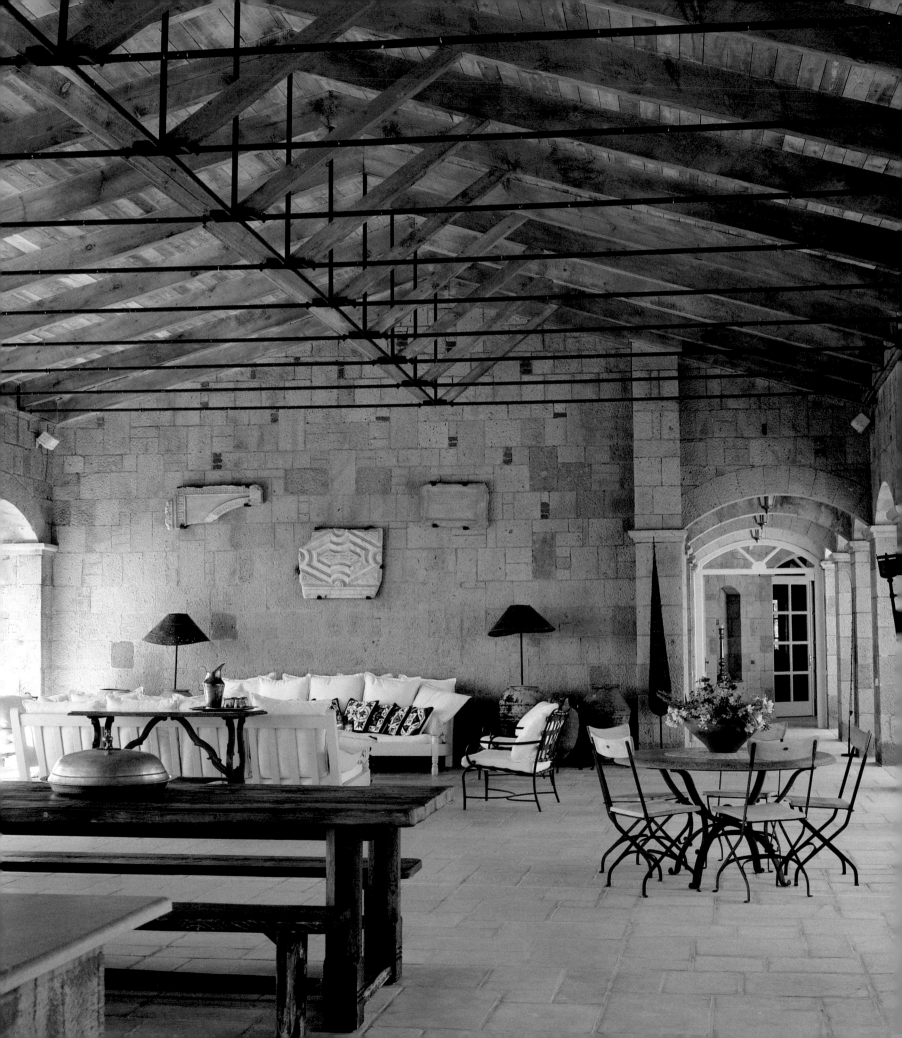

As you enter the courtyard through massive oak doors, you are greeted by an impressive composition of tall, slender cypresses and ancient olive trees with twisting trunks like living statues. The olive trees, some more than a century old, were chosen for their gnarled good looks and transplanted here from neighbouring estates. Alev's bright idea worked perfectly thanks to the knowledge and experience of the eminent Italian landscape designer Ermanno Casasco, who was commissioned to design the garden. The remains of the chapel and the monastery's original well in the middle of the courtyard are the central features of the garden. The paths are paved with black-and-white pebble mosaic. The numerous cells round the courtyard have been transformed into guest rooms, spacious living areas and a large kitchen. The five guest rooms lining the north wall each occupy two storeys, with a bedroom upstairs and a living area downstairs – simple but comfortably designed with fine touches.

The west side, which faces a magnificent panorama of the archipelago, is divided between a gallery and drawing rooms. The terrace of the covered gallery becomes the main reception room in summer. Here the Komilis entertain their guests and enjoy fantastic sunsets as they look out to sea to Halis's ancestral home on the horizon. The colour scheme is confined to the biscuit-coloured flagging of Bandırma marble, specially sand-blasted, the greyish tint of the massive walls of cut stone and the pale warmth of the Canadian pine beams used for the handsome hanging roof, a remarkable feat of engineering as its 17-metre span has to resist howling gales in winter. Wrought-iron furniture with white cushions and little details such as a pair of tall cypress sculptures made of rusty barbed wire, by the Turkish artist Tuğrul Selçuk, and wicker lampshades and torch wall lights designed by Alev complete the baronial atmosphere.

The gallery (left) enjoys legendary sunsets over a magnificent panorama from its west-facing side. It has been the stage for many parties and gatherings; sometimes a lamb is roasted on a spit in the huge hearth. The barbed-wire cypress tree is by Tuğrul Selçuk and the lampstands, made from olive-oil vessels by Alev Komili, add to the medieval atmosphere. The construction of the 17-metre-wide hanging roof, using steel and Canadian pine beams and no additional supports, is one of the architectural wonders of the house, strong enough to withstand powerful gales. The courtyard of the monastery (below) with its ancient olives and a view through the arches of the gallery to the archipelago and the island of Lesbos beyond.

Preceding pages, left: The monastery of Leka Panaya rises above a sea of olive trees (top). Looking from the gallery into the courtyard (second from top): the mature olive trees with sculptural twisting trunks have been individually selected for their looks and successfully transplanted here. The pebble mosaics in the courtyard (third from top) were executed patiently by Battal Etlik and art students from Istanbul. Arzu Komili designed this black cat when she was ten, and helped with the laying. The indoor swimming pool opens onto the lawn and the extensive garden with pockets of scented plants (bottom).

Preceding pages, right: The whitewashed walls and pale unpolished marble floors all add monastic charm. The star motif on the floor was an unexpected gift from the master builder. İnci Eviner, a successful contemporary Turkish artist, made the four pictures using a mixture of leather and acrylic.

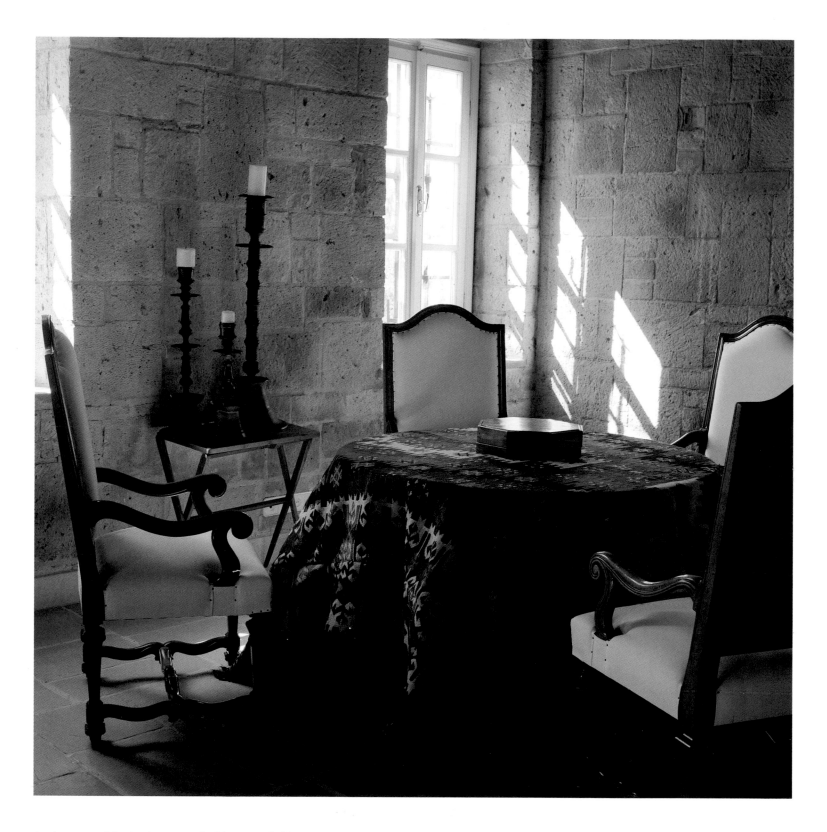

A quiet corner of the drawing room with a kilim-covered table.
The Ottoman cast bronze candlesticks are from Ayvalık. The
Provençal armchairs were inherited from Alev's grandfather.

The interiors are plain, with very little furniture —
a few gothic armchairs, oak tables, contemporary
sleek sofas in off-white, sometimes combined with
family heirlooms such as Alev's grandfather's
armchairs. All fit handsomely with the monastic
texture of the building. In the morning room there
is a rustic collection of old wooden coffee pans.
Upstairs the master bedroom, Arzu's room and
the spare bedrooms are all kept stylishly austere.
Fireplaces in every room, and one huge brass brazier
in the middle of the drawing room are the only
sources of heat in winter. 'It is perfectly cosy,
especially once the thick stone walls have warmed
up,' Alev says. 'As in the old days, you wear warm
clothes.' In the basement she has built a small Turkish
hamam of Marmara marble and an indoor swimming
pool which looks out through the garden to the
view beyond.

The garden in front of the swimming pool is planted
with clusters of rosemary, lavender and box and at
least six different varieties of scented jasmine. Odd
millstones, once used to crush olives, huge terracotta
olive-oil containers, and wooden oil presses are
scattered round the garden. Among the elegant
cypresses and ancient olives, deckchairs with
umbrellas for extra shade face out to Ayvalık bay and
the archipelago. This is where the family spend most
of their afternoons with friends and relatives.

Alev's abundant energy means that she also finds
time for charity work, teaching in poor Istanbul
neighbourhoods and organizing volunteer university
students. Although they have busy lives and a house
in Istanbul, Alev and Halis come back to Cunda often:
every December for the olive harvest, every spring
to prune the olive trees, and in summer to swim in
the blue waters of the island. They also sail and fish,
and take long walks over the hills in spring. On some
mornings Alev sets out at five o'clock to walk round

the island, returning for a late breakfast. 'I have
trekked all over Anatolia, plant-hunting with friends
from the Black Sea Mountains to the Taurus.' She
collects new plants suited to the arid climate of the
island, even experimenting with special lawn grass
from Africa that does not need watering: 'Which is
also why,' she adds, 'the olives from Cunda are so
famed — the dryness of the soil makes the flavour
of the oil more intense.'

In the downstairs drawing room
facing the sea the 18th-century
chaise longue is French; the leather
travel chest next to it serves as a
low table. The abstract painting is
by the Turkish artist Erol Akyavaş
and the sculpture on the floor by
Sarah Levy.

The kitchen cupboards and the table were made from pine by local carpenters (left). The decorative plates on the wall are modern. The screws of old olive-oil presses (below, left), each carved by hand from a solid oak trunk, serve as the feet of a side table in the hall. On the wall hang the lids of two old sailor's trunks, decorated inside with charming paintings of steamships. One of the many guest bathrooms (below, right), understated but elegant. The hand-painted tiles are from Italy.

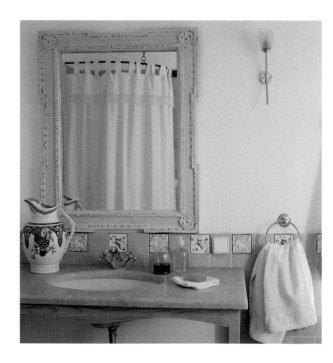

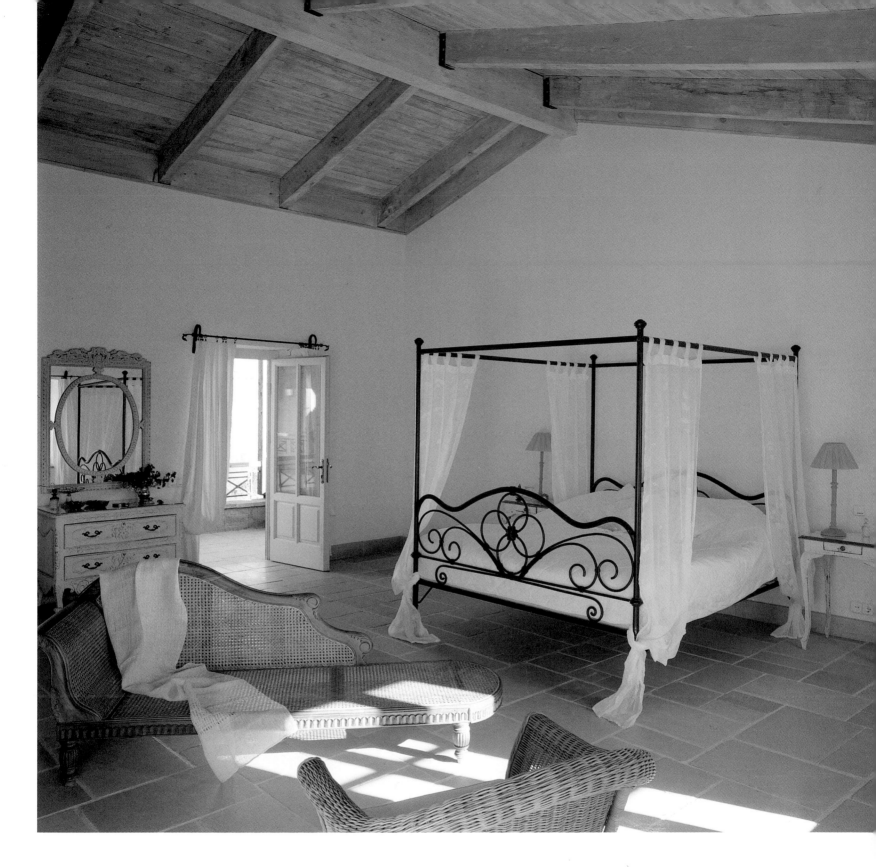

The four-poster bed in the master bedroom was designed
and produced by the local blacksmith. The daybed is from the
Çukurcuma antiques district of Istanbul. The white muslin curtains,
light and fresh, are ideal for summer.

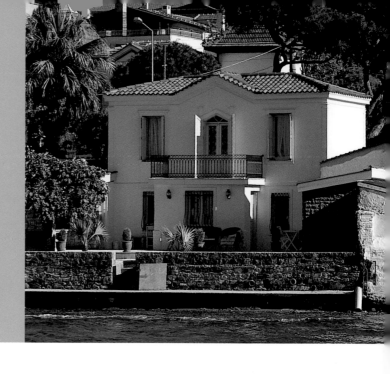

Erdal and Betül Sayıl
A miniature Harbour
House at Ayvalık

The front door adorned with a canopy of wisteria (above, left). The seaside façade (above, right) is sweet and simple, with a tiny balcony overlooking the bay of Ayvalık, where the Sayıls moor their catamaran. A collection of colourful Kütahya plates line a shelf (below, right), mimicking the apple shelves of traditional houses. The blue opaline globe is from an antiques market in Istanbul.

A corner of one of the guest bedrooms (opposite). The printed cottons, tin lanterns and naïve oil painting of two women in Trabzon having tea, by Betül's father, all give it a simple, carefree atmosphere.

Whether seen from land or sea, the Sayıls' house on the Aegean coast has an appealing symmetry: a door in the middle with a window on either side. Simple, elementary, but at the same time a symbol of security and shelter.

Betül is a freelance writer and her husband, Erdal, an architect specializing in office blocks, but they share a passion: the sea. They are both accomplished sailors and met through this shared interest. One June day in 2003, as they sailed past Ayvalık on *Tykhe*, their catamaran, they spotted a tiny house on the shore. 'It was impossible not to fall for it; in three days it was ours,' Erdal says, adding: 'that was the easy bit. It took more than a year to bring it back to a habitable state.'

Betül and Erdal still work in Istanbul but spend most weekends in spring and autumn in their miniature house, using it as a base in the summer months to explore the Aegean islands undersail. They moor their catamaran in the bay in front of the house.

Two mature umbrella pines flank the house, dwarfing it further. Betül and Erdal have left the old garden gate with its peeling paint just as they found it, secured with a rusty padlock. A new entrance in the side wall of the garden was opened, with a wrought-iron garden gate. The garden is small and tidy and is paved with encaustic tiles in pale geometric patterns supplied by a famous old artisan in Ortaköy on the Bosphorus. According to Erdal, he turns out 'eight square metres of tiles a day, not a centimetre more'. The house itself is a cube with white walls and a terracotta tiled roof. The only decoration on the façade is an elegant pediment crowning the entrance. At the front there is a pretty veranda the size of a card table, with a fine

iron balustrade and a pergola which encourages a gorgeous wisteria as old as the house itself to create a mauve-blue canopy every summer.

Stepping inside, there is a hall, or *sofa*. The walls are panelled and painted an off-white. The two rooms on either side of the hall are the bedrooms. They are shipshape, with a window front and back, one looking onto the garden, the other out to sea. The door at the end of the hall, which has double glazing and extra shutters against the wind, leads onto a tiny balcony with a wonderful view of the bay of Ayvalık.

'The north winds blowing in winter from the snowy mountains are icy,' Erdal says. 'It can get very, very cold, even in the first months of autumn, but because I love the wind so much, I don't mind' – even on bracing days he puts the deckchairs out on the quay below.

Plain but beautifully made stairs lead down to the living area. The lie of the land means that this floor, concealed as a basement from the garden, is at ground level on the sea side. The stairs, like the floorboards and beams upstairs, are of Siberian larch, a heavy pinkish timber often used for boat building. The boards were reclaimed from an old chalet in Austria and transported to Ayvalık, where they were

Light from the front door pours into the hall (above), which is the size of a small rowing boat but beautifully proportioned. The curtains are hand embroidered and the blue glass finial was found at an antique dealers in Bebek, in Istanbul. One of the minuscule guest bedrooms (near right). The idea of a raised platform is taken from the traditional *seki* in Turkish homes which served as a sitting area and transforms into a generous bed at night. Drawers underneath are for storing bedclothes during the day. A washbasin in one of the guest bedrooms (far right). The powder-pink travertine bowl and tiles are from Manisa, ancient Magnesia.

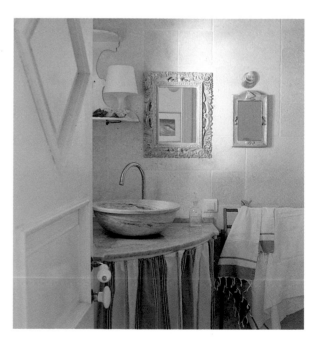

sanded by hand until silky, then left unpainted: the source of the fresh scent of resin in the house.

The ground floor consists of two parts divided by a handsome stone wall of dressed stones from a local quarry. A small room with a desk and daybed serves as a study, and a living area for rainy days leads into a modern, functional kitchen designed by Betül.

Betül and Erdal are both excellent cooks and proud founding members of the Slow Food movement in Ayvalık, a prosperous market town with the best olive oil in the Aegean, delicious seafood and fine wines. Its hinterland produces the tastiest fruit and vegetables. This was the cornucopia of antiquity: the source of chestnuts and almonds from Magnesia, figs from Caria, a luxurious purple dye from murex shells – weighed in gold – and tons and tons of golden quinces from the hills of Ayvalık itself. Indeed, the quince, *Cydonia oblonga*, takes its name from the ancient port of Kydonia. Ayvalık, the modern Turkish name for Kydonia, means quince larder.

A gazebo built on the quay next to the kitchen serves as an outdoor dining room. The gazebo, or *kameriye* in Turkish (from the Arabic *kamer*, or moon, where one sits to watch the moon), is sheltered from the

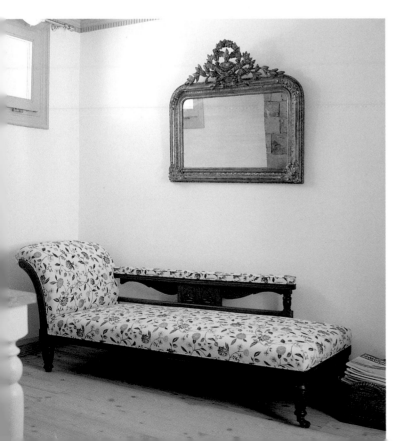

The Sayıls' bedroom, with wisteria-blue painted doors, shutters and ceiling (above). A *susani* serves as a curtain. The blue bedspread is from Eğin in central Anatolia and the pendant lighting created from glass beads is by the Italian company Leucos. Upholstered with printed offcuts from a wholesaler's on the Golden Horn, an elegant chaise longue in the study (left). The gilded mirror was bought from a dealer in Üsküdar, a suburb of Istanbul. A shoal of terracotta fish by a local artist washed up in a niche (right).

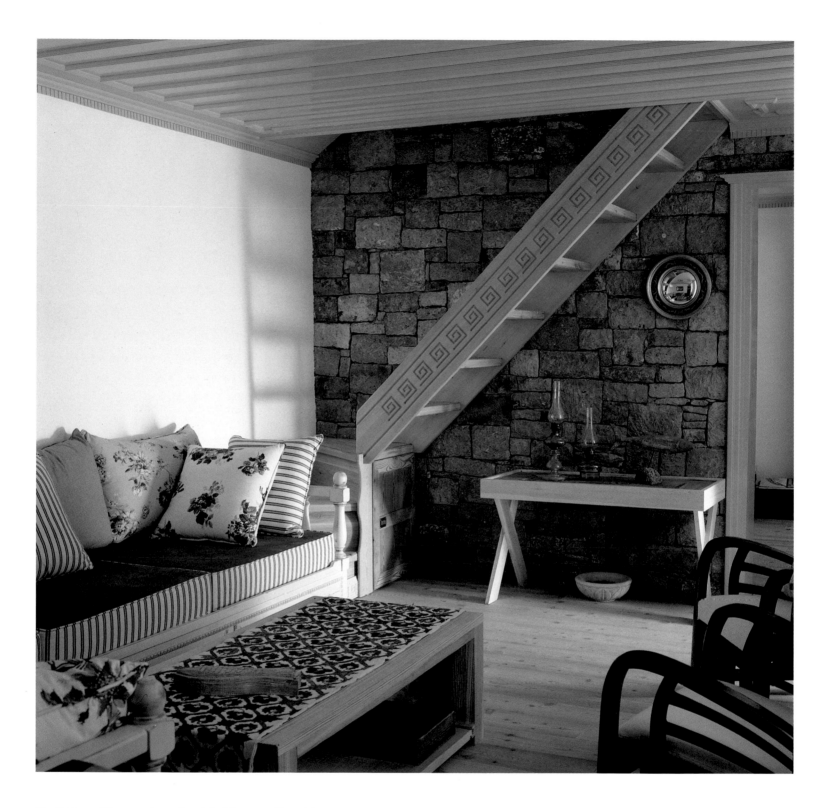

The dividing wall between the study and the living room. Most of the furniture was designed by Erdal. The larchwood stairs, which lead up to the front hall and the bedrooms, were lovingly crafted by three carpenter brothers, joiners for three generations.

Masonry created by local artisans with recycled dressed stone from a quarry on nearby Sarımsak Point (left). This is one of three or four traditional Ayvalık styles of masonry. The miniature medicine cupboard was discovered in a secondhand shop on Cunda Island. The gazebo, or *kameriye* (below, left), next to the kitchen on the sea side, is the outdoor dining area. The roof of the gazebo was designed by the architect-owner of the house. The wooden slats are fixed at such an angle that they deflect the rays of the sun when they hit the quay in the late afternoon. A bowl of green early summer plums (below, right). Ayvalık is a centre for the finest produce.

sun by a roof of slanted slats designed by Erdal, and from the chilly north winds by fixed windows. A commanding dining table in the centre is a reminder of how the host and hostess enjoy entertaining friends and family. 'The social life is better here than in Istanbul,' says Erdal over a tumbler of amaretto on the rocks.

Two guest bedrooms and a utility room are ingeniously lined up like railway compartments along the garden wall, leaving a narrow passage from the front garden to the sea side. The rooms were built from scratch but with reclaimed stones by skilful local masons — they look even older than the house. The guest bedrooms are not spacious, but are cleverly planned and comfortable, inspired by traditional architectural elements like the *seki* or raised platform, which allows room for any number of beds, and shelves close to the low ceiling. Charming details such as small tin containers planted with houseleek on the window sills and the designer Tord Boontje's 'Garland' paper lights, combined with printed floral and stripy cottons in white, blue and red, achieve a cheerful, welcoming effect. With all the comforts and epicurien pleasures this miniature seaside house has to offer, the Sayıls must never be lacking in visitors.

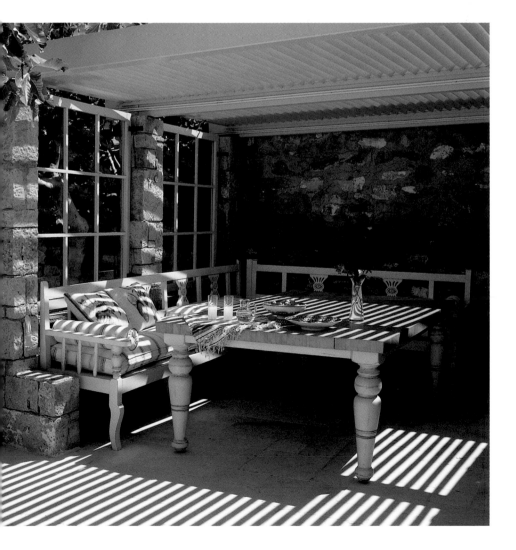

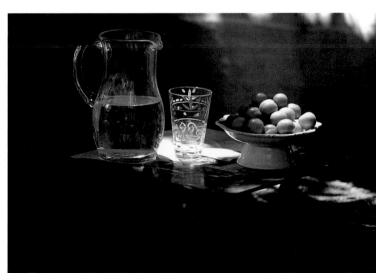

Selden Emre's grand house on the island of Cunda, which once belonged to a Christian priest, dates back to the beginning of the 19th century. In its day it was one of the town's most prestigious houses, located on the hill next to the basilica on Merdibanli sokak – the street with steps.

Cunda, off the coast of Ayvalık in the northwestern Aegean, is a small island attached to the mainland by a causeway. The largest of twenty or so islands in an archipelago that forms a lace-like pattern along the Aegean coastline, Cunda is the only one that is inhabited. With its magnificent views and scented breezes blowing down from Mount Ida, Cunda has always been a popular retreat. The island's architecture suffered in the riots and civil wars of the final days of the Ottoman Empire, and in a massive earthquake in 1944. But elegant 19th-century neo-classical features are still visible everywhere.

Selden is a brilliant antiquarian with a keen eye for exquisite objects. Her three-storey house dominates its neighbours, but it is not ostentatious. It has been beautifully and faithfully restored to its former grandeur, but this grandeur is in no way at odds with the other old houses in the neighbourhood, all of them listed, and no fewer than 551 under conservation by the state. The pale pistachio green of the exterior paintwork marries happily with the wooden shutters, the white detailing and the exposed stonework of the arched doorway.

Old architectural features, which often prove to be clever practical solutions, are still in use here. For example, rainwater is collected from the roof and channelled through zinc gutters and pipes into a cistern in the basement. Nowadays there is a city water supply and if there are any water shortages one can order a tanker; but as Selden says, 'why not

Selden Emre
A grand townhouse on cunda island

The bay of Ayvalık seen from Cunda, with Lesbos in the distance (top, left). The priest's house (centre, left), beautifully restored by Selden Emre. The date 1809 is carved on the keystone of the arch. A comfortable working and dining table sits on a raised platform (below, left). Beneath it is the cistern, where rainwater is collected from the roof. This was the original kitchen in the old house, and when the very thick wall behind the velvet sofa was stripped of its tiling intriguing masonry, two niches and a tiny window emerged.

The landing on the first floor (opposite). The two spare bedrooms are located symmetrically on either side of the tall, arched window of the main door. The colour of the silk brocade kaftan matches the pale sage green paint of the shutters and cupboard doors.

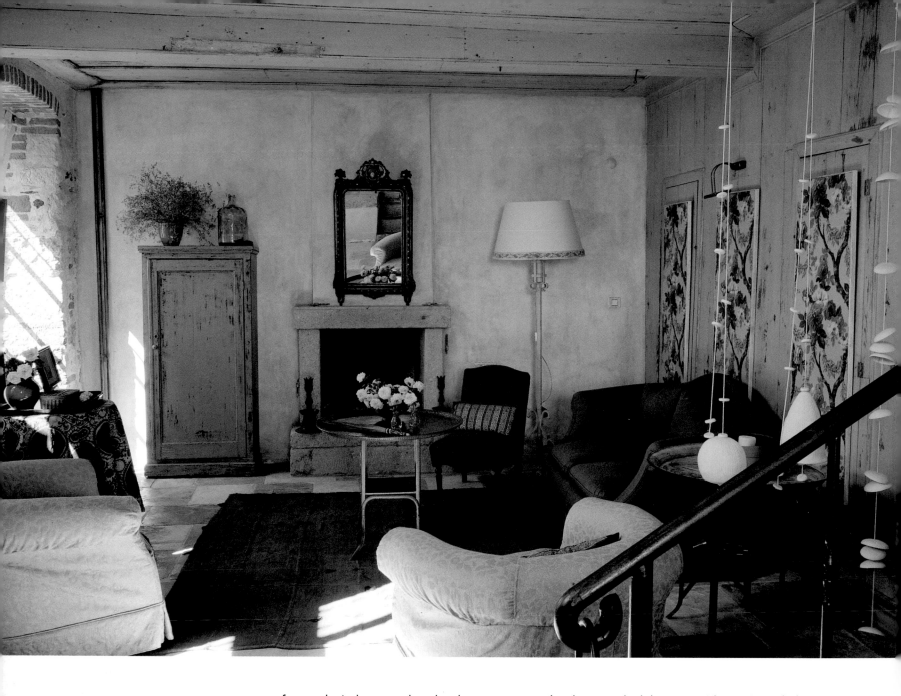

use a perfect ecological system that already exists?' As a result, all year round she enjoys the softest of water. 'Rainwater is free and it makes your hair silky, the laundry soft and your plants happy.' All she did was install a small pump to bring water to the upstairs bathrooms. During the entire restoration, concrete and synthetic materials were avoided. The solid stone walls, often lime-plastered and limewashed, and the wooden ceilings and floorboards, all help to keep the house cool in the summer months, making air conditioning unnecessary.

An elegant arched doorway with massive oak doors opens into a spacious hall with chequered black-and-white flagging salvaged from another old building, the frosty patina of their age adding to the general atmosphere. A palette of dove greys, sage greens, faded mauves and soft creams is enlivened by a vivid umber-coloured velvet nursing chair next to the fireplace. On the garden side of the hall is a raised platform, under which stands the cistern, filled to the brim with rainwater. On this platform, where the kitchen was originally located, is a second well-used fireplace with its original hearth, a sofa and a dining-

Light pours into the spacious hall, which serves as the living room (opposite). The mirror above the fireplace was bought from a dealer in Cunda; circular Ottoman copper trays serve as tabletops; the wind chimes were brought back from Puerto Rico.

The raised platform above the cistern (below) is another inviting corner next to the original hearth of the house. The stairs leading to the first floor are the only modern feature. The top-floor landing (right) with fine sea views. The floorboards are sanded, sealed, waxed and restored to their natural sheen.

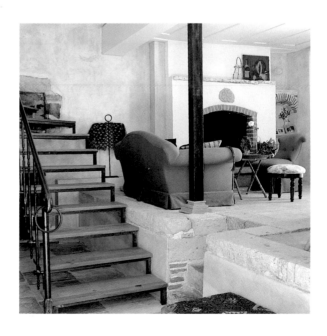

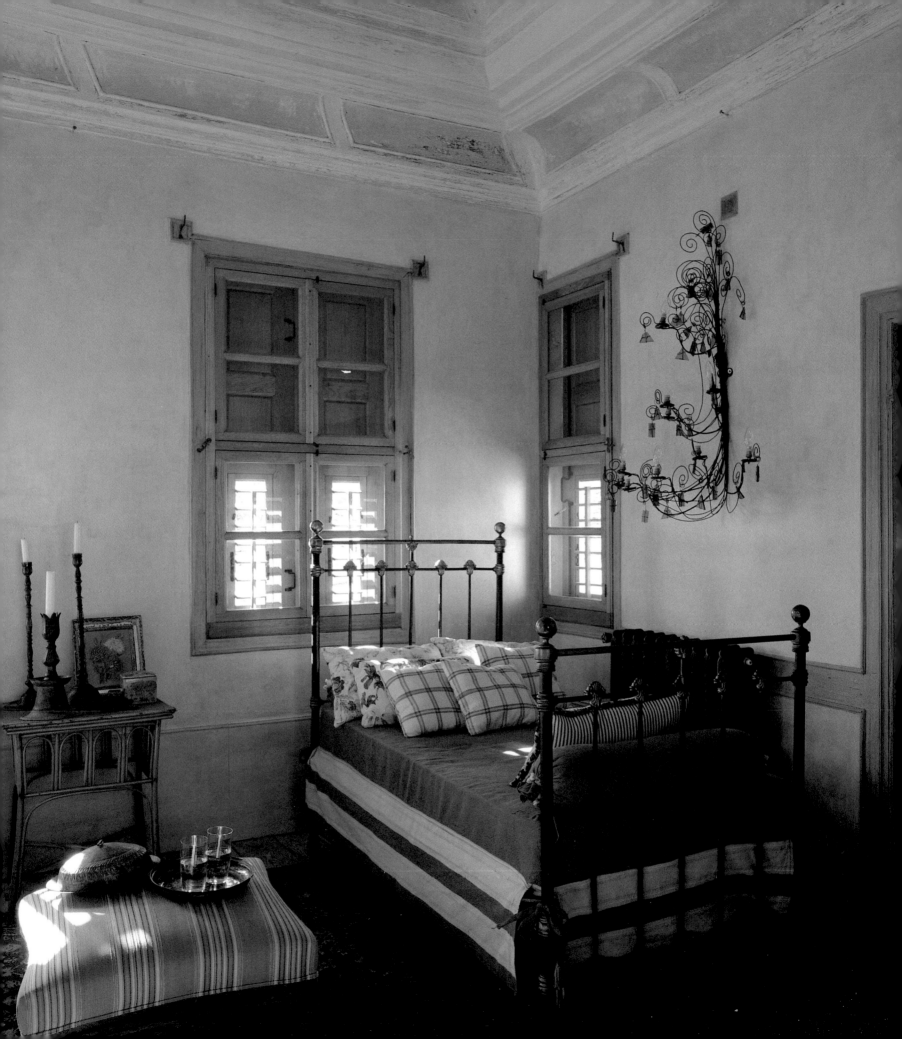

cum-working table, all offering corners to rest, work or just contemplate. Selden's three cats also seem to be most at home here. Beyond is a very small, bright kitchen with a small balcony, a later addition, where breakfast can be taken. From the platform one also has access to a little veranda where most summer afternoons are spent and where stairs lead down to a charming walled garden, lovingly lined with pots and containers of sweet basil, old scented roses, fragrant lemon geraniums and clove pinks.

A wrought-iron staircase with wooden steps – one of the few modern features of the house – takes one up to two rooms on the first floor, separated by a landing. The ceilings are lower as these were originally the winter rooms, traditional in all Ottoman houses. Sandwiched between two floors, they were easier to heat in winter. The shutters here are inside, so that they can be easily closed on stormy evenings. Selden has converted them into delightful guest bedrooms. All the cupboards, shelves and niches have been preserved, offering not only generous storage, but also handsome partitions, and even concealing

a bathroom in one of the rooms. All the woodwork is painted a distressed sage green.

The lath-and-plaster second floor overhangs the street, jutting out over the strong stone walls of the two lower floors and resting on delicate iron consoles. The rooms on this floor have magnificent views from every window, even in the bathrooms. Selden reserved the two larger adjoining rooms as her bedroom and boudoir. The latter has a vaulted ceiling with plaster cornices and was presumably once the main reception room of the house. The ceiling has traces of painted decoration, and the plaster of the walls is inlaid with small wooden plaques which would have enabled the owners to hang curtain rails above the windows and numerous heavy framed paintings around the room without damaging the plasterwork.

Selden has a fine touch: the colours, furniture and objects she has chosen all have a poetic, uncontrived feel. The restoration may have taken two years to complete, but it is so skilful that it looks as if it was effortlessly achieved.

Originally this room on the top floor (left) was the main reception room, known as *başoda* or 'head room'. The vaulted ceiling is decorated with a rosette and cornices with traces of painted floral motifs. The little wooden squares on the walls were inserted to support picture hooks. The pair of handsome wall lights were designed by Selden and commissioned from the local blacksmith on Cunda. The room now serves as a boudoir and an extra bedroom for friends. A detail of the room's ceiling (right).

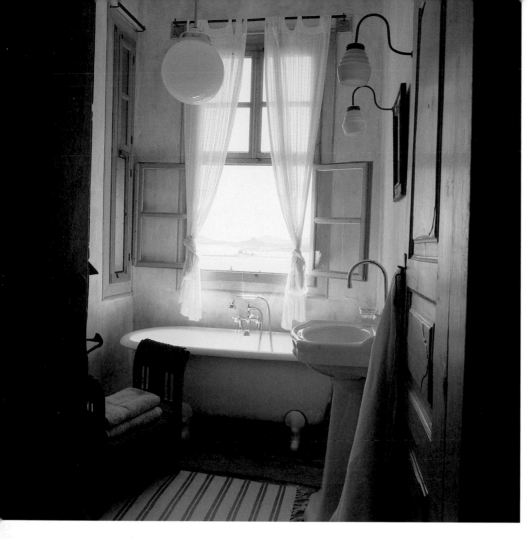

Selden's bathroom on the top floor (left) with breathtaking views of the archipelago. The colour of the blue glass shades of the wall lights caught her eye when a tinker was passing the house with his cart. A pink guest room with a canopied bed (below, left). A shower and a washbasin in the corner are concealed by a screen hung with a faded vintage French wallpaper. Another corner of the same room (below, right). The old rose colour scheme and Selden's light finishing touches give it a dream-like feel. Surprisingly, the 19th-century ornate cast-iron radiators are modern Turkish replicas.

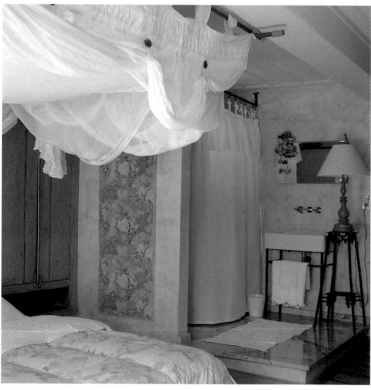

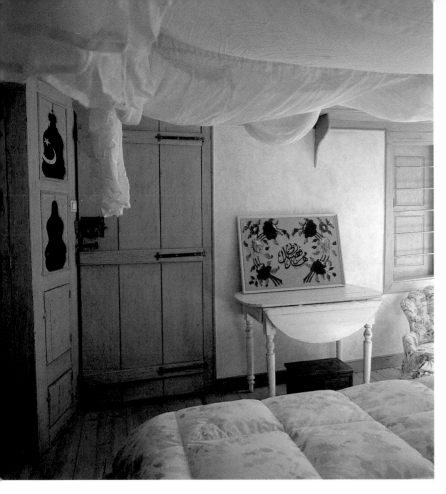

One of the two guest bedrooms on the first floor (above, left). The wooden cupboards, with their niches, are original and have been painted with natural pigments. The muslin canopy above the bed is a simple but elegant structure made with canes. The wooden cupboards, shutters and dado rail (above, right) are all original: they were repainted and distressed by a colourist who specializes in natural paints. The matt pale greyish sage used on the woodwork, the leitmotif of the house, was obtained by mixing pigments such as ochre, umber and indigo. In this bedroom (right), the fitted cupboards ingeniously screen an en-suite bathroom. The vintage Louis Vuitton and Samsonite luggage completes the colour scheme. From the window one has access to the roof of the kitchen, a little terrace with pots of geraniums and scented basil.

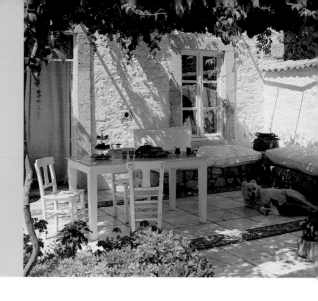

Zeynep Öziş
A stone house
in Alaçatı, çeşme

Zeynep Öziş's new house, built from scratch in stone in the traditional vernacular of Alaçatı (above, left), is in a walled garden shaded by a mature fig tree, banana plants and olive trees. The patio (above, right), with its natural pergola of grapevines, white-painted café chairs and table, is an outdoor dining area. The lobby of the Taş Hotel (below), Zeynep's other home, has a relaxed Mediterranean atmosphere, with dried herbs and wickerwork baskets.

The daybed (opposite) is the perfect spot for an undisturbed siesta in the shade of the headily scented fig tree.

Zeynep Öziş chose Alaçatı, a remote windswept village on the Aegean, near Çeşme, an hour's drive from Izmir, to fulfil a long-nurtured dream of building a boutique hotel. She had been working at one of Turkey's leading marketing companies, but felt she had come to a crossroads in her life and needed a change. She made up her mind. All her friends protested and tried to dissuade her. 'Alaçatı was not on the map when I came here for the first time in 1992,' she says, 'but I felt somehow at home here, although I don't know why. Perhaps it was because the way the locals speak reminded me of my grandmother. She was a Turkish émigré from Salonika, and the majority of the villagers here also came from the same area in 1924.'

Zeynep returned to Alaçatı some years later and bought a century-old stone house that had belonged to an olive-oil merchant. The renovation took a year. She had no professional training, but used her instinct, and her father's gift of an old copy of *Neufert's Architects' Data*, supervising the building work on her own. 'I was lucky. There are skilful local builders and craftsmen in Alaçatı who still use the traditional techniques.' She used recycled building materials such as old dressed stone, original wooden shutters and roof tiles. In 2001 Alaçatı's first hotel opened; Zeynep called it the Taş (Stone) Hotel.

While some friends were still worried – and some people were even joking, 'Who is going to stay in a hotel here: the fishermen?' – Zeynep never lost her belief that since she liked the place so much, other people would want to come. Her engaging personality and marketing expertise worked wonders. The *Sunday Times* listed the Taş Hotel in their top 20 continental hotels. The Italian travel magazine *Dove* and others have followed suit. Zeynep's eight rooms are already booked in advance all year round. Little wonder that a cluster of new small hotels have followed in her footsteps, as well as little cafés that serve delicious mastic-flavoured pastries and Turkish coffee, and exquisite shops selling local products such as wines, hand-made olive-oil soaps or embroidered linen.

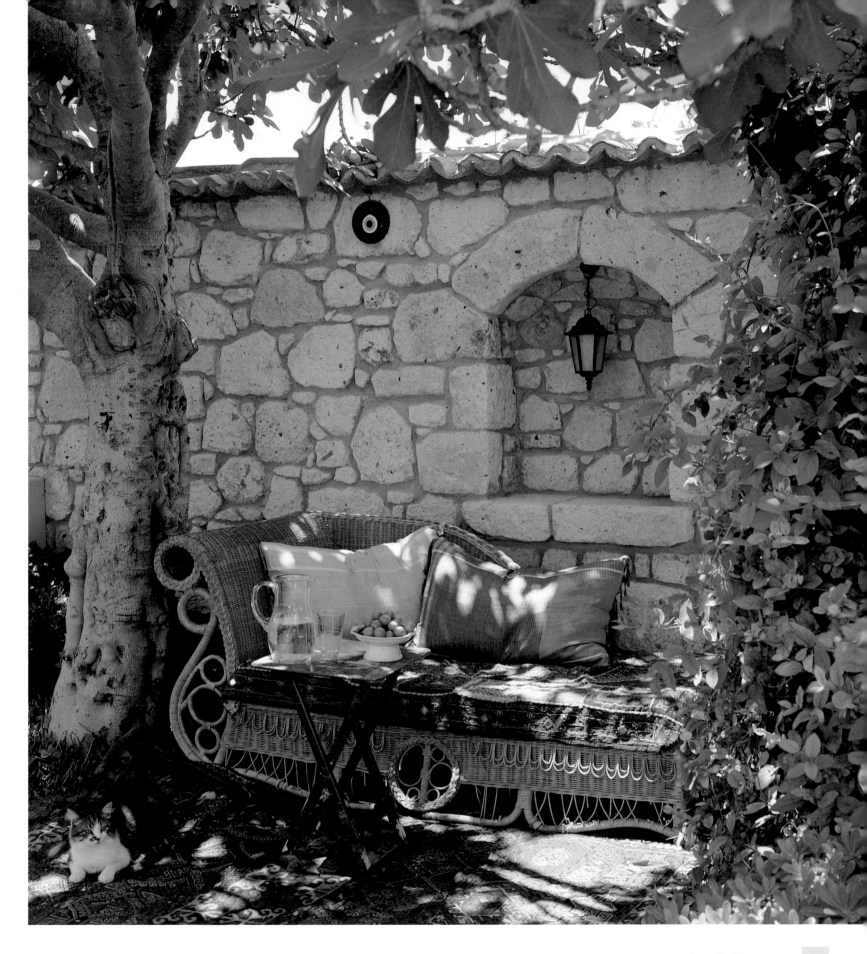

The fireplace is a century old, reclaimed from a demolished mansion. Simple and unpretentious, Zeynep's house is welcoming and comfortable.

The olive-oil merchant's house is located on a street corner with a walled garden and windows on three sides. The ground floor of the house, which was used by the previous owners as an olive-oil depot lined with huge terracotta vessels, serves today as a spacious and welcoming lobby and a library with a log fire and deep sofas, while the living quarters upstairs are transformed into bedrooms that are bright and delightful. Some rooms look down onto the garden, with its small swimming pool shaded by cypresses, honeysuckle, jasmine and plumbago. Others look across the street to neighbouring gardens. The colour scheme, apart from the unplastered stone chimney breasts and plumbago-blue painted shutters, is many shades of white: whitewashed stone walls, white linen chair covers, white piqué bedspreads and white muslin curtains. The occasional piece of antique furniture – a chest of drawers Zeynep inherited from her family, an old wardrobe or a little drawing – accentuate this cloud-like atmosphere. Zeynep and her lovely golden retriever welcome guests.

After restoring one house, she then decided to build herself another in a walled garden next door. It is a much smaller stone house, which was built from scratch in the traditional style of the village. However, it doesn't look modern: downstairs a practical open-plan kitchen/living room houses an impressive log-burning fireplace. Kilims, books and lovingly collected pictures on the walls are the only colours that set off Zeynep's favourite white-on-white palette. The garden has many inviting corners, depending on the time of day. Likewise, the patio with its natural pergola of mature vines is clearly the setting for many an alfresco lunch or dinner. The atmosphere is happy and relaxed, reflecting Zeynep's way of living. It explains why everyone loves staying in Alaçatı. And thanks to Zeynep, this windy corner of the Aegean has become not only a mecca for sporty windsurfing types, but also a romantic, literary retreat.

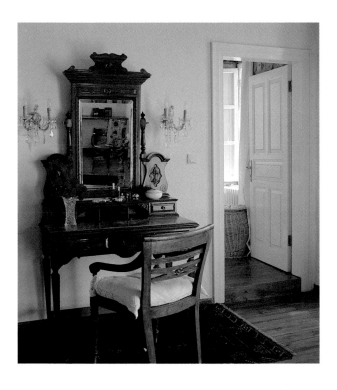

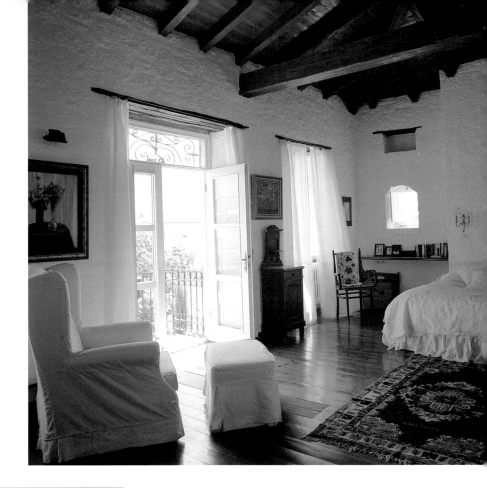

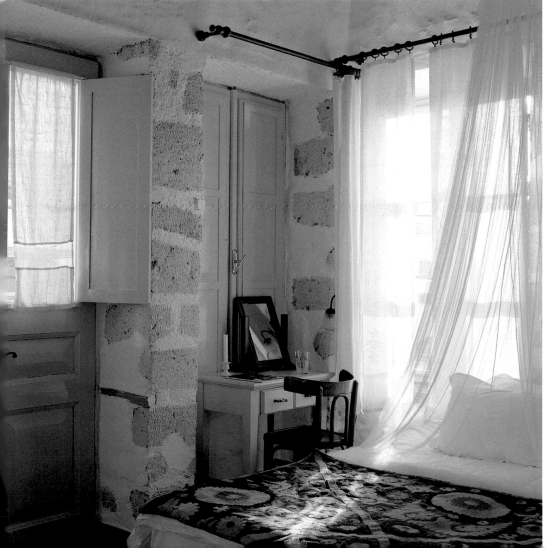

A corner of the master bedroom (above, left). The turn-of-the-century dressing table and the crystal wall lights contrast with the rustic whitewash. The beams and stone walls (above, right) are in the traditional style of the village. Light filtering through one of the corner guest rooms (left). The exposed masonry, the plumbago-blue shutters and the colourful *susani* bedspread all give the room a welcome informality.

Rifat Özbek
A DESIGNER'S HILLTOP HOUSE in YALIKAVAK, BODRUM

Bougainvillea, oleander trees and lavender bushes, which thrive in the Mediterranean climate, lead up to Rifat Özbek and Erdal Karaman's house (above, left). Balconies shaded by reed pergolas offer a wonderful view of the sea and the bluest of Mediterranean skies. A blue-beaded barber's fly curtain from North Africa glitters in the sunlight (above, centre). More strings of beads decorate a pepper tree in the garden (above, right). A modern interpretation of a Turkish Kütahya tile (right).

The whitewashed living room (opposite) has a fresh feel: the pale grey, lavender and blue striped textiles are all from local markets. The large canvas of a Bodrum fisherman smoking a cigarette by the sea is by Cengiz Özer, a Turkish artist living in Paris. A pale tangerine silk throw from Senegal and embroidered kilims from Anatolia complete the colour scheme.

Yalıkavak is one of the most romantic spots on the Bodrum peninsula. From its hills you can look down onto the turquoise waters of the Aegean. When Rifat Özbek and his friend Erdal first stepped into the garden of their house there, it was fragrant with the scent of orange and tangerine blossom and Rifat remembers entering 'a shady tunnel of olive trees' lining the path. 'We fell in love with the house that very instant.'

Rifat is a man of sophistication. Brought up in a waterside *yalı* on the Bosphorus, he spent his student

years in London, where he studied architecture, then fashion, living in his parents' flat in Belgravia. As a designer he soon acquired a celebrity following. 'Rifat Özbek breathes Turkish chic into international fashion,' a newspaper enthused when Princess Diana posed in a Rifat turquoise jacket with a motif of crescents and stars. Kate Moss memorably wore one of his dresses inspired by Iznik tiles. But Rifat likes to spend at least half the year away from the frenzy of the fashion world in this modest, tranquil house.

Many years before Rifat set foot in the place, an American woman had commissioned the Viennese-trained architect Ahmet Iğdırlıgil to build her a house in the local style in five acres of unspoilt olive grove. Ahmet created a traditional house with small windows and walls half a metre thick, to keep the heat out in summer. It was built by local masons, who used stone carved from the rocky hillside. A traditional mortar of lime and stone dust, prepared as the masons cut and chipped the blocks into shape, was used for cementing the stone and plastering the walls.

The house was wonderfully simple, but it needed a few extra touches. Rifat and Erdal called on the original architect, Ahmet, and the three men set to work. They installed French windows in the living room and bedroom, so that one can step out onto

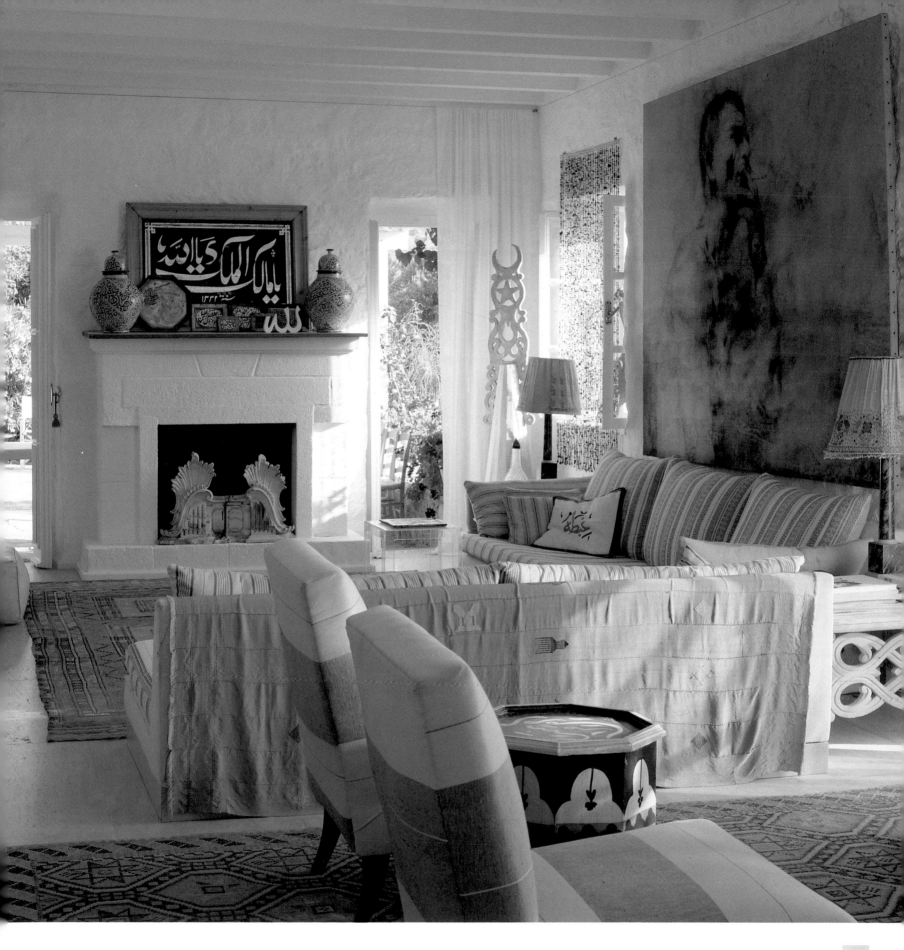

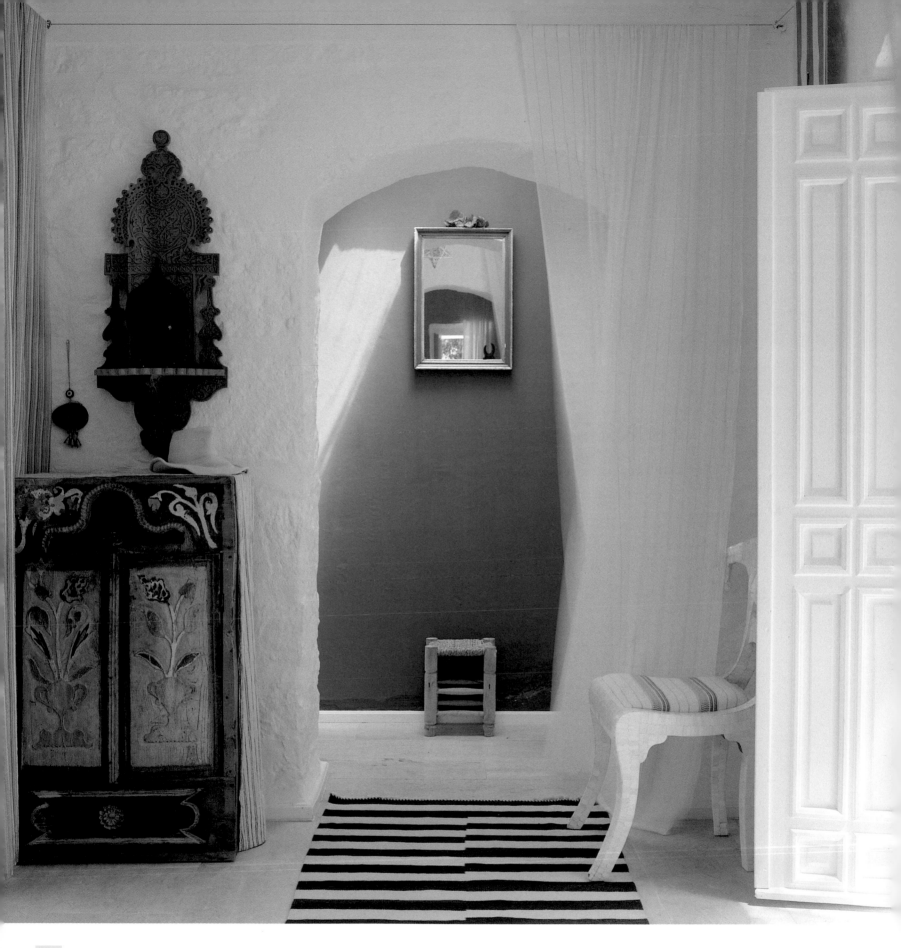

balconies shaded by reed pergolas overlooking the bay. To one side they added an outdoor kitchen with a decked terrace serving as a dining area. Here an old stone fire surround carved with Seljuk motifs, a present from a neighbour, was carefully reconstructed; Rifat uses it to grill fish and on cool evenings, when he and his guests are dining alfresco, a log fire burns in the hearth. The finishing touch is a gorgeous sliver of a swimming pool. 'The greenish tiles catch the blue of the sky and turn turquoise,' says the architect. Thick lavender bushes add contrasting colour and flowering lemon trees add a heady scent.

Erdal has chosen plants for the garden that thrive in the benign climate: vines and bougainvillea, oleander, pepper and citrus trees. Terraces of olive trees lead up to the house, and herbs, cucumbers, onions and tomatoes grow on the terrace behind it. Rifat enjoys working there with the gardener, just as he enjoys cooking his own produce and entertaining.

The interior of the house is simple, with traditional *sedirs* cutting down on clutter. But Rifat likes to mix different styles. He describes the house as 'contemporary Anatolian'. A palette of pastel colours and the breezy lime-white of the walls create a backdrop for little bursts of colour such as blue glass beads or printed cottons from the bazaars of Central Asia or North Africa. Artfully scattered around the house are pop-art posters, old photographs, objects old and new, basic and fantastical, collected at home and abroad, from galleries, boutiques, bric-à-brac shops and village markets. Objects such as the carved wooden *alem* (a crescent-and-star roof finial that once crowned an old village mosque), a low painted table from Morocco and a Senegalese pale tangerine-coloured silk throw give the living room the trademark Özbek flair.

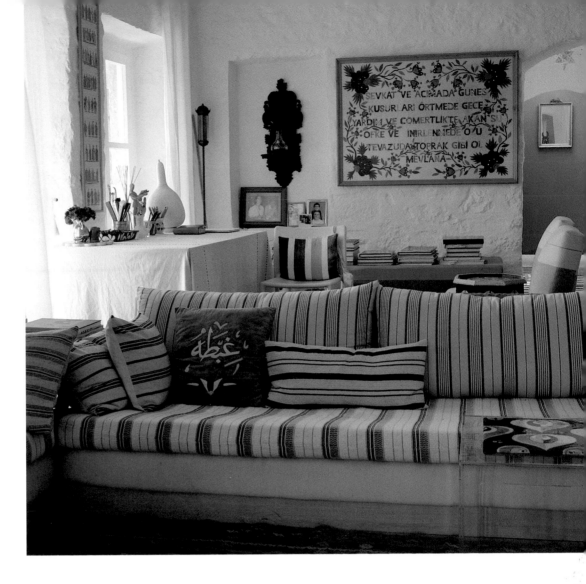

Light streams in from a skylight (opposite), turning an indigo blue wall into a vibrant focal point.

Inspired by traditional *sedirs*, striped cushions are used for seating in the restful living room (above). Özbek's desk with its artist's materials next to a window (left). Above it hangs a fine illustration of Ottoman costumes.

A pair of folding chairs found in the village (above, left). The apple-green cabinet seen through the kitchen door holds glass and tableware (above, right). A set of glazed earthenware water jugs of the kind still used in villages (below). Rifat's elegant dining table (right), picked up in Çukurcuma, Istanbul's antiques district, is teamed with basic country chairs.

Oranges are harvested from the garden (opposite); the French doors are lined with a colourful ikat from Uzbekistan and adorned with an Indian door decoration.

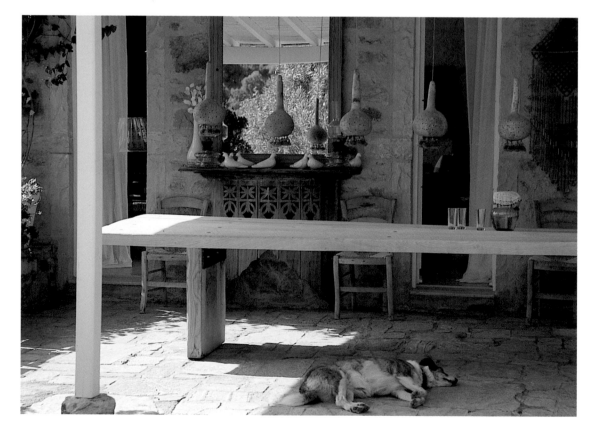

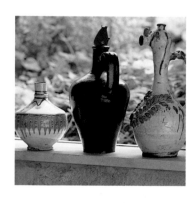

Teaming stripes with floral patterns and pale plain fabrics, and marrying them with an array of interesting objects is Rifat's painterly forte (left). His visual verve transforms even ordinary objects (below, left): a narrow strip of stripy wallpaper, evil-eye beads and an Indian chair. Naïve bird paintings grouped together in the bathroom next to a delicately cut-out wooden niche reclaimed from an old house (below, right).

A delightful mix of patterns, shades and textures arranged in the bedroom. A bold *susani* hangs above the bed (opposite).

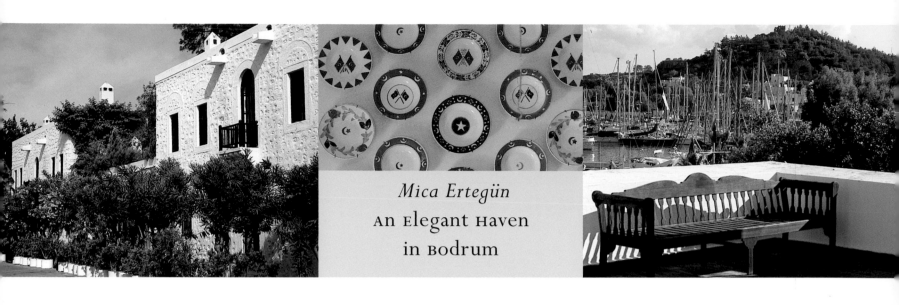

Mica Ertegün
AN ELEGANT HAVEN
in BODRUM

The Ertegüns' Bodrum mansion (above, left) and the roof terrace with a view of the marina (above, right). The decorative star-and-crescent plates (above, centre) were manufactured in the 19th century in France and Belgium for the Ottoman market. Mica found them in flea markets, junk shops and antiques shops in Turkey and abroad. The dining room, where guests take their meals on rainy days (right and opposite) is home to some of Ahmet's dozen or so Roman amphoras, found on a shipwreck near Knidos.

When the late Ahmet Ertegün, the legendary founder of Atlantic Records, and his Romanian-born wife Mica, an interior designer of international renown, found their Bodrum property in the late 1960s, it was a ruined mansion. In those days Bodrum was a delightful, picturesque village free of tourists.

For three decades before Ahmet died in 2006 at the age of 83, they spent at least two months a year in this elegant haven. It is still open to guests during the summer months.

Today, on one side of Bodrum's palm-fringed bay, the Ertegüns' magnificent white mansion faces the sea, the harbour and the castle beyond. The half-ruined *konak* they bought was built in stone in the local tradition. A pair of two-storey wings originally served as the living quarters: the *harem* in one wing and the *selamlık*, or men's quarters, in the other. Each wing had a separate entrance with a loggia above and tall chimneys. An elegant arched gateway for carriages connected the two.

The mighty stone walls and narrow windows of the façade were kept by Turgut Cansever, the Ertegüns' distinguished architect, the missing sections of the back walls were replaced, and two symmetrical buildings were added at the end of the rectangular

rear garden. The outdoor space created between the new and old buildings was made into a delightful courtyard inspired by the traditional *hayat*, paved with black-and-white *rodoskârî* pebble mosaic and with an Ottoman marble fountain at the centre. Parterres of sweet basil were shaded with cascades of plumbago, fragrant honeysuckle and tall umbrella pines and the garden was lined with tangerine and orange trees. Today, it is such a dense oasis that the outer walls are no longer visible and there is a sense of

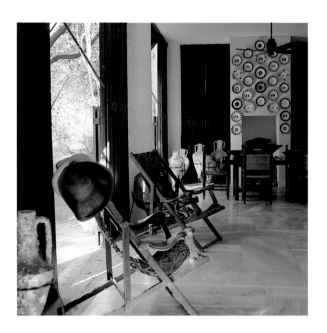

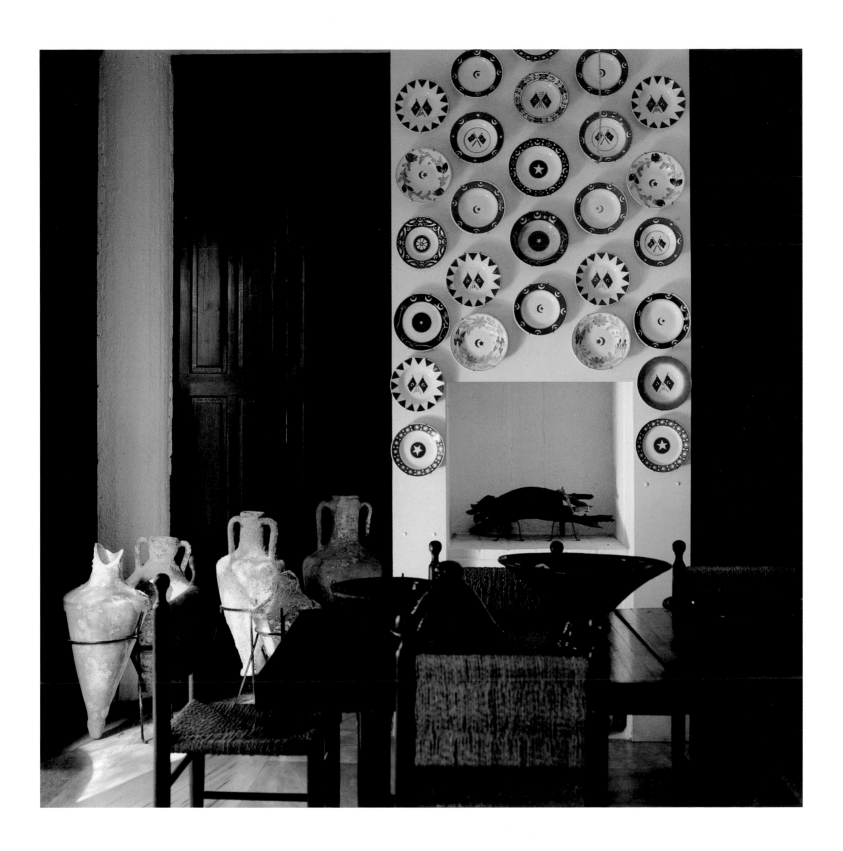

limitless space, with many corners in which to sit among the whitewashed terracotta pots and fluted columns, enjoying the scent from an arcade of Smyrna jasmine which wafts up to the bedrooms upstairs. Adjustable lattice shutters were used not only to filter the light, but also as a brilliant means of separating or bringing together the living areas, which flow effortlessly between the old and the new, the indoors and the outdoors. So successful was the project that it won the 1980 Aga Khan Award for Architecture for 'the imaginative combination and transformation of old existing structures into functional and beautiful environments'.

The additions at the back provide guest bedroom suites with their own entrances and conceal utility rooms in their basements. The ground floor of one wing has been turned into a dining room with a fireplace and a grand kitchen. The other wing is a spacious marble-floored living and entertainment area where, at either end, a modern fireplace inspired by traditional hooded Ottoman fireplaces gives the space a sculptural dimension. Stairs lead up to the main bedrooms, where an alcove conceals an extraordinary bath carved from a solid piece of Marmara marble, and more spare bedrooms. Another flight of stairs leads to roof terraces on the top of both wings.

Mica is behind the sophisticated, clean-lined look of the interior. The white stone walls and smooth marble floors, combined with the plain, pale upholstery, are a perfect setting for the superb antiques. The bedroom walls are whitewashed, but the ceilings and floorboards of hand-planed pine bring out the richness of the Anatolian kilims. There is the odd touch of colour in a painted wardrobe door, a framed picture, a cushion cover. Every detail is considered with exquisite care and taste.

An antique tinned copper tray serves as a low table between the cushions scattered on the floor in the drawing room downstairs. The fireplace has an Ottoman-style hood (above). A corner opening onto the jasmine-scented garden (right), with Roman marble fragments and a sailor's trunk with a painted lid.

The whitewashed stone walls – complementing the smooth marble floors and the plain pale upholstery – are the perfect foil for Ahmet's superb collection of Ottoman calligraphy (opposite).

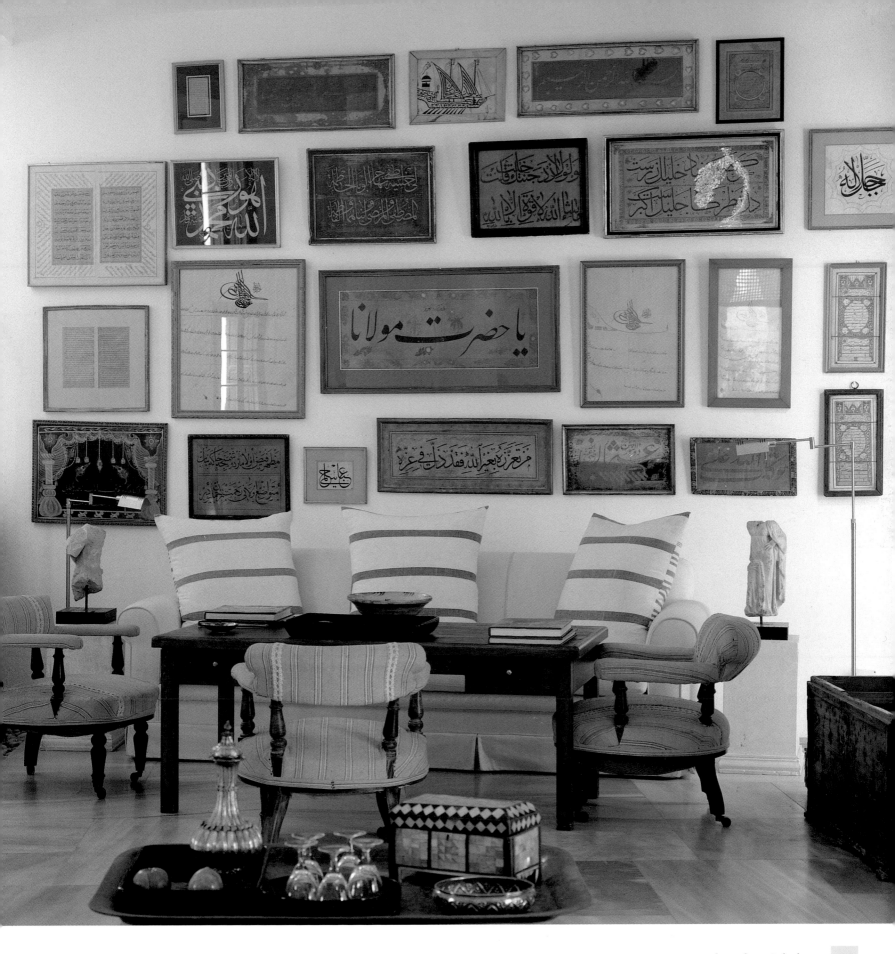

The wardrobe doors are hand-painted antique pieces, beautifully complementing the kilims and the cushions made from precious Ottoman silk textiles. The white piqué cotton bedspreads and white muslin curtains set off the antiques.

Originally designed as a library, 'the Pasha's room' (opposite), with a garden view, was later converted into a guest bedroom. The iron bedstead, fine curtains and flat-weave rugs all recall a traditional Turkish house.

The blue room, with a fine view to the harbour (left). The handsome blue opaline lamp bases were converted from old gas lamps. A bedroom (below) with reclaimed panelling from an old *konak* in Kayseri. Embroidered cotton curtains frame the window of the spacious two-bedroom suite, which opens onto the pine- and jasmine-scented garden.

The dining room (opposite) inspired by traditional timber-panelled Turkish houses. Adjustable lattice shutters were used as an ingenious way to separate, or bring together, the living areas, which flow effortlessly between indoors and outdoors.

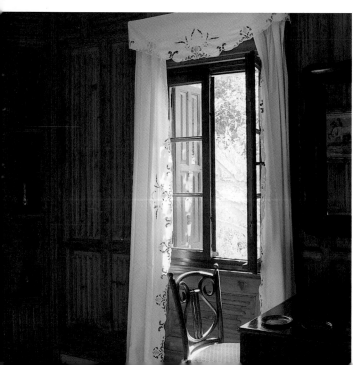

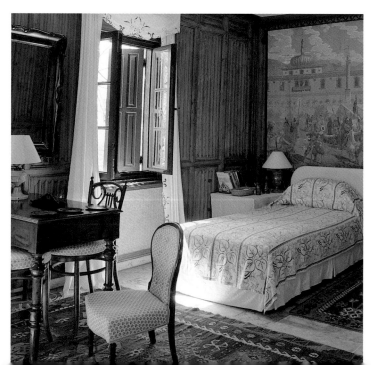

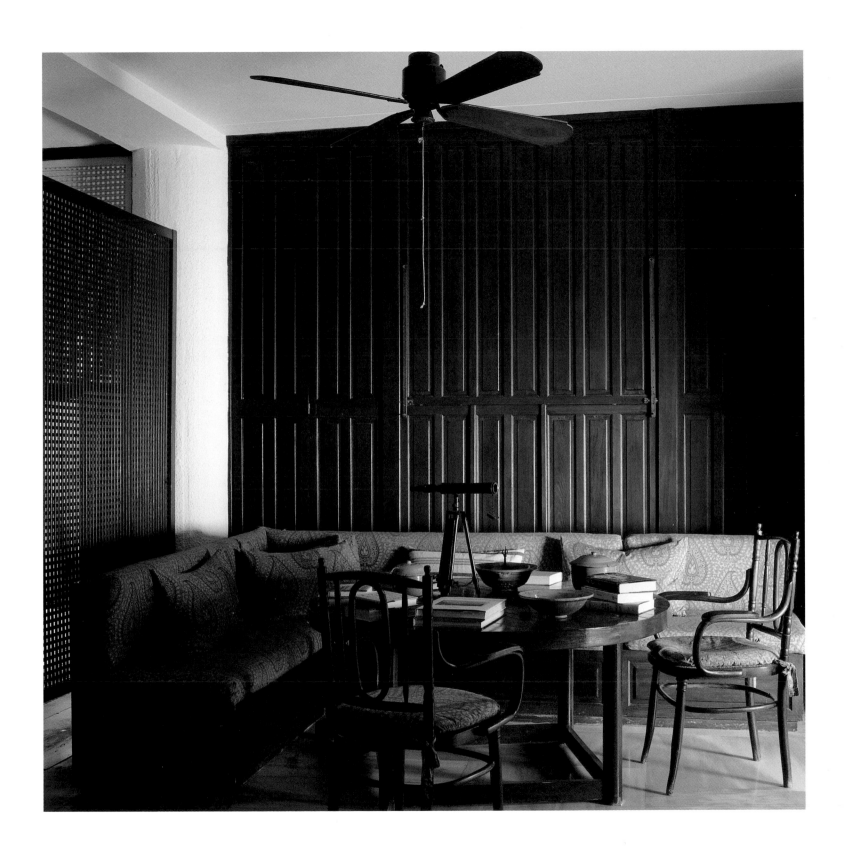

Sema Menteşeoğlu
A lakeside bohemian house
in Köyceğiz

Plums growing in the orchard (top). Sema Menteşeoğlu's numerous pet chickens wander all over the garden (above). Sema has an eye for artefacts and materials, and she has transformed a corner of the kitchen (right) into a bold tableau of black and white checked tiles and brightly coloured textiles. It also houses a collection of simple oil lamps, enamelled teapots, ladles and skimmers bought from pedlars in Anatolia.

Not far from where the turquoise waters of the Aegean meet the indigo waters of the Mediterranean, rise the ancient ruins of Caunus. They look out across four miles of giant reedbeds, protected from the sea by a glorious spit of sand where turtles lay their eggs at night. Beyond the acropolis lies a freshwater lake, its shore lined with plumy white reeds, and in the distance is one of Turkey's prettiest villages, Köyceğiz.

Fifteen years ago the painter Sema Menteşeoğlu returned here from Perugia in Italy, where she had been studying art. Not a great deal had survived of the ancestral home on the shores of Lake Köyceğiz where she had lived as a child. The stone *konak* her great-grandfather Ali Rıza Pasha built on these family estates in 1878 was dilapidated. Most of the land had been sold off, but Sema took the brave decision to stay on with her two young daughters and renovate the site.

At first she was able to live simply in a corner of the ruined house, where only the ground floor was still standing. As restoration progressed, she started to add a new bedroom or bathroom. As soon as part of the old *konak* became habitable, she moved in. 'It was like stretching after a nap,' she says, and it suited her modest bohemian nature. Rustic simplicity is her style. With her pet hens and roosters pecking around her, and her beloved cat Nokta snugly asleep on the doorstep, she is in her element in the kitchen-cum-studio, which opens onto a patio leading to a shady walled kitchen garden of apples, plums,

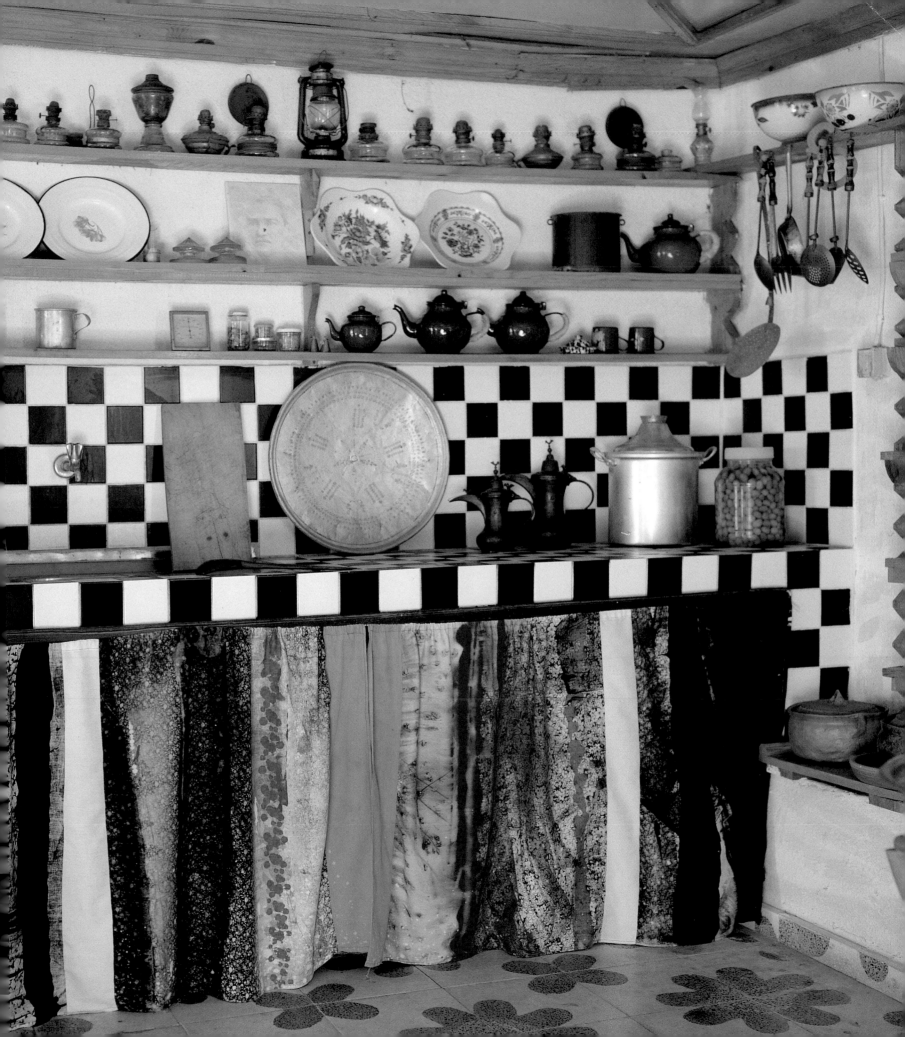

mulberries, almonds and pomegranates. She grows her own vegetables, which she feeds only with goat's manure. She prepares preserves during the garden's summer harvest, and in winter pickles green olives from her olive grove on an island in the middle of the lake. Above all, though, she enjoys entertaining a constant stream of family and friends, some passing, some staying.

Many an hour is spent on an inviting deck in the garden, which is furnished only with stripy runners and piles of cushions, in contrasting colours, arranged with a painterly eye; Sema made them from simple printed cottons bought at the local market. Huge

copper trays that also serve as tables arrive from the kitchen laden, depending on the time of the day, with tea, cheese and olives, or drinks and mezes. A bohemian style may colour Sema's life, but her Ottoman great-grandfather would surely have approved of her generous ways.

The influence of her tutor from Perugia, the sculptor, painter and poet Bruno Orfei, is reflected in Sema's vibrant palette and innovative style. Her surroundings, her house, her possessions are all her canvas. 'Life is art, and it should be lived mindfully,' she says. Something she herself accomplishes with dedication and flair.

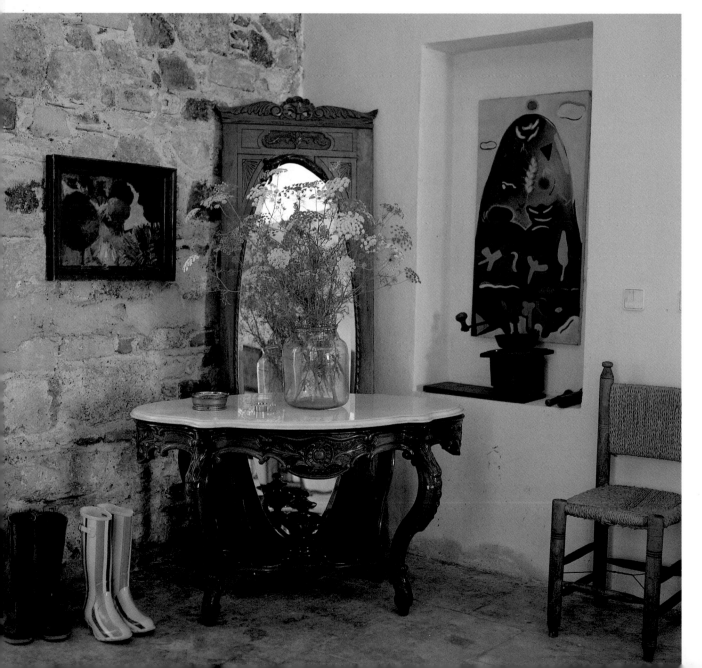

In the entrance hall (left) one of Sema's early paintings from the 1990s hangs in the nook above an old-fashioned coffee mill. The other picture is a woodprint that Sema made when she was fifteen. The marble-top table and mirror are family heirlooms that contrast with the exposed stone wall, one of the few walls left of the ruined mansion of her childhood.

The main hall downstairs (opposite), with a terracotta storage jar from a nearby village and a stripy kilim runner woven by her neighbour from remains of knitting wool, all add to the atmosphere.

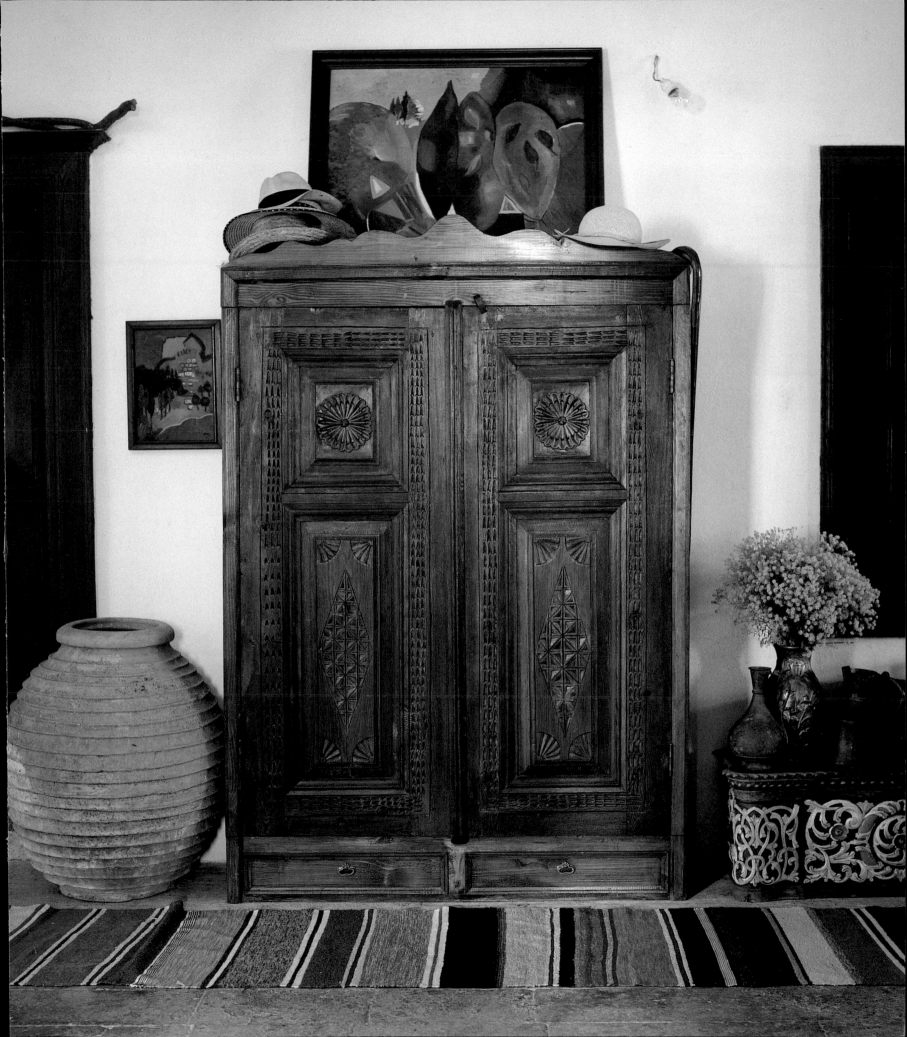

A sculptural work created from the ribs of Sema's old rowing boat (right). The boat's well-worn blue paint has been sparingly touched in with white by the artist. Beach pebbles set in cement (below, left). Nokta, the cat, wakes from a nap (below, centre). A basket-house in the garden (below, right). Traditional to the area, although now rare, such huts are woven from wickerwork, plastered inside with mud, and roofed with reeds or local tiles. This one is a hundred years old, and Sema uses it to store a bumper harvest of pumpkins.

The lake is in the shadow of the spectacular Taurus Mountains (opposite, above). An old oxidized zinc-plated door panel is painted with Miró-like designs; Sema also cites the undeciphered pictograms of Easter Island tablets as an inspiration (opposite, below, left). She made this three-legged table (opposite, below, right) from mulberry branches.

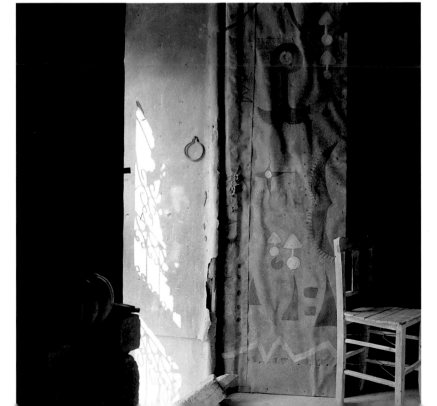
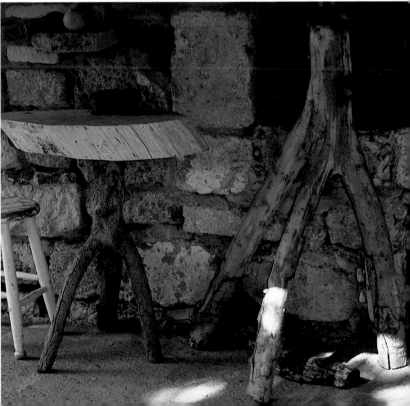

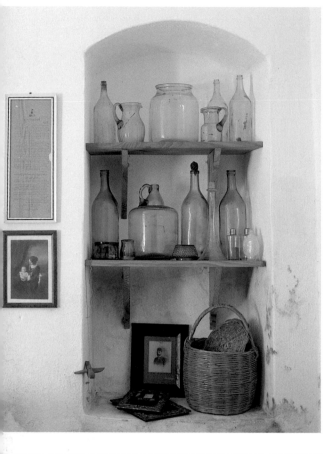

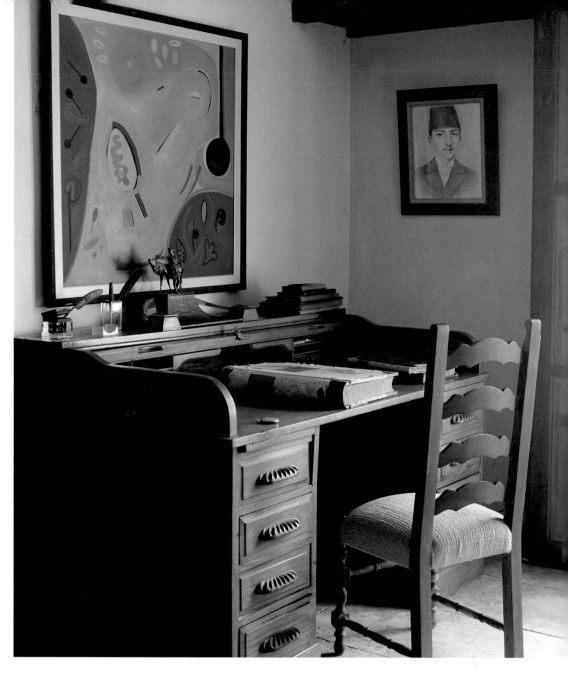

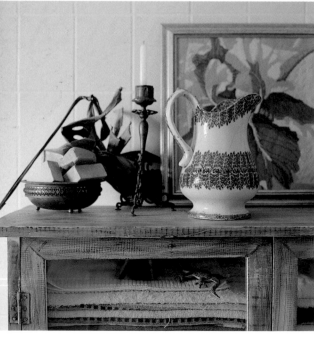

A small collection of vintage glass bottles and jars and family photographs in one of the guest rooms (above, left). A linen chest and handmade olive-oil soaps (left). The artist's desk (above), which once belonged to the office of Sema's grandfather in Izmir, and one of her oils painted after a dream. The portrait of her grandfather was drawn by a friend from a photograph.

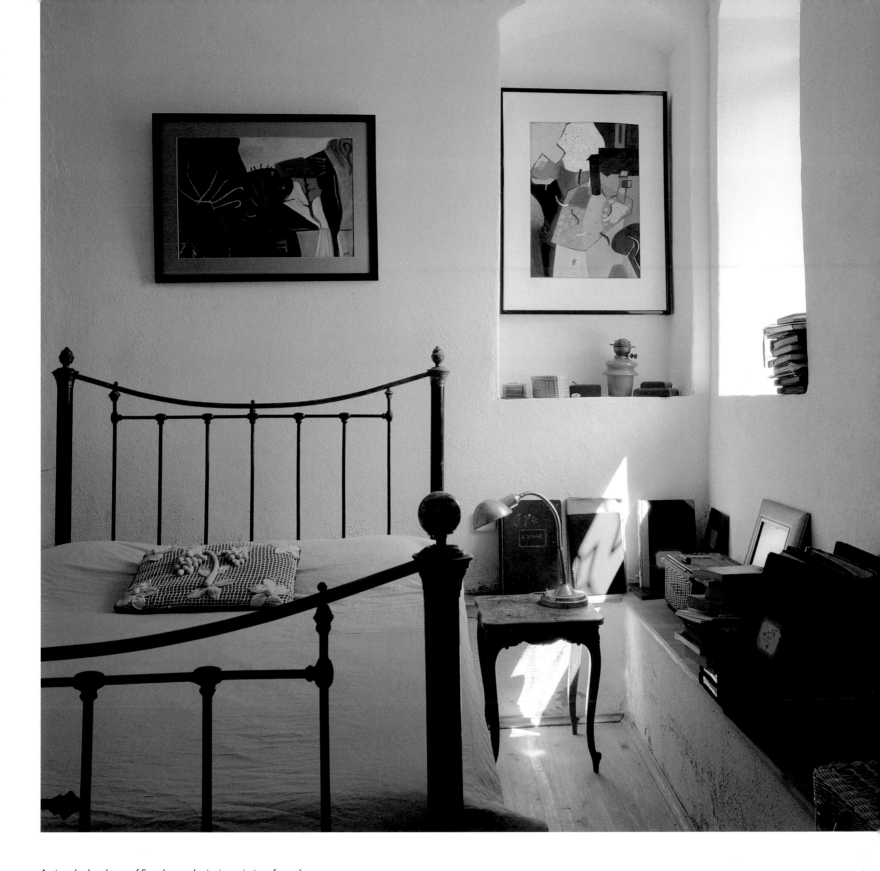

An iron bed and two of Sema's award-winning paintings from the 1980s. Combinations of odd objects are carefully arranged as in a collage, adding either shape or colour to the design of the interior.

Mehmet and Emine Öğün
A coastal cottage
in TORBA, BODRUM

Seen from the sea, the house, of cream-coloured local stone, stands in a small garden of umbrella pines, olives and oleanders (above, left). The henna-red mortar gives the stone an attractive texture: The terrace overlooking the sea (above, right): it is easy to imagine spending afternoons there enjoying the scent of the maquis and listening to the waves. The wooden stairs leading up to the twin bedrooms (below) are made of alder from the nearby mountains.

Torba is a peaceful, remote and undiscovered spot, just north of Bodrum, one of the most popular tourist locations in Turkey. It has been spared by the developers and is guarded by pine-clad mountains. A few bays to the west of Torba itself, reached by a dirt road, is the hidden haven created by Turgut Cansever, the renowned architect, with the help of his two architect daughters, Emine and Feyza, and Emine's architect husband, Mehmet Öğün. A cluster of forty or so stone houses set around a few old ruined farmhouses in an ancient grove of centuries-old olive trees, the charming village of Demirköy deservedly won the 1992 Aga Khan Award for its architecture.

Emine and Mehmet live with their two daughters in the smallest, most charming of the Demirköy houses. Once a farmer's cottage and one of the few houses still standing in the olive grove when the land was purchased for the model village, it became the architectural inspiration for Turgut Cansever's designs and the nucleus of the project. For eighteen years Emine and her husband have been coming here every summer. And it is here that Cansever still comes to stay.

Right on the water's edge, the house occupies a small piece of land one tenth the size of a tennis court in a wide wooded valley. It is minute, despite its massive stone walls, but contains everything one could need. Emine and Mehmet have kept the cottage's original square floor plan, making hardly any changes.

A delightful terrace lined with terracotta pots of red geraniums looks out to the deep blue horizon to the east and serves as a perfect outdoor living room. 'After the sun disappears behind the house,' Emine says, 'this is where we spend all our afternoons and nights.' French doors lead from the terrace into the house. The ground floor is an open living space used as a sitting, reading and working area. Another set of French doors at the back open onto the garden behind.

Wooden stairs lead up to two small bedrooms and a shower room on the first floor, which the two teenage sisters share with their parents. The bedrooms, divided by a large wardrobe, are identical

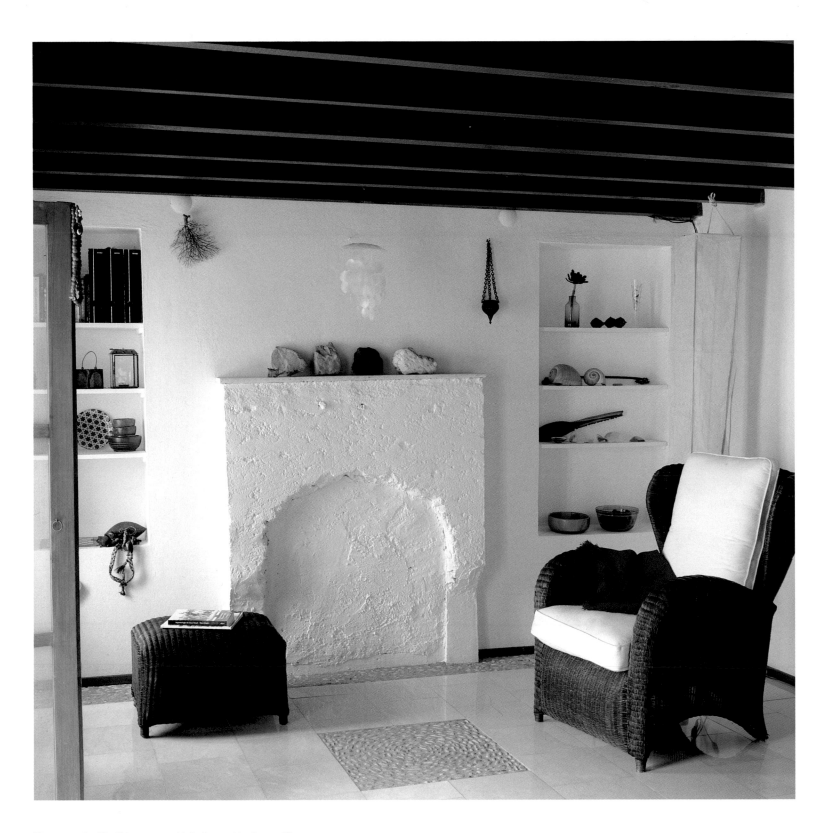

The cottage's white living room, with its heavy alder beams. The two fireplaces have recently been blocked up – as the owners say, when the house was shut up for winter, the chimneys became a back door for mice looking for somewhere to nest in the house. The marble floor has an inset square of pebbles.

in size and share an equally simple approach to furnishing.

The roof's beams are exposed and, like the other wooden elements, such as the window frames and doors, have been left unpainted. The natural texture and colour of the local timber, alder, softens the strong visual effect of the stone walls. Small windows on either side of the two bedrooms allow light to pour in. There is no clutter, either on the white walls or on the floor.

A long stone hut at the end of the garden, originally the farmhands' dormitory, was converted by Emine and Mehmet into guest quarters. Thick stone walls, small windows for ventilation and an almost complete absence of concrete are the key to a cool interior.

The raised garden is protected from winter storms by a stone sea wall. The little quay and steps leading down to the sea have the same texture as the façade of the house: a light creamy stone from a nearby quarry. The same source must have been used for the new houses. Mortar and fillers are mixed with the henna-red iron-

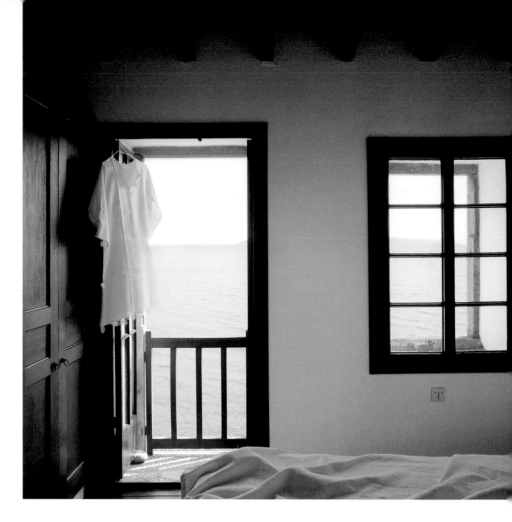

rich soil of the area (*demir*, the origin of the village's name, means iron). The narrow garden paths are paved with the same stone cut into square paving stones. When building Demirköy, this family of architects were very careful to preserve the ancient olives, fig trees and pines that had stood there for a hundred years and longer. 'We tried not to interfere with the natural fabric of the valley. We did not want to disturb anything. We were walking on tiptoe.'

Indeed they managed to integrate the new houses into the environment. The terebinth and tamarisk shrubs native to the area have all been preserved and the wonderfully restful garden is full of the colours and scents of the Mediterranean. 'Because nature outside the house is so vibrant and bountiful,' Emine explains, 'the monochrome sparseness indoors is reassuring. A nomadic approach to life, perhaps, but we come here just to live. You don't need much more than that, do you?'

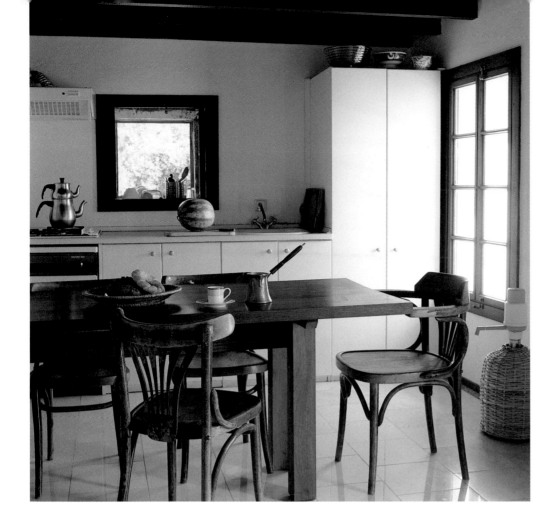

Simple and uncluttered, the cottage's interior is practical and has a relaxed feel. The large dining table in the kitchen (left) was made by Demir's resident joiner. The classic Thonet chairs are modern copies. Baskets with pebbles collected from the beach serve as doorstops (below, left). The door at the back of the house opens into a small walled garden (below, right). The large drawing table with Emine and Mehmet's laptops is where the couple, both architects, work in summer.

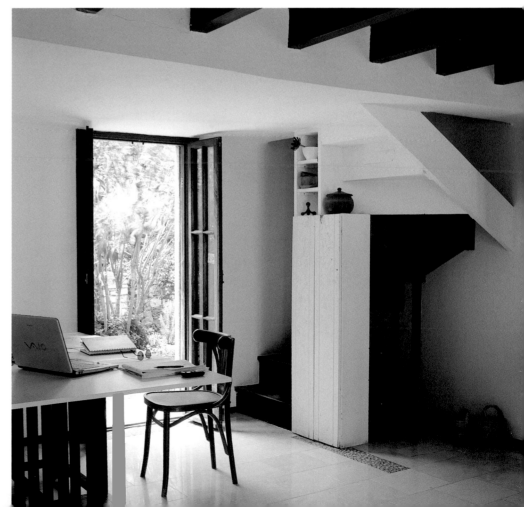

A large wardrobe divides the two upstairs bedrooms. The parents' bedroom with its little wooden balcony looking out to sea (opposite, above). A corner of the sisters' room (opposite, below).

Autumn

The storks are the first to leave, towards the end of August. How they know the precise moment summer has passed is one of life's mysteries – it is long before the trees turn, or the hills are painted ochre, amber and honey. With the approaching end of summer it is time for people to say farewell too, leaving the sun-drenched resorts behind to return to shady interiors: it might be a concrete cube, a high-ceilinged turn-of-the-century apartment or an artist's studio with an autumnal view of Seraglio Point from the window. Or it might be a stone mansion on the Black Sea, or a farmhouse on the windswept island of Bozcaada in the Aegean.

Market stalls are piled high with golden quinces, red-cheeked pomegranates and mouth-watering grapes. In the country people prepare for the long cold winter months ahead. Tea is harvested, tomatoes and aubergines are sun-dried, pickles, preserves, cheeses and bulgur readied and stored. Wine is left to age, and looms are built for colourful weaves.

The Turkish word for autumn is *sonbahar*, the last spring. As temperatures drop and the rain falls, nature awakens one last time before going to sleep for the winter. Roses come into bloom again, grass becomes greener, the fiery colours of dahlias and asters fill the gardens. These last sunny days are always a joy, whether you are in the country or the city.

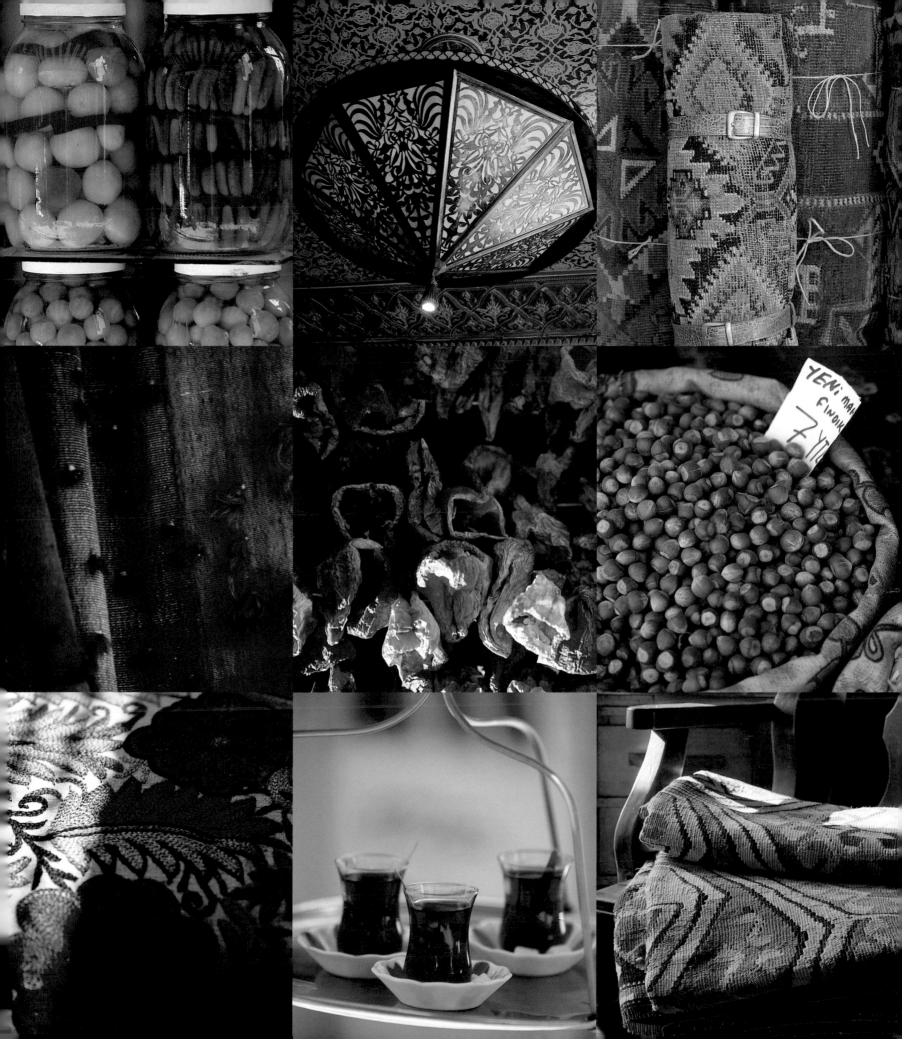

Reşit and Şebnem Soley
A vintner's home on the
island of bozcaada,
near troy

The stone house (above) stands in a vineyard surrounded by olives and pines. It was the first new house on the island to be built in the Bozcaada vernacular, a replica which would itself become the trendsetter for others. The benches and low table in front of the house are a viewing point from which the valley below, the sea and other islands beyond can be seen.

The kitchen units (opposite) were designed by the architect and manufactured by the joiners of Leo Design, Reşit Soley's architectural practice in Istanbul. They are all on wheels, so that the kitchen can be reorganized on a whim. The painting, dated 1989, is by the US-educated Turkish artist Tomur Atagök and was inspired by Toulouse-Lautrec. The door leads to the small living room.

Twenty years ago Reşit Soley, an Italian-trained architect and creator of many Istanbul high-rise blocks, went to stay with a painter friend on Bozcaada (Tenedos), a small, tranquil island in the northern Aegean, off the Anatolian shore of ancient Troy. He remembers how 'stepping out that morning, I heard for the first time in my life the sound of the stillness'. That was the moment he decided to build a house here. Not long afterwards he bought an abandoned vineyard and commissioned local builders to construct a cottage in the island style. 'I didn't interfere as an architect,' he remembers, 'I only told them what I wanted to have, and this is what they produced. I am pleased with the end result.' Reşit's home is unfussy and perfectly modest, with two bedrooms and a kitchen-cum-living room, but what makes this little cottage extraordinary is its location. Nothing man-made – no other house, no road – is visible: it stands in absolute solitude at the northwestern side of the island with a spectacular view of the Aegean Sea and the sister island of Gökçeada (Imbros). In the past twenty years Reşit has often come here, using his time for contemplation and to seek inspiration for his demanding work. It

has been a retreat: he could enjoy the stillness, surrounded by vines and olive trees.

Judging by the varieties of oregano, the cistus plants and the olive trees around the house, the climate in this spot on Bozcaada is mild and Mediterranean – Reşit is planning to organize scientific research and documentation of the island's bountiful flora. Bozcaada means 'whitish isle' in Turkish and approached by ferry from the mainland, the island looks arid, almost treeless and has indeed a whitish glint. It was this mineral-rich, limy volcanic soil, combined with the sunny climate and constant, chilly winds, that made the island famous for its wine. The Spanish traveller Clavijo visited in 1401 and wrote that he found many vineyards, but that the island was desolate. In 1464 the Ottomans captured it from the Venetians and during the Ottoman reign it was repopulated and its viticulture revived. The Ottoman traveller Evliya Çelebi would write 200 years later that Bozcaada had the finest wines in the world.

Reşit founded his Istanbul-based architectural practice, Leo Design, in 1983, and spent almost twenty years designing concrete, glass and steel city structures for

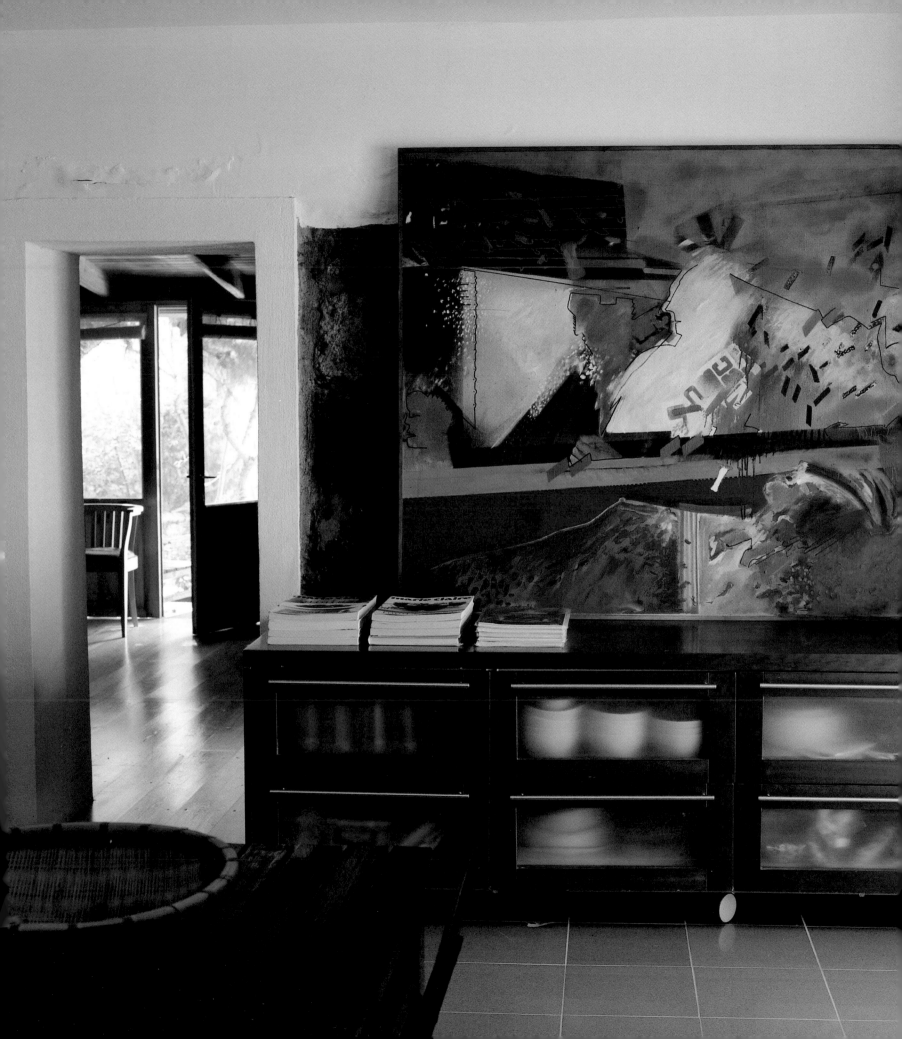

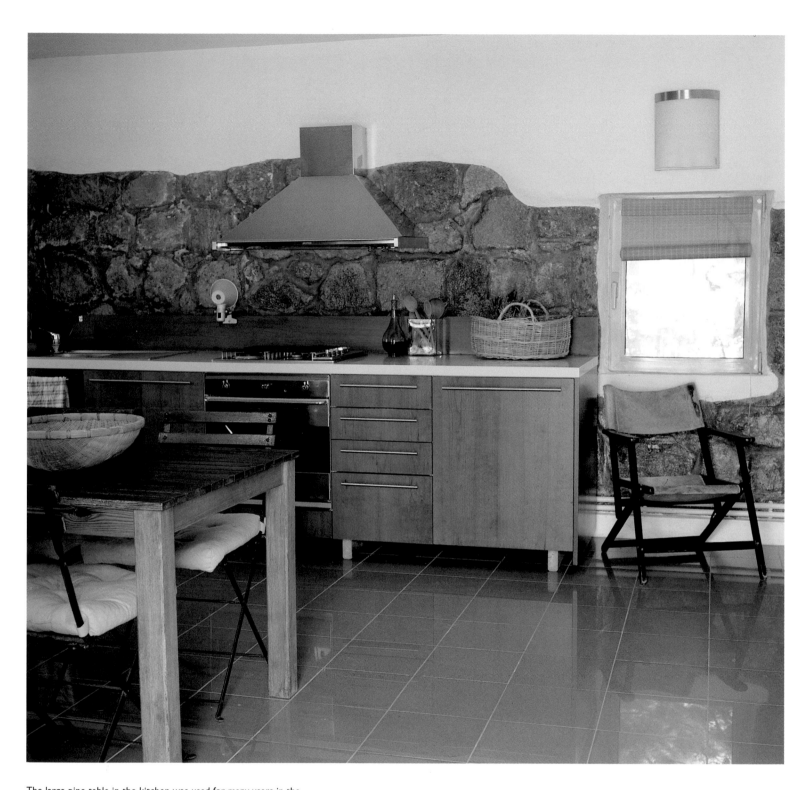

The large pine table in the kitchen was used for many years in the garden of Reşit's Istanbul house. Refurbished, it serves here as a perfect dinner table. Around it are folding chairs: Reşit found a broken skeleton of a chair made in 1800, forgotten under a tree in the garden of a deserted orphanage. He took it as a model and ordered his ironmonger to reproduce new ones using the same soldering techniques.
The director's chair under the window was also re-created from a broken chair.

banks and corporate headquarters: most were improbably conceived in this idyllic location. But one day – he remembers the date very well: 29 August 2002 – he decided to make a change in his life and start a small vinery. This was despite, he admits, never having had even a pot plant before. He simply could not bear to watch the existing local grape varieties disappear and with them an entire culture that had survived many thousands of years. 'I made a fortunate mistake. I planned to buy 20 hectares (50 acres) of land to experiment and ended up with 200 hectares. Soon the partners I started the project with had left me, but I didn't give up. When a state-owned brandy plant on the island was auctioned off, I put in the highest bid and bought the 2,000-square-metre factory. I am a fatalistic man, I suppose. I believed this was my *kismet*, my mission, and of course it changed my entire life, more so than I ever intended. I became a farmer.'

He transformed the old factory into Turkey's most modern wine-making plant, equipping it with the latest technology. The land was cultivated once more, including the neglected vineyards around his cottage, and in 2004 he had his first harvest. In 2006 at an EU-sponsored wine competition five of his six wines were nominated for gold and silver medals.

Reşit has become an ardent believer in biodynamic farming, which takes into consideration soil, plants, produce, animals, and people, employing old traditional methods such as crop rotation and the use of purely natural manure, and plans the agricultural year according to the celestial calendar. This is all part of his mission to produce ecological, organic wine. Reşit's idealism and energy are limitless. His ambition is to revive the old local grape varieties and create his own wines. 'There is no point adding to the countless cabernets or merlots all over the world,' he says. 'My dream is to rescue the island's unique vines, so renowned in the past, and to add them to the oenophile's list.' He has already started with the four existing grape varieties on the island. He chose the brand name 'Corvus', the Latin for crow, the most intelligent and most adaptable of birds, of which there are many on Bozcaada, for his wines.

Reşit lives with his young wife Şebnem, an interior designer, in his stone house, perhaps now no longer an escape, more a home. Plainly yet tastefully furnished, it has a large kitchen where they enjoy cooking and entertaining friends at the long dining table. Next to the kitchen is a less spacious living area with a pair of comfortable sofas. The checked

Above the playing cards (below) is the name 'Bozcaada' on a zinc stencil used to paint wooden boxes for transporting wine. The office of the Corvus winery (bottom). The black leather chairs are Eames, the beige sofa is by Matteograssi and the light is by Ettore Sottsass. The Turkish painter Bedri Baykam's large canvas from the late 1980s was painted after the artist met Andy Warhol. The grand piano in the middle of the winery (right). The glass flagons, some more than a century old, were unearthed on the island. A few still have traces of wine inside.

upholstery of the sofas contrasts with the unplastered grey stone walls. This cosy room is only for cold nights and rainy days. Otherwise life is spent outdoors. Both are agreed: 'We never bothered to create a garden. The nature around the house stretching as far as the eye can see, nothing else, is our garden.'

The winery is a much larger living and working space. Ten minutes' drive from the house, in a way it is like an artist's studio, where the finest wines of the future are created. Surrounded by huge steel containers, full of wine for slow ageing, stands, improbably, a Blüthner grand piano. Reşit's daughter and friends, amateurs and professionals alike, love to practise here. Even a group of drummers came the other day and asked for permission to play. Reşit, a devoted jazz lover and saxophonist, says it was simply marvellous and they played for many hours. The acoustic qualities of the room – formed by the panelling in the ceiling and the steel tanks which provide a resonant, well-rounded tone – are exceptional but quite unintentional. The visual refinement was, however, deliberate: the straight, sharp lines of the timber ceiling and roof windows, the gleaming steel tanks, the dark piano are all carefully composed like a work of art. A collection of vintage glass wine bottles and flagons add a delicate contrast to the composition and, with the beams of light pouring through the windows in the roof, give it the air of a Dutch painting. Likewise the little corner for wine-tasting: four wine-red chairs and a Philippe Starck table contribute the only colour to the grey tones.

In the office one very handsome working table, where Corvus was designed and the finer technical points of oenology are discussed, dominates the space. It is lined with half a dozen Eames chairs. An elegant pale beige Matteograssi leather sofa for guests and a huge painting by the Turkish artist Bedri Baykam add sumptuousness to a subtle, minimalist, but exquisite, room.

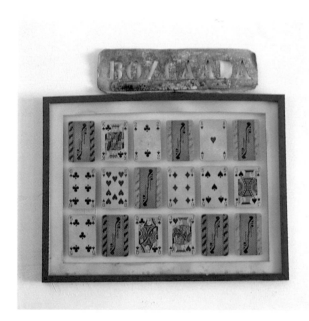

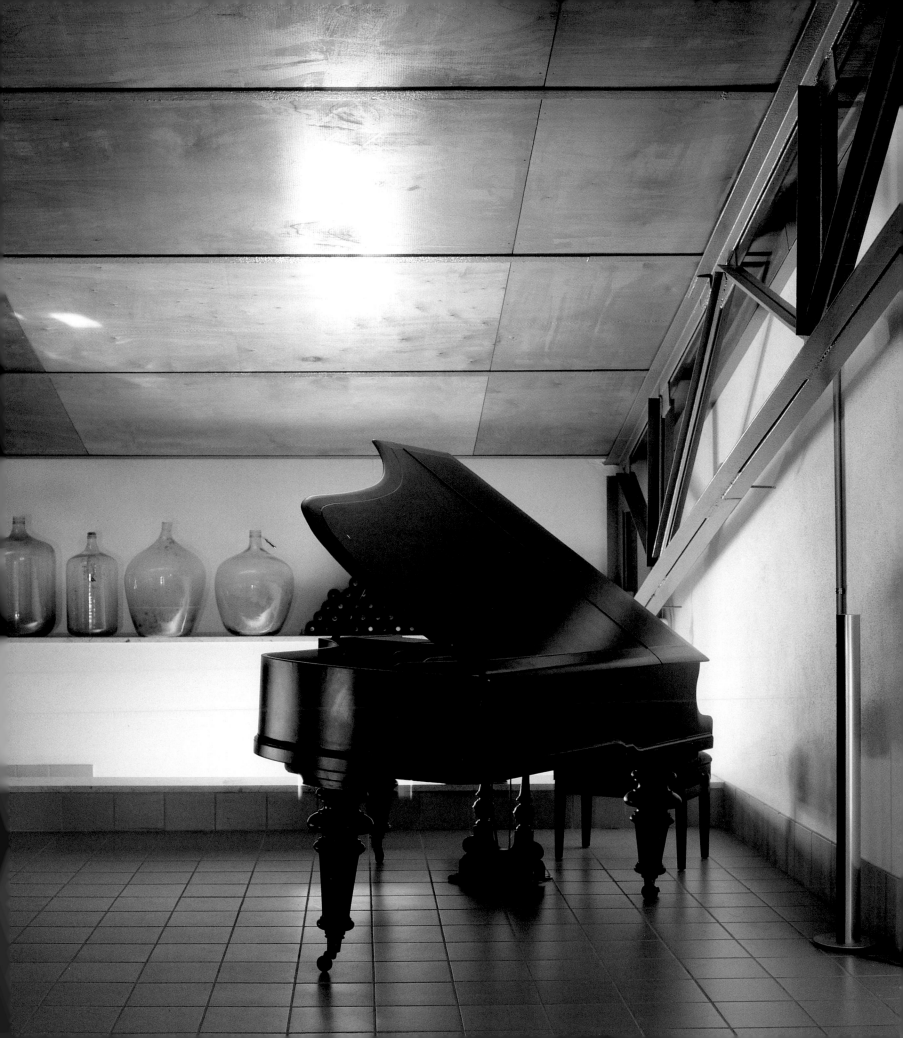

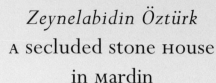

Zeynelabidin Öztürk
A secluded stone HOUSE in MARDIN

Massive stone houses in Mardin with 'filigree' carving on the façade (above). The remains of the legendary Mardin fortress, which was one of the few to resist Tamerlane's armies in the 14th century, can be seen behind. Fanciful stonework (above, right) around circular and teardrop apertures on the façade. The elaborately carved entrance to a school in Mardin (right).

Outdoor bedrooms (opposite): the wooden *taht*, or throne, serves as seating during the day and turns into a bed under a starry canopy on summer nights.

Overleaf: This bedroom (left) once belonged to Hacı Abdullah Bey, who built the house. The door is of walnut. The ornate brass bed is like a jewel contrasting with the severe structure. The servants' door next to the main entrance (right).

A proper stronghold, surrounded by walls several metres thick, with buttresses and ramparts pierced with narrow windows, and a gatehouse for its entrance, this palatial fortified Turkish townhouse was built at the highest point of Savur, a town close to the city of Mardin on what is now the Turkey–Syria border. Today, the house is the family home of the Öztürks and it is where Zeynelabidin Öztürk, a civil servant, and his three sisters and four brothers were all born. Their ancestors had migrated from Baghdad in the 15th century, when Mardin was a prosperous trading station for caravans on the silk road.

In the late 18th century, Zeynelabidin's ancestor Hacı Abdullah Bey built his monumental townhouse, choosing the highest point above the Savur river and the town, just below the remains of the Roman citadel. It leans against the bedrock and is reached from below by broad steps. Above the gate, the Bey's wish is carved in stone: 'With Allah's permission I have built this house. May my children continue to live here in happiness.' It seems his wish was granted: two centuries later the Öztürks are still enjoying the house. Zeynelabidin's widowed mother and his youngest brother live there permanently, an aunt and her family occupy a wing and all thirty rooms become bedrooms when the family gathers.

Savur, like Mardin, always prospered from trade and agriculture. With its marvellous winding narrow streets and steps, archways, massive stone walls, flat-roofed stone houses built like strongrooms, towers, minarets, monasteries and churches, time seems to have stood still. Hacı Abdullah Bey's castle's façade shares the Gothic characteristics of the local architecture. It is built of local pale ochre limestone,

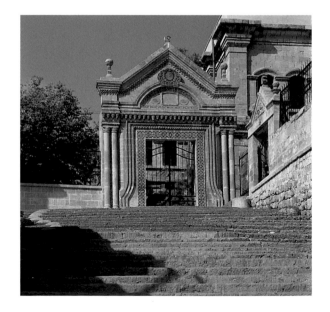

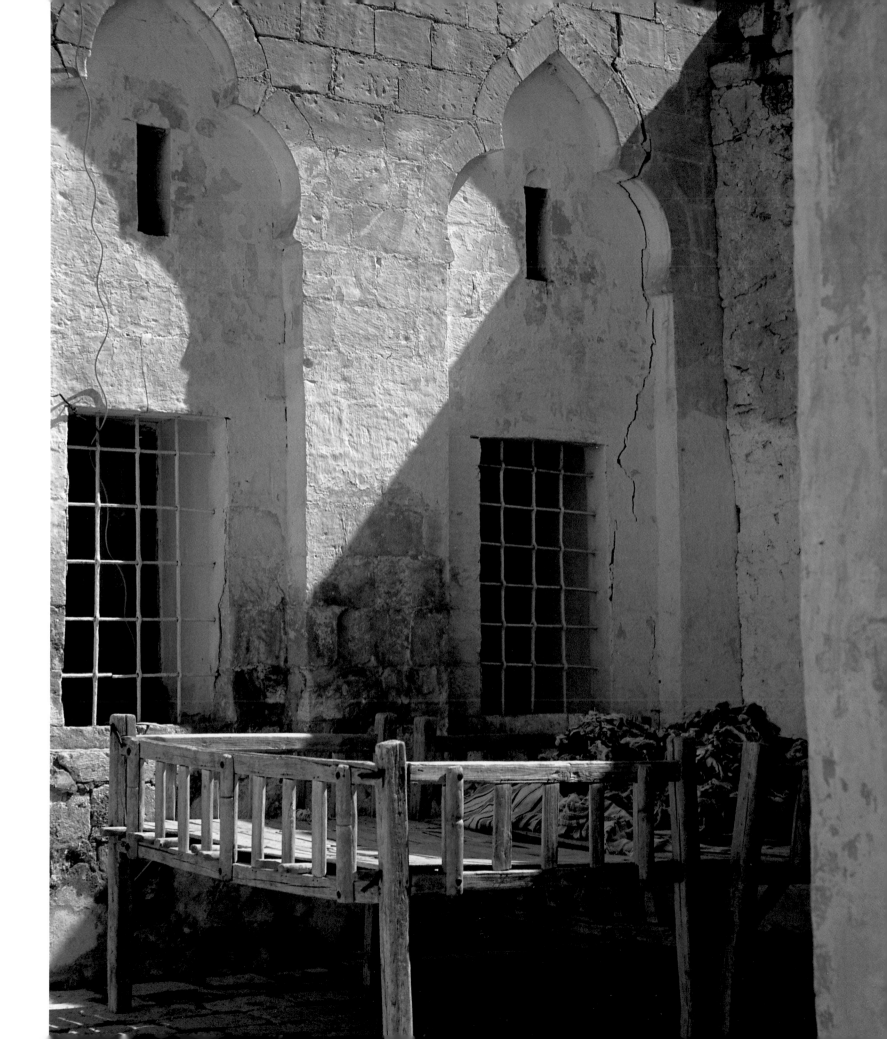

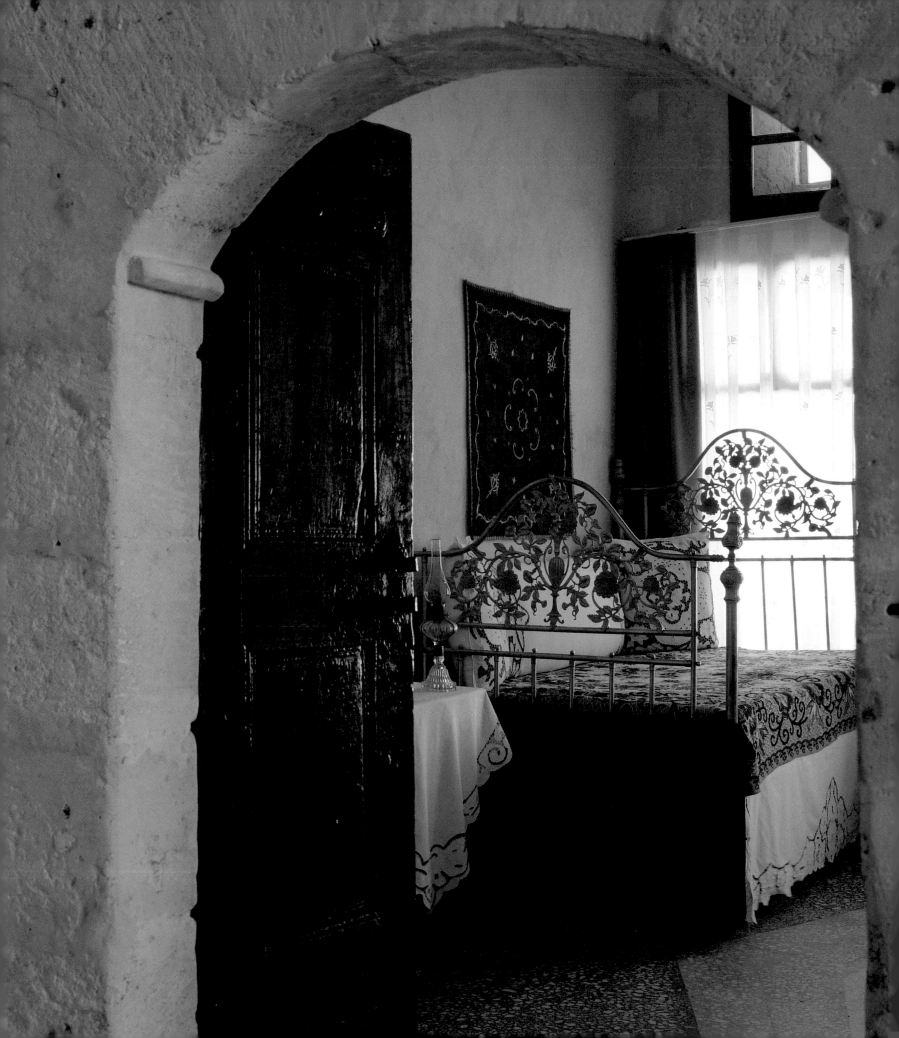

embellished with round, pointed and trefoil arches, brackets, rosettes, cornices and consoles. This form of carving in a manner so delicate and intricate is rightly known as 'telkârî', meaning filigree.

The walls and flooring of the interior are also of stone, which provides coolness in summer. Timber is scarce. Walnut was available for the wealthy but used sparingly, only for shutters and doors. Mulberry wood was used for the lintels, but, as Zeynelabidin explains, 'it should be a non-fruiting mulberry, which is as valuable as mahogany because it won't be worm-eaten'. Otherwise poplar is used for planking and supports. The house has a classical floor plan, with women's and men's quarters – harem and selamlık. Both sections are planned around a cool shady inner courtyard, or hayat, lined with flowerpots and festooned with grapevines on wooden pergolas.

The başoda, head or master room, is on the top floor of the selamlık side of the house. Zeynelabidin describes how one part of the room was originally an outdoor loggia, known in Turkish as a köşk, with low divans around the walls. Its arches faced the emerald green valley of the Savur river. Recently, as the family grew, the arches of the loggia were bricked up and set with windows to gain another room. This was the most prestigious room in the house, and the high vaulted ceiling is decorated accordingly with brush-work floral sprays and scrolling leaves, echoing the fine carpets on the floor. A cornice of stucco mouldings borders the ceiling, which has a star-shaped centrepiece of mirrors that reflect the light outside. The decorative 18th-century stained glass upper windows are framed in moulded plaster.

Zeynelabidin's mother, 'the Great Hanım', has kept everything as it was when she came to the house as a young bride at the age of 18. The basement was originally stables, a large central kitchen, larders, a hamam and other storage and utility chambers. The spacious, high-ceilinged rooms of the three upper floors are decorated and arranged in the traditional manner, with a few pieces of 19th-century Western furniture. The subtle colours of the carpets and sedirs (built-in benches) contrast with the limewashed stone walls and the pale lace-like stucco embellishments around the niches and on the lintels and hooded fireplace surrounds.

Zeynelabidin's wife, Ayşegül, is from Thrace. They have a flat in the centre of town, but Ayşegül stays with her mother-in-law when there are paying guests. 'When I go to the house,' Zeynelabidin confesses, 'I am overwhelmed with contentment. It is a feeling not dissimilar to my childhood when I was together with my father and grandparents.' He recalls with fondness games of football in the courtyard with his siblings and numerous cousins. The wood-burning kitchen stoves also served to heat water to supply the hamam and other parts of the house. He also remembers when his mother made yoghurt from left-over milk. He used to take it to market to sell and the money he earned that day was his pocket money. 'At home I feel complete,' he says.

The ceiling of the *köşk* of Hacı Abdullah's castle (above, left), with its faded painted decoration reminiscent of rich floral patterns found on Persian carpets, and its mirrored star-shaped centrepiece that reflects the light. Detail of the cornice in the master room upstairs (above, right). An old mirror framed with stucco ornamentation complements the hand-embroidered cotton blinds and finely crocheted lace, which were made by Zeynelabidin's grandmother 50 years ago (near right). Pointed arches are very much part of the architecture of the region (far right).

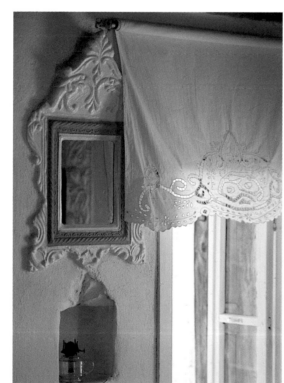

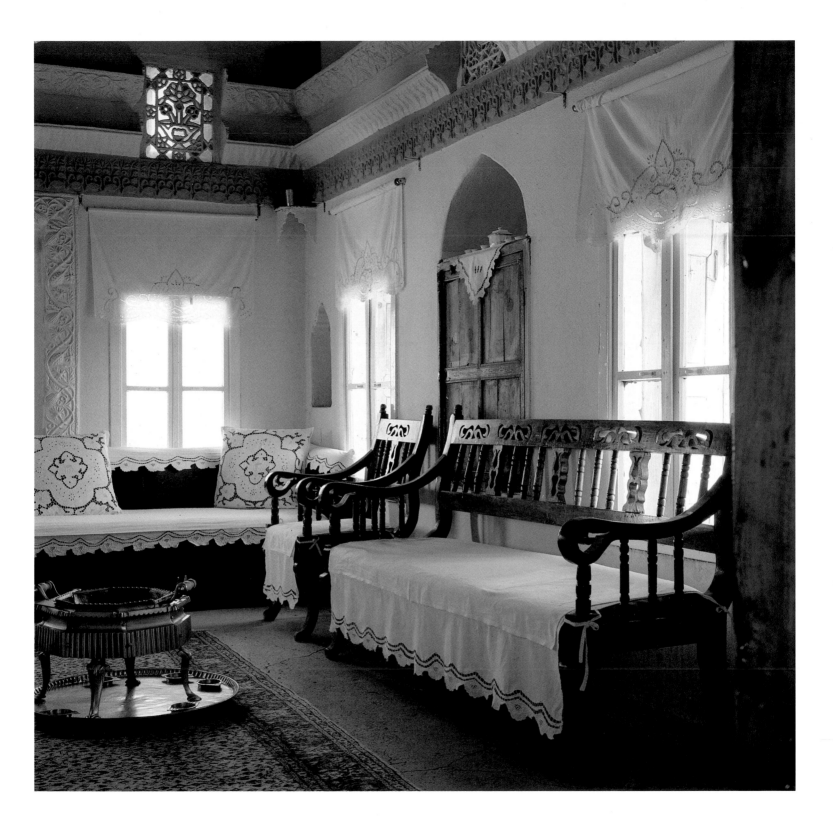

The master room, with its pristine white embroidered covers and blinds echoing the stucco ornamentation of the walls. Beneath the stained glass window are shelves, which in the past were used to display a collection of fine Iznik plates and antique glassware. The armchairs were made by Zeynelabidin's father as a wedding present for his bride.

Jacques Avizou
A cave house in cappadocia

The tuff, or hardened volcanic ash, is easily carved (above, left). These three cones have been hollowed out to create chambers on many storeys, like an apartment block; they are linked to each other with carved steps. A corner of the patio of one of Jacques Avizou's 'maisons' (below, left). Old and new have all found a home in Jacques' 'maisons'. The deckchair is made by his team of carpenters. An old piece of marble serves as a low table.

Dappled with shade, the terrace in front of a kitchen, with a pergola of reeds and a vine (opposite). The barbecue is created from an old fireplace. A slab of stone reclaimed from a salvage yard is used as a dining table.

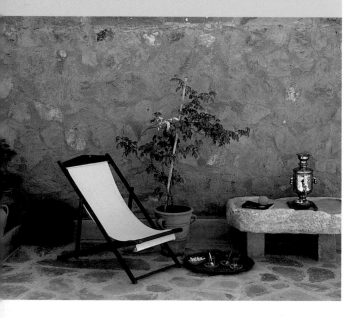

In 1997 an international travel magazine wrote about a remarkable Frenchman who was restoring the crumbling stone houses of the village of Uçhisar, 'high on one of those Cappadocian valleys of honey-coloured cones'. 'Today lovingly brought back to life, they stand tall once again,' it concluded. Work in Uçhisar is still being carried out.

Jacques Avizou, from Albi, came to Cappadocia in central Anatolia twenty years ago. He was on holiday when he was bewitched by the surreal sight of the 'fairy chimneys'. Two volcanoes, Erciyes and Hasan, erupted millions of years ago, covering the land with many layers of volcanic ash and lava. The ash settled into tuff and the lava layer on top became basalt. In the following millennia, the weather eroded the softer ash and sculpted a fairy-tale land of canyons, cones and mushroom-like pillars. The unique panorama and the fine ruined houses on the hillsides are extraordinarily romantic. It is little wonder Jacques never left. 'I had discovered my paradise,' he says.

The settlements of Cappadocia date back to prehistoric times. Homes, shelters and even underground cities were made in the hardened volcanic ash. The early Christians dug out hidden chapels and refuges from the Romans. In later centuries, the rockface was steadily hollowed out into cave dwellings and sanctuaries. As the settlements grew, people also built handsome houses above or in front of the carved-out chambers. The valleys had been cultivated for vines since early times. Cappadocia remained home to prosperous farmers until the 1950s and 1960s, when industrialization and the resulting economic boom meant that local people chose to live in new quarters in concrete blocks or to migrate to the big cities. Almost all the houses were abandoned or used as barns, if not left to crumble away entirely.

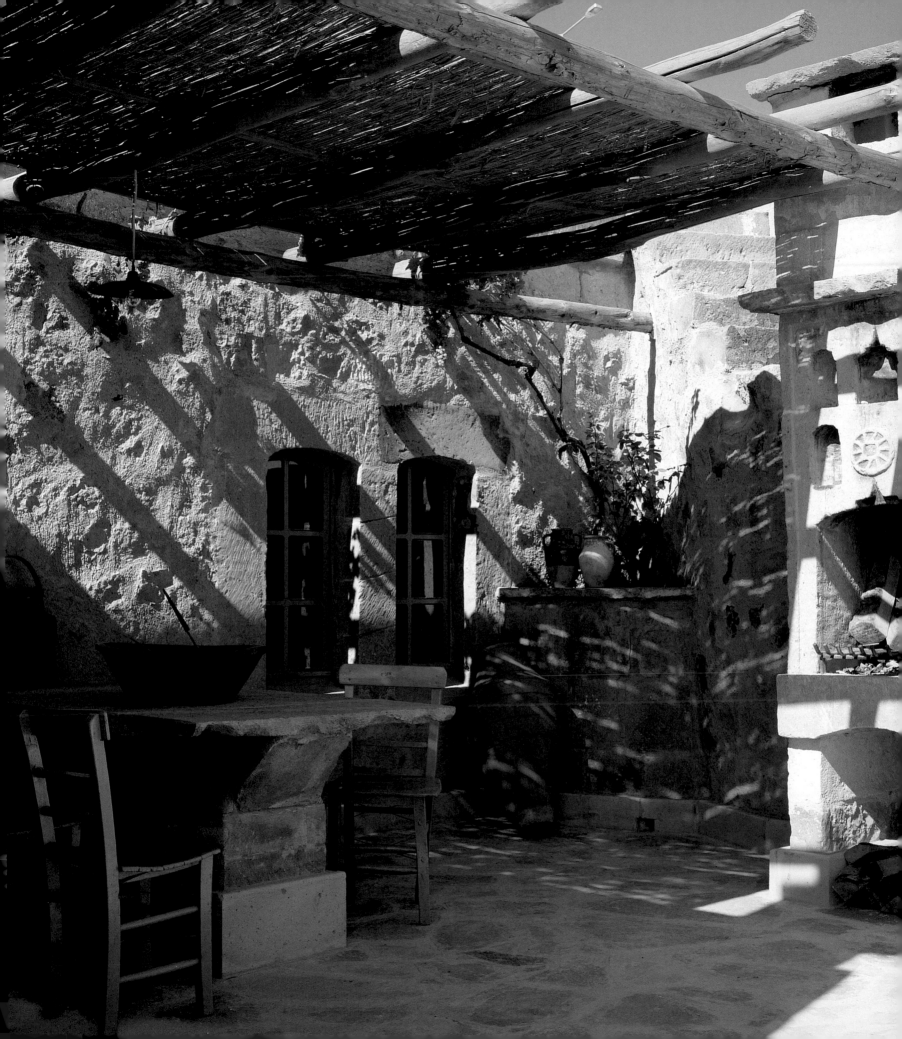

From the patio an archway opens into an inviting courtyard (top).
The original bread oven, still in use. Old rustic objects such as glazed
ceramics from Avanos, on the banks of the ancient River Halys,
a lantern and a wooden dowry chest are harmoniously arranged.
A hand-carved architectural ornament of Nevşehir sandstone
quarried nearby (above, left). An old camel's head decoration (above,
right). The centrepiece is embellished with many buttons and a mirror
to avert the evil eye. The interior of an old house named 'Maison le
Sucre' because its first owner was a sugar merchant (opposite).

An architect and city planner, Jacques quickly set
up a company called Société Sémiramis and started
a programme to restore a dozen of the ruined old
houses in Uçhisar, a ghost village perched on the edge
of the rockface looking east to the snowy peak of
Mount Erciyas in the distance. It is registered by
Unesco as a World Heritage Site.

Jacques' artistic talent blossomed in Cappadocia.
So far he has finished ten handsome houses and five
studios, all with a timeless quality. They are known as
'Les Maisons de Cappadoce'. Each 'maison' has a name
that is a reminder of the state he found it in. For
instance, the 'Maison la Paille' was used to store hay,
the 'Maison les Chèvres' used to be a barn for goats
and 'Maison la Forge' was where the ironsmith had
kept his bellows.

The main characteristic of the local architecture,
as Jacques explains, is the 'barrel-vaulted ceilings
constructed out of stone, always about three metres
across', which lend Uçhisar a uniformity of overall
texture. Jacques remained loyal to the traditional
building techniques as well as to the style of the
region, and skilfully brings out details such as the finely
carved lintels over the doors and windows, and the
delicately sculpted fireplaces, brackets, columns
and capitals, mostly recycled and reinstalled both
inside and out, often with traces of earth paint left
untouched. To replace any missing parts he either uses
the same sandstone, quarried in Nevşehir and carved
by the local stonemasons, or salvages old building
elements from the nearby city of Kayseri which match
the local stone.

The houses have different floor plans, but facing east,
they all share the spectacular sunrise. The bedrooms
are spacious and minimalist. Shower rooms are
devised differently in each house, all imaginatively
designed, and living areas are often planned with
an adjoining kitchen. A shady terrace, leafy patio or
flower garden, sometimes even a little fruit orchard
and a small vegetable bed, extends each living space
outdoors. Ornamental water features such as

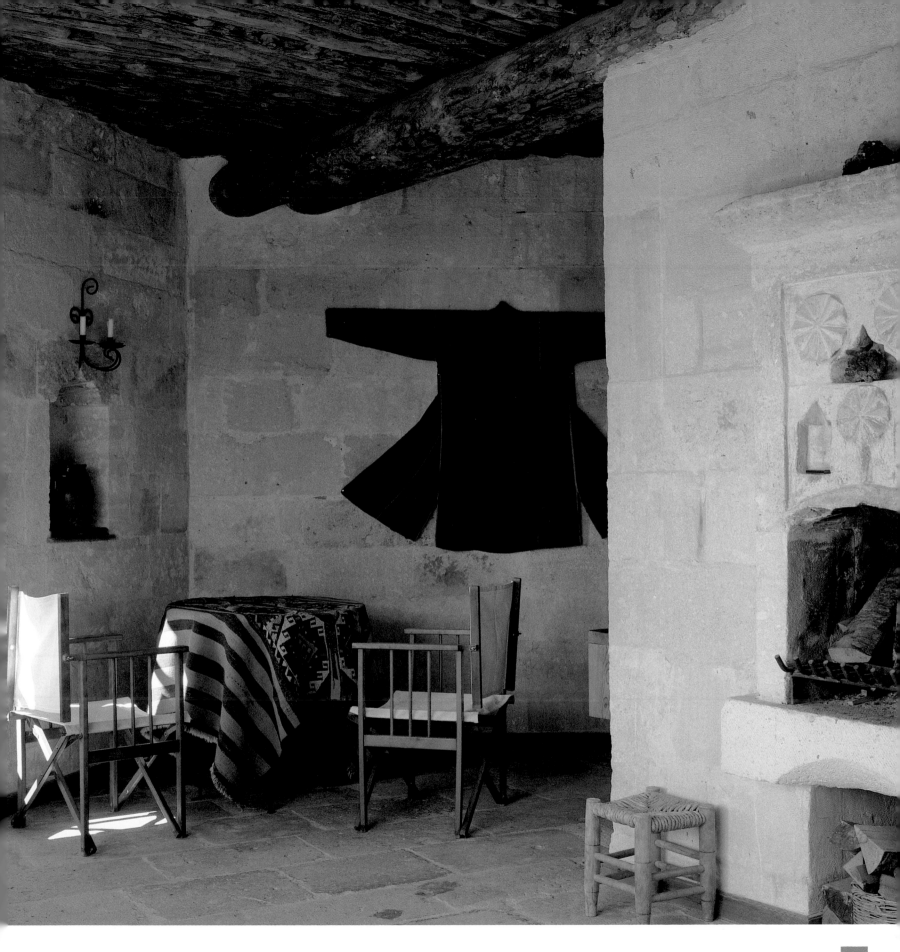

fountains or a small rooftop terrace pool further accentuate the outdoor life, and there is always a fine old sculpted fireplace for use as a barbecue.

The rooms are designed according to traditional principles; they are uncluttered, functional and furnished with sophisticated simplicity and a love of natural materials. The focus of most rooms is an old salvaged fireplace, carved from the local limestone, which is ready to be lit on cool evenings. Ornate carved or painted doors and lids are skilfully recycled into wardrobes and cupboards. Recessed alcoves and nooks offer little shelves for a bedside light or book. Tables and side tables created from slabs of old stone or marble are combined with simple wooden chairs or basic wrought-iron furniture. Delicate lace-like bars at the windows and balconies contrast with the bold square shapes of the dressed stone walls and the round forms of voluminous terracotta storage jars. Anatolian kilims and flatweaves, and glazed pots from the nearby town of Avanos, on the clay-rich banks of the Kızılırmak, the ancient River Halys – a centre of pottery since Roman times – are artfully arranged against the matt chalky colours of the interiors.

No two exteriors are alike: the details – bas-relief ornaments, colonnaded verandas and arched gates –

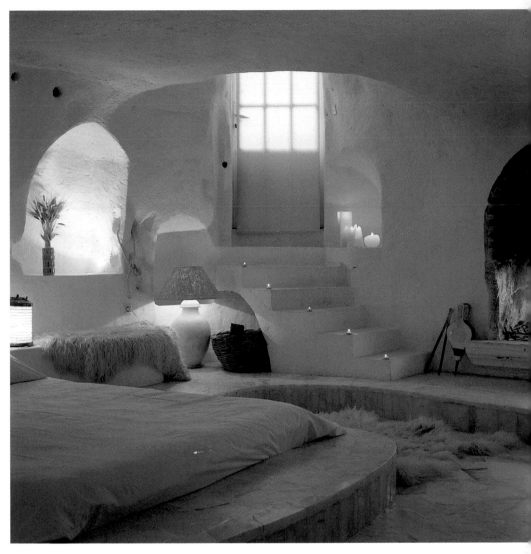

give each façade a different air. Each has its own ingenious design solution, small secrets and imaginative details. Most striking are the 'hollowed-out' chambers, entered through rooms with vaulted or flat-timbered ceilings, which have been carved from the soft, porous tuff. The end result is a concave chamber or, as Jacques likes to say, a 'troglodytic' room.

Jacques still enjoys living here, and others are joining him, such as the young Turkish couple who have opened a good restaurant, Elai, in the once abandoned but now beautifully restored village café. Strong-willed idealism, artistic vision and a fine team of loyal craftsmen have made it possible for others to enjoy this fairy-tale setting.

The ornate fireplace in this bedroom (opposite) is original and ready to be lit, with extra firewood beneath.

Interior of a troglodytic chamber (left), with concave walls and ceiling and pockets for storage. Soft, porous tuff (or hardened volcanic ash) can be hollowed out effortlessly with a special heavy metal scraper. A sizeable room takes about two weeks for three people to complete. It is an old custom to work in threes. Interior of the cave dwelling 'Maison les Chèvres' (above). The owner had been using it as a stable for his Angora goats.

İlker Şevketbeyoğlu
A TEA PLANTER'S STONE MANSION
in the çağlayan valley,
FINDIKLI

A ladder leads to the granary, or *serander* (above, left). The lush tea gardens (above, centre). The house's façade is created by setting riverbed stones into the individual squares or 'eyes' of a timber frame built without nails (above, right).

The minimalist but welcoming interior of the Şevket Bey *konak* (opposite).

Çağlayan, near the Black Sea coastal town of Fındıklı, is a district surrounded by mountains. Fındıklı, which literally means 'place of hazelnuts', is thought to be where the hazelnut, or *fındık*, originated. The nut has been cultivated here since at least the time of the ancient Scythians.

The *konak* of Şevket Bey is the oldest of the many fine mansions in Çağlayan. Built in the 1770s in the middle of a large estate, the house was once surrounded by hazel groves, orchards, farmland and forests. But in the 1930s tea was introduced to the region, and today, the steep hills around the house, like so many others, are covered with tea plantations.

İlker Şevketbeyoğlu inherited the mansion and estate with his brother and sister. He is a direct descendant of Şevket Bey, the 18th-century notable who gave his name to both the house and the family. İlker, a retired economist, recalls how when he was a child the orchards in the hills had so many varieties of apples and pears that the table was never without fruit from early

summer to late autumn. Some were stored in the *serander*, or granary, to be enjoyed in winter. The *serander*, built on stilts of juniper wood, was where his grandmother kept not only the cornmeal ground in the estate's mills, but also the honey they produced, along with hazelnuts, chestnuts and walnuts, pickled home-grown fruit and vegetables, as well as cheeses preserved in hides and salted anchovies.

Located in low-lying country not far from the coast, Şevket Bey's *konak* was vulnerable to attack in periods of strife and was therefore built, like neighbouring mansions, as a mini-fortress. For a short period following the Crimean War in the middle of the 19th century, the family had to abandon the property, moving south to Adana until the Russian armies retreated and they were able to return. İlker's grandfather died during these troubled times.

The massive ground floor, which serves as a barn and storeroom, is built of stone and is almost windowless. Stone steps lead up to the front door and living

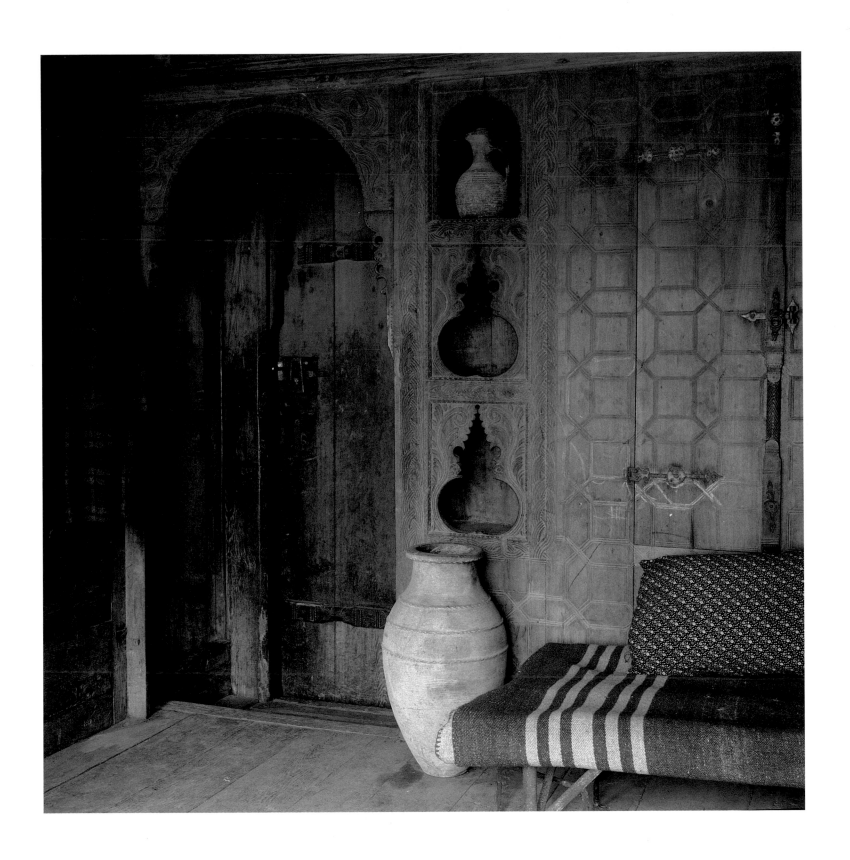

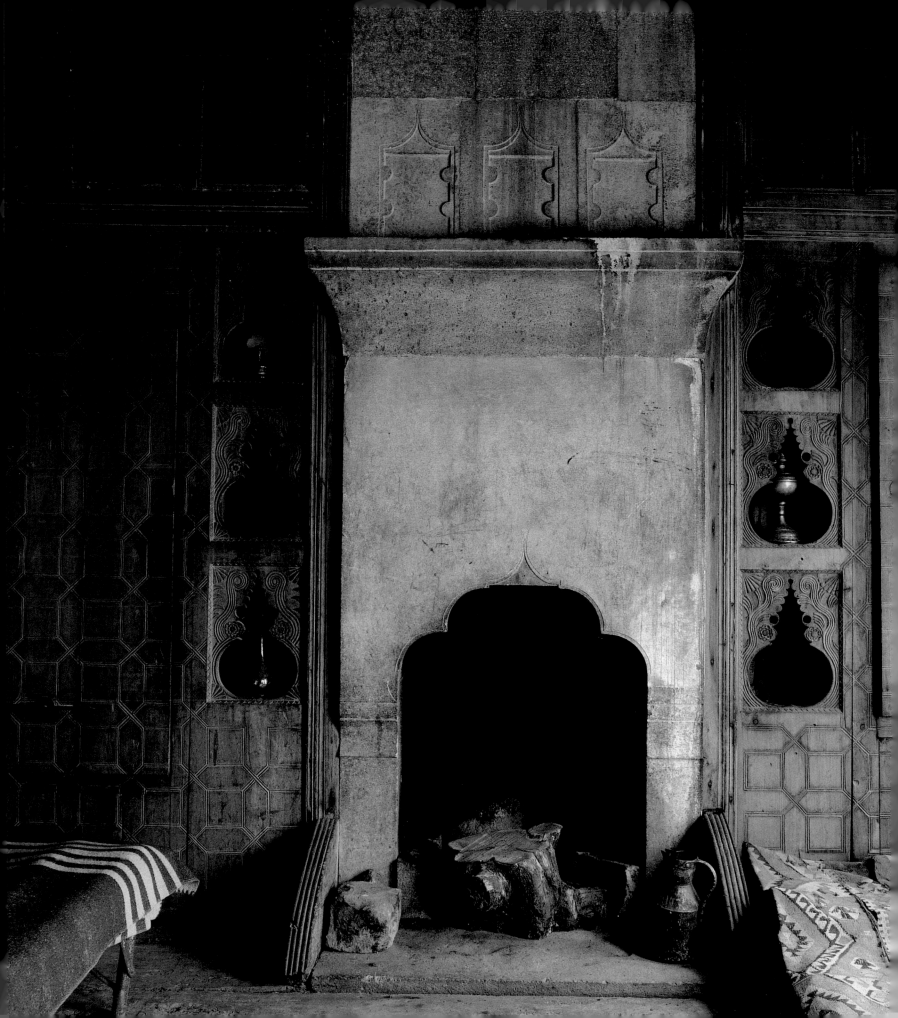

quarters. The façade above ground-floor level is solid yet attractive, using a local stonework technique called *göz dolma* ('eye-filling'), in which each square in a grid of chestnut timbers is filled with a large, smooth volcanic stone picked from the nearby riverbed.

Through an arched gate one enters a small courtyard. A separate building off to one side used to serve as a large kitchen, another as a lavatory, though neither exists today. The interior floor plan is simple: a large hall, or *sofa*, leading to rooms that are light and airy, with tall windows that look out onto the surrounding woodlands and tea gardens from the four corners of the house. The beauty of the interior lies in its panelling. From the hard-wearing beech or ash floors to the wooden ceilings, the walls are lined with simple golden panelling in pine or spruce that exhibits a perfect sense of proportion. In contrast to this plain silken beauty, the doors and the decorative niches of the fireplace surrounds are carved, chased and chiselled with motifs of delicate flowering plants. Precious walnut wood, combined with mulberry and ash, takes on the texture of brocade.

A fireplace with finely chiselled woodwork niches and a cupboard door with hexagonal patterns (left). The low platforms, or *sedir*, on either side of the fireplace provide daytime seating and night-time beds. Water used for washing is warmed in the copper ewer next to the hearth. An elaborately decorated fireplace niche (right). Here walnut wood has been carved by skilful carpenters. The rest of the shelving, used to keep valuables, such as photographs of loved ones or a verse from the Koran, is also delicately carved with very fine borders.

A fireplace stands against an outside wall in each room. 'Huge roots of oak used to burn in the fireplaces twenty-four hours a day when I was growing up,' İlker recalls. 'Every morning the fire was rekindled from the dying embers. It was better than any central heating.' On either side of the fire are raised platforms, or *sedir*, with kilims, rugs, soft matting and cushions. They create comfortable places to sit during the daytime and at night can be used for sleeping.

The Şevket Bey *konak* is one of countless mansions in this corner of the Black Sea. But many, unlike this one, were abandoned as families moved away to the cities in search of new lives. İlker's own family have moved away; however, each year they return for the tea harvest. Six or eight families, all descendants of Şevket Bey, take turns to share the property, enjoying the simple but real pleasures of their ancestors and breathing new life into the venerable house.

In Şevket Bey's *konak* finely carved and coloured Arabic verse and floral sprays adorn a sandstone mantelpiece (opposite). The man wearing a fez is a descendant of Şevket Bey. Every house on the Black Sea has a workshop, where beds, tables, stools, cupboards or ladders are manufactured and major repairs are carried out. The surrounding mountains are a rich source of timber and many members of the household are accomplished carpenters.

This handsome Shaker-like built-in cupboard is as old as the house (right). The 19th-century mural on the plastered wall depicts steamships and trains as well as flowers (below, left). Prayer beads (below, centre) and a home-made stool made without nails (below, right).

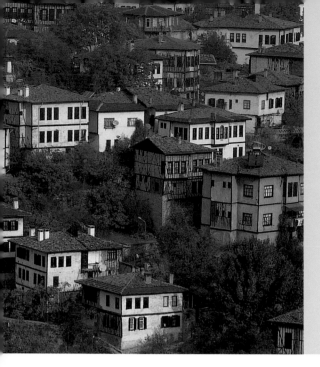

The Gökçüoğlu Konak
A traditional ottoman house in safranbolu

The proud *konaks* of Safranbolu (above, left). All the 19th-century houses have been under a preservation order since the town became a Unesco World Heritage site in 1994. Intricate window decoration (above, right), including latticework and hand-turned railings, all made from wood without the use of metal nails. The ceiling decoration of the bride's room (below, right), stained with a saffron-dye to give it a warm golden glow. The woodwork technique is called *hazerpare* (thousand pieces) – the pieces are interlocked to create radiating medallions.

A corner in the Blue Room (opposite). It has a wood-burning fireplace, *sedirs*, a narrow closet for bathing concealed behind the panelling, niches and cupboards with endless storage space, including a long narrow built-in cabinet for *chibuks*, the traditional smoking pipes. Each room is a self-contained apartment.

The old Ottoman town of Safranbolu once thrived on trades such as tanning and metalwork, but it was from the precious saffron crocus that it took its name. Wealthy burgers lived in large mansions or *konaks*. They had one for winter and another, up in the breezy vineyards, for summer.

One of the finest of the vineyard *konaks* was built for the Gökçüoğlus in 1896. The present owners, Özlem Urgancıoğlu and her parents, come in the summer to welcome guests.

When Özlem's family bought the *konak* in 1998, it had been uninhabited for years. Initially they wanted to create a museum. Özlem grew up in Safranbolu and her family, like many old families here, already had two mansions. 'But so many houses were being abandoned, because their owners were moving away to Ankara or Istanbul, or preferred to live in modern flats,' she explains. 'This *konak* had always been a jewel. We couldn't bear to see it become a ruin.' It took two years to restore.

With its limewashed façade, elegant timber structure and overhanging eaves, the house is impressive. On the top floor, the four corner rooms are like jetties supported on wooden consoles. A covered, cobbled

courtyard, or *hayat*, would have been open to the garden on two sides through a trellis screen. Today, the screen has been glazed and the cobbles replaced by flagging, and the courtyard is used as a dining room for guests.

The upper floors, built of timber and mud brick, rest comfortably on the stone ground floor. Soft wood such as pine and fir is used generously, beech and walnut more sparingly and for interior finishes only.

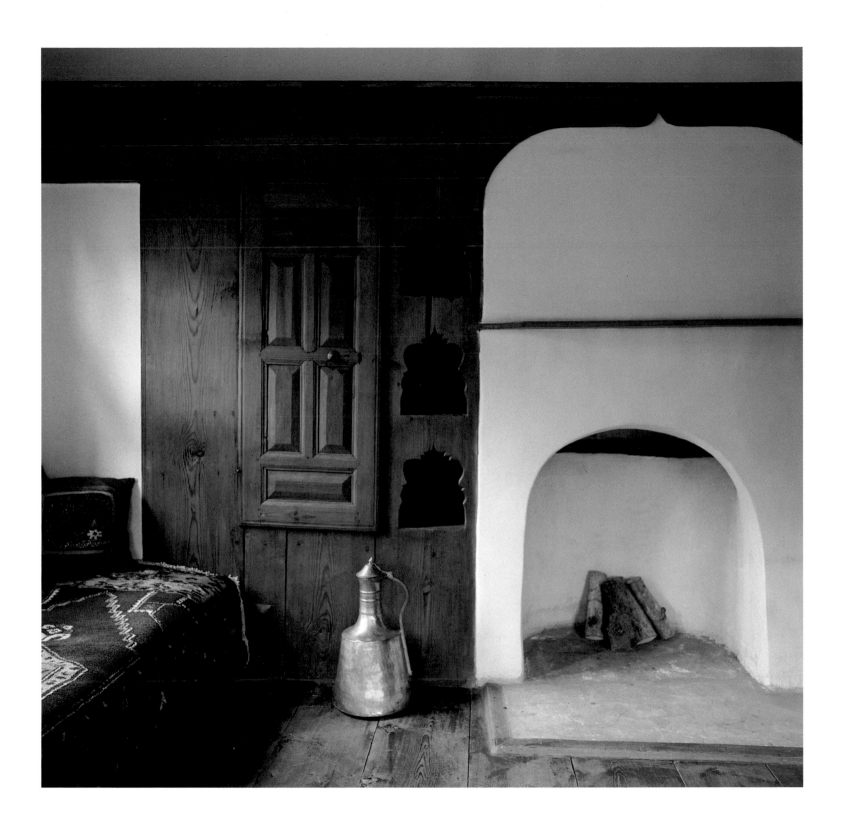

Fine hand-crocheted lace with rococo motifs of garlands (below, left). This beautifully intricate lacework is still made by the women of Safranbolu. A silver-plated bookstand with a Koran (below, centre). The most prestigious room in the house, the *başoda* or master room (below, right), where guests were offered coffee or sherbet. The crisply starched cotton covers of the *sedir* backrests and blinds create a harmonious whole.

In one of the guest rooms, the old fireplace flanked by small niches has been transformed into a decorative alcove (opposite).

The timber comes from the Black Sea Mountains to the north. Weathered wooden stairs take one to the first floor *sofa*, or hall, one side of which leads to an open balcony overlooking the courtyard. This was where the women of the house and neighbours congregated to prepare pasta for winter, as well as for henna parties, weddings and social gatherings.

These houses were designed for large households. Each of the many rooms is a perfect square, organized to provide self-contained comfort and privacy. Most have a fireplace. A deep *sedir* runs below the large windows, offering plenty of sitting and working space. Panelled walls conceal huge fitted cupboards where mattresses were stored during the day and rolled out as bedding at night. One cupboard was a closet large enough to step into for a quick wash. Another held basic cooking facilities. Food for the family was generally cooked in the kitchen next to the house.

The top floor of the *konak* has an oval-shaped hall with a splendid inlaid wooden ceiling. As always, there is a jetty-like room in each of the four corners. With even wider vistas, these are the best rooms in the house. The *başoda* or master room was where the most important guests were welcomed. The bride's room is also on this floor. Each newly wed couple would reside in it until the next new bride came along. It has perhaps the best ceiling in all Safranbolu: a sunburst medallion of interlocking, inlaid strips of different woods stained with saffron.

Özlem had to keep the décor of the rooms simple to avoid upsetting the house's architectural character. The bathing closets became showers. The fireplaces are no longer in use, but everything else, above all the original *sedirs*, has been preserved. The lace on the *sedir* covers and blinds is all crocheted by the leisured women of Safranbolu.

There is a kitchen garden, and the family still prepare jams, pickles, tomato paste and *pekmez* – grape and mulberry molasses – for winter. Every summer Özlem comes to the vineyards of Safranbolu with her family. They live in a house in the garden of the *konak*. She remembers playing barefoot in the garden as a child and swimming in her grandparents' indoor pool – another unusual local feature. Safranbolu is no longer the old town she grew up in, but she tries to keep its memory alive.

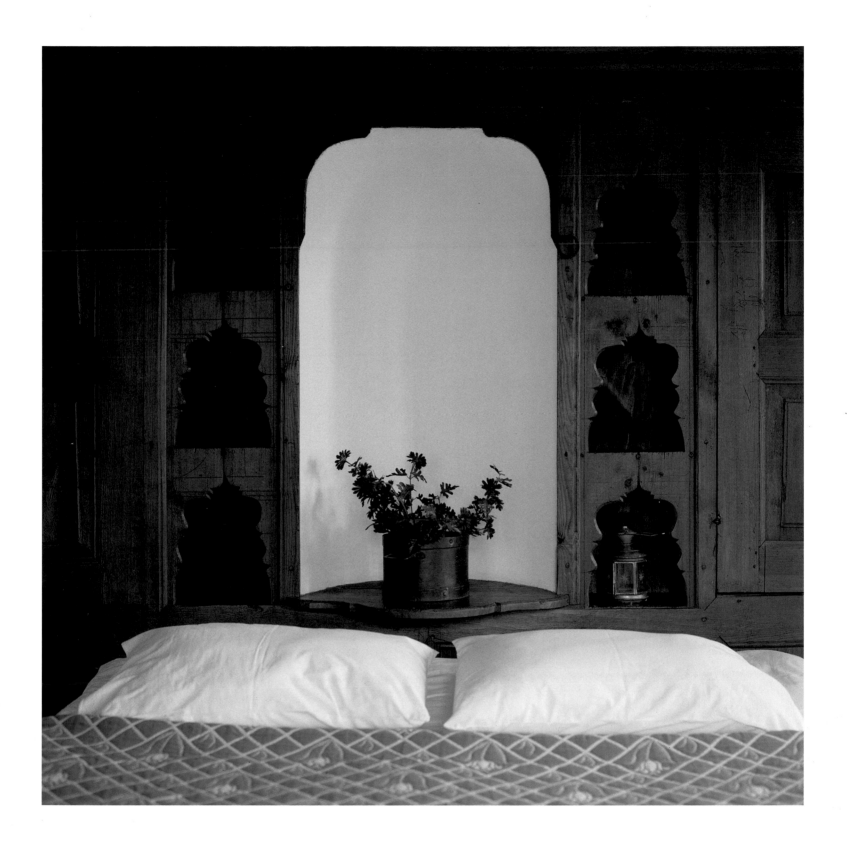

Mustafa and Caroline Koç
A sophisticated chalet in the BOLU MOUNTAINS

The shingle roof of the chalet drying in the sun after a shower (above, left). The west-facing deck of the chalet (left) enjoys not only spectacular sunsets, but also an unlimited view of the sky and rolling clouds. It makes the perfect outdoor living area on fine days, and is where Mustafa and Caroline Koç entertain their family and friends. A side entrance to the chalet, the easy elegance of which is derived from the warm tones of the timber and the plain lines of the construction (below, left).

In the front hall (opposite), Mustafa's collection of canes, tidily displayed on the white walls above a row of wellington boots. A kilim from Konya with a bold lozenge pattern adds a splash of colour to the otherwise unadorned entrance hall of smooth honey-coloured timber.

On the sloping skirts of the Bolu Mountains between Istanbul and Ankara is a chalet built in 2002 by the architect Esen Talu for the young industrialist Mustafa Koç and his family. It is situated on a hilltop, like an eagle's nest, 1,000 metres above sea level, facing other forested hill tops, with a valley below. This sleek, one-storey chalet, with clean, modernist lines, is built of timbers bolted together.

Cedar is used extensively for the interior finishes and exterior walls, as well as the shingles covering the roof. Esen says the design was inspired entirely by the local vernacular, and the main concern when planning it was to integrate it both with the small neighbouring village of Gövem, a hamlet of about 80, mainly wooden, houses, and the natural environment. The end result, Anatolia with a hint of Aspen, is in perfect harmony with the landscape.

Here Mustafa and Caroline and their two daughters, Esra and Aylin, come in the winter from Istanbul to enjoy the views and fresh air, and above all the snow. Whereas in cities such as Istanbul and Ankara the snow comes and goes, here, because of the altitude, the area is virtually snow-covered from late autumn till early spring.

'We try to come as much as possible at the weekends and during the short holidays,' says Caroline. Judging by the outdoor hot bath, the snowmobiles, sledges, skis, even the langlauf raquettes hanging next to the coats in the hall, it's not only the children who dream all the time of coming back.

'The girls do a lot of sledging in the garden,' says Caroline, 'but if there is enough snow we take the snowmobile and go all the way to the top of the mountain, to the *yayla* as we call it, and have picnics

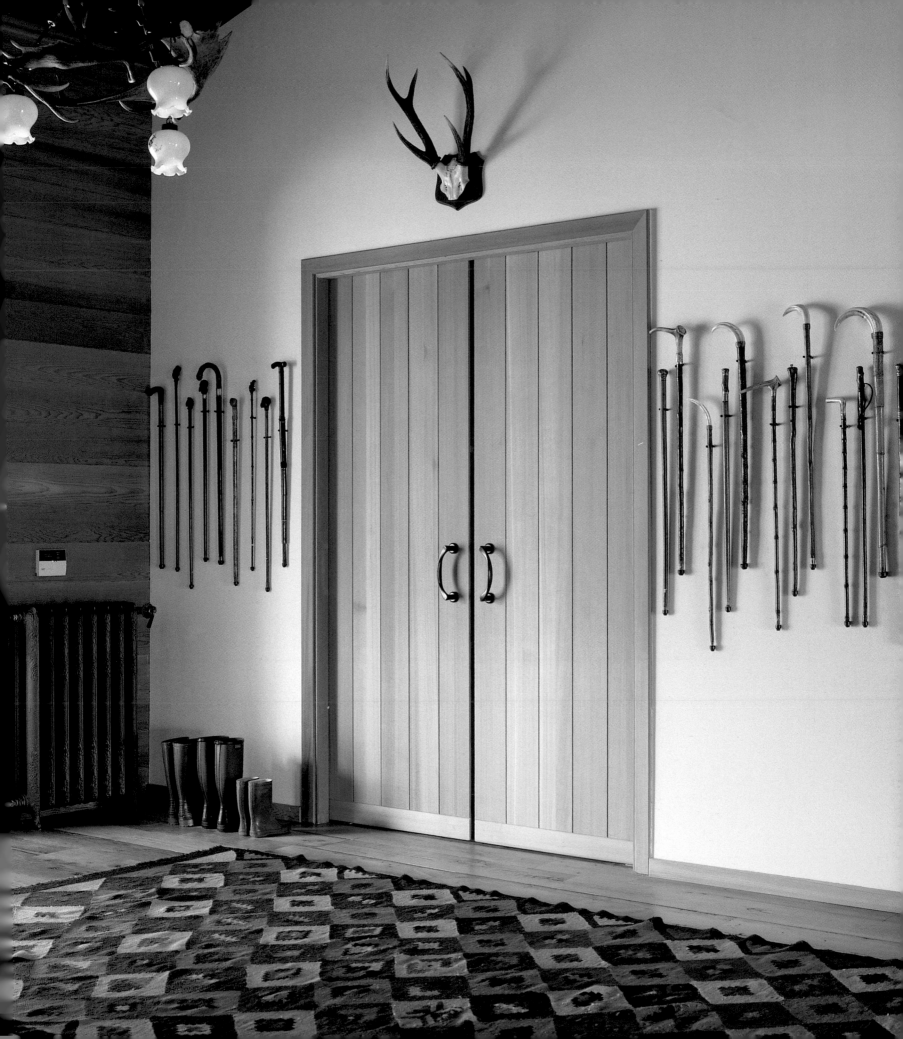

A large 18th-century wooden bell found by Caroline in an antiques shop in Bali (right). The small family of iron reindeer were bought on a visit to New York. A naturally lit corridor (below), reached from the front door on the right, and opening onto the open-plan living room on the left, runs the length of the house, from the guest bedrooms at one end to the utility rooms at the other. Huge black lampshades by Santa & Cole accentuate the modern, minimal lines of the architecture. Through the door at the far end the silhouette of the traditional bread oven is visible. It was reclaimed from the village and rebuilt in the garden, where the chef bakes fresh loaves for alfresco lunches.

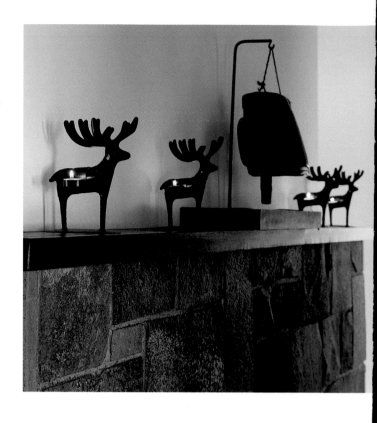

on the high plateaus.' In spring, when the snow around them melts away, they pile aboard their all-terrain vehicle.

The open-plan interior, like the exterior of the chalet, is stylishly chic – simple and eminently practical. It is built on two levels, dictated by the natural slope of the site. The hardwood flooring is of broad honey-coloured planks of reclaimed timber, with old blemishes like traces of nail holes and cracks adding character.

The entrance area leads down a few steps to the main living area, where there is a huge fireplace and sizeable soft sofas, all covered with warm woollen tweeds or flannels and many cushions. To balance the reflected light from the whiteness outside, the colours indoors are kept to a subtly dark palette. Two Andy Warhol prints over the mantelpiece, of

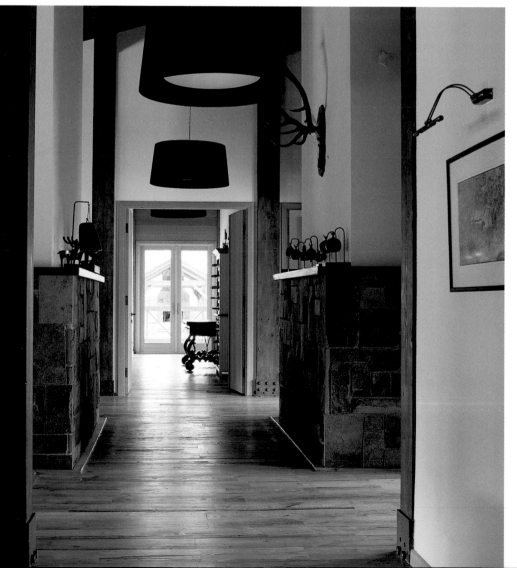

a zebra and of a ram, add splashes of bright colour. Koç means ram in Turkish, and the family emblem is the horns of a ram – so it is not perhaps a coincidence that horns and antlers of every size and shape adorn the walls, including an impressive chandelier made of shed antlers that crowns the living room. A couple of leather armchairs and the leitmotif of checked fabrics give the interior a clubbish flair.

The living area connects to the dining room, which has a raised open kitchen area behind the dining table. A spacious deck with dizzying views extends the whole length of the building. Numerous deckchairs and tables, including an ice bucket carved from a piece of wood and part of the balustrade for champagne, indicate that this spectacular deck facing west is an outdoor living area, where Mustafa and Caroline entertain their brothers and sisters and other family members and close friends, 'when the weather permits, of course,' says Caroline.

Both Caroline and Mustafa are keen skiers, sailors and riders. They don't keep horses here, but they do have a family of three pet deer in a spacious pen in the garden – purchased from a zoo on the Black Sea. The three guest bedrooms and guest children's bedrooms, all plainly but tastefully furnished, show that the house is enjoyed to the full. Wicker baskets, carefully labelled to show their contents – children's gloves, spare hats and wellington boots of every possible size – are lined up next to the front door. Animal photographs taken by Mustafa in Africa, a picture of a mother and baby elephant in the children's playroom and enormous exotic insects such as the alarming *Acrophylla titan* from New Guinea in one of the bathrooms all indicate that life in the chalet is organized around a sociable family of energetic, animal-loving youngsters. A fun-filled outdoor life.

Caroline runs a successful home-textiles business ('mainly towels and sheets') with the brand name of Haremlique which explains her welcoming touches: the cosily quilted bedspreads or the lavender sachets on the guest beds. She is also the chairman of the influential Family Health and Planning Association, a leading charity in Turkey. 'But we are very careful never to allow business to cross the threshold of the chalet,' adds Caroline with a smile. 'I love the fact that we are very isolated here and therefore it is very relaxing and quiet. It is definitely my second home.'

A corner of the living room (below, left). Drawings of the falcons, buzzards and eagles that live in these mountains and leather wing chairs create a clubbish comfort. The photographs of Africa by Horst Klemm grouped together above a scroll-ended chair with Colefax and Fowler checks in the hallway (below, right).

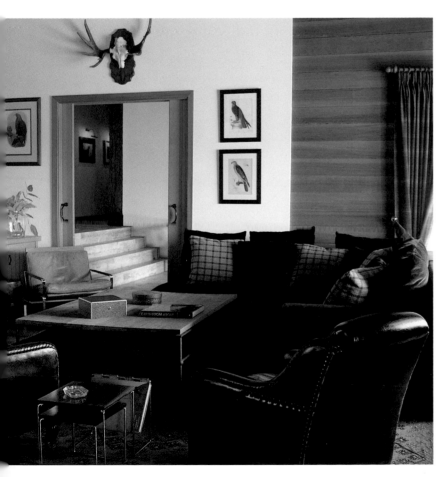

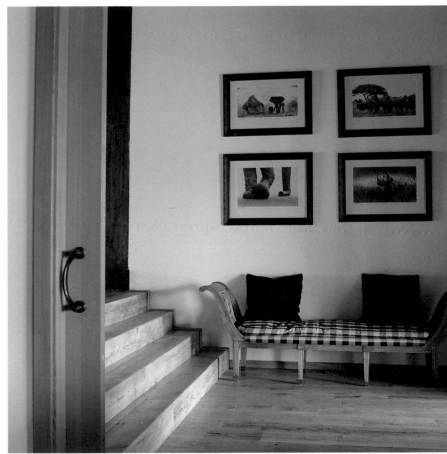

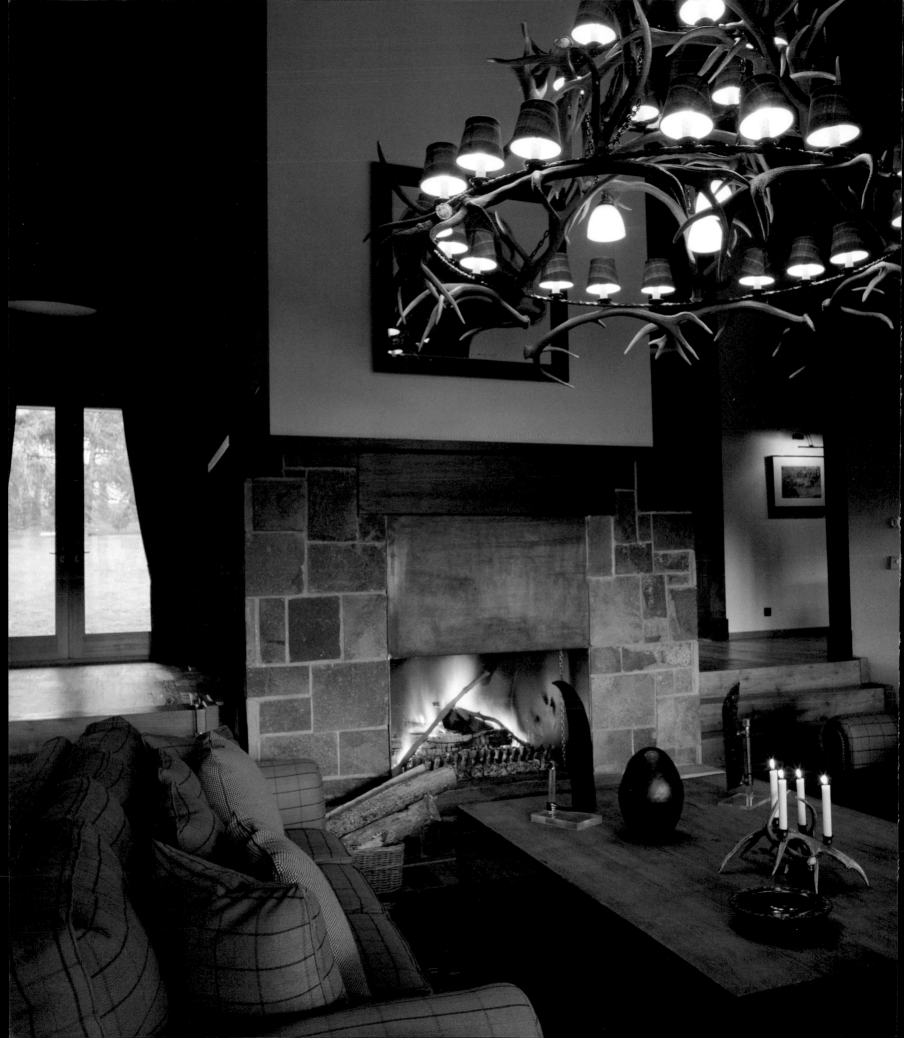

A roaring log fire in the living room (left). The solid timber steps on either side leading up to the central corridor, which is hung with photographs, mainly of Africa, by Peter Beard, Horst Klemm and Mustafa Koç, all chosen and framed by Caroline. The sofas, with their many cushions, are covered with warm materials such as woollen tweeds and flannels. The chandelier of shed antlers has checked lampshades. The table laid for dinner in the dining room (below, right). The evening light pours in from the terrace on the left. The open-plan kitchen (right) is on a raised platform. An Aga in the far corner provides warmth and is used for all the cooking. The kitchen cupboards with distressed paint and gleaming vintage copper utensils all add to the atmosphere.

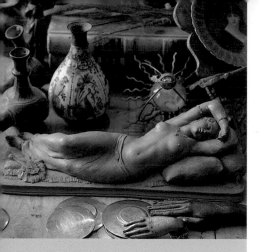

Hakan Ezer
A sumptuous apartment in Teşvikiye

The objets d'art on the low table in Hakan Ezer's drawing room (top). The French creamware odalisque dates from the first half of the 20th century. The cushion cover (above) is a fragment from an old cover used to adorn the bride's horse during ceremonial wedding processions. The drawing room (right) has an Edwardian feel. A 1990s painting by the Turkish artist Canan Tolon hangs next to a turbaned Ottoman figure used as a target board by Austrian soldiers and dated 1809. The Belgian bronze lantern is dated 1880. The 18th-century Ottoman calligrapher's cabinet (on the table) is inlaid with tortoiseshell and mother-of-pearl and was made in Istanbul.

Hakan Ezer, a dynamic young interior designer, lives in Teşvikiye, a district of Istanbul where Armani, Gucci and Max Mara rub shoulders with fashionable cafés, expensive hairdressers, antiques shops and art galleries. Until the 1850s the area was idyllic hills and meadows where archery tournaments, in which the Sultan himself took part, were held. When Sultan Abdülmecit, a contemporary of the young Queen Victoria, built his new palace and the delightful Linden Tree Pavilion on the Bosphorus at Dolmabahçe, he longed for a modern European town to spring up. Development was allowed on the meadows and people were encouraged to move to the new district, which was given the name Teşvikiye, which literally means 'encouragement'. Foreign architects were fashionable and the tall apartment blocks that soon lined the boulevards were every bit as exuberant and elegant as those that were going up at the time in Vienna, Paris, Barcelona and London.

Hakan lives with his cats and dog in a gorgeous apartment block near the Teşvikiye Mosque, in a flat entirely in tune with the architecture of the exterior. It has the unmistakable feel of an Edwardian studio. An eclectic collection of much-loved objects acquired around the globe is arranged with élan: tall Russian Empire armchairs, a swaggering Belgian bronze lantern recalling a Timurid helmet, a painted Ottoman niche panel, a pair of gilded wooden statues of Venetian saints and, of course, Persian carpets. The paint on the walls is a colour he mixed himself: he calls it 'tree bark'. A rich, deep shade, too subtle to be maroon, it is the perfect backdrop for his treasures.

After studying interior and furniture design, Hakan went to London to learn the art of goldsmithing and in the early 1990s he started a career as a jewelry designer. Later he returned to the realm of interiors. He was brought up in a 1960s-style home: his father was an architect with minimalist northern European

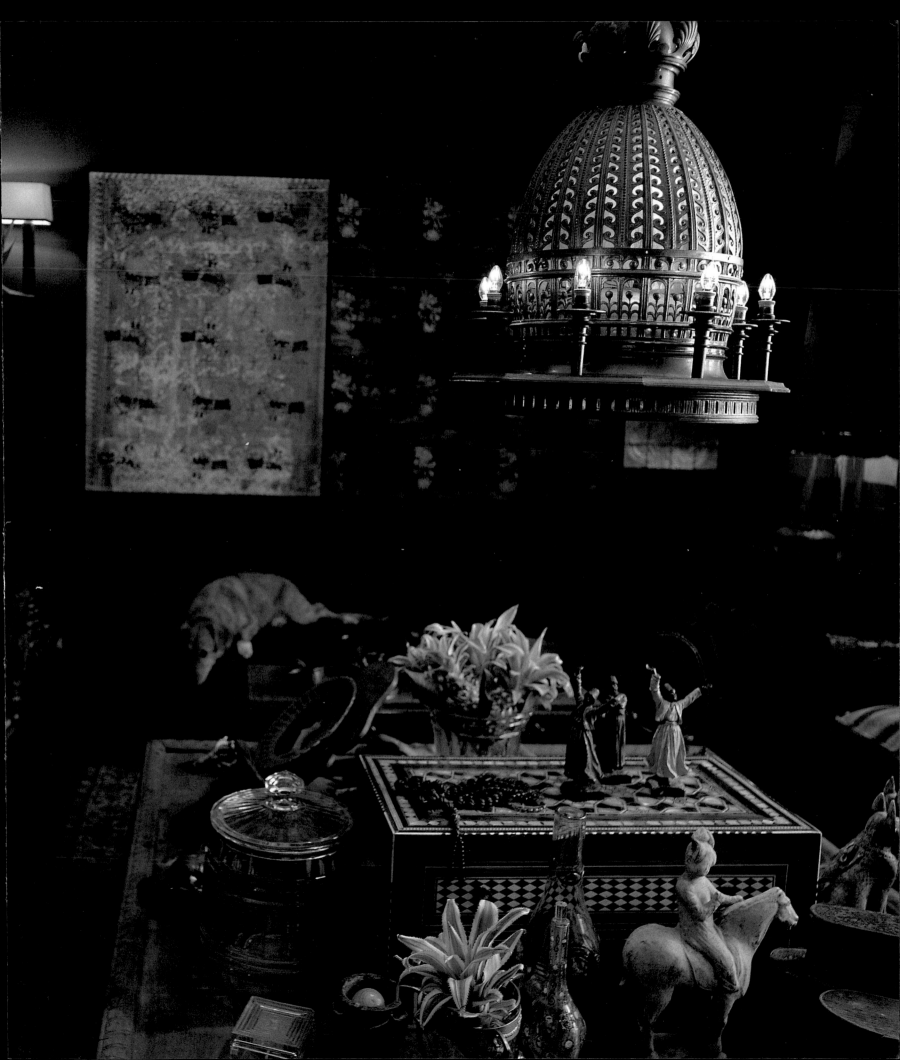

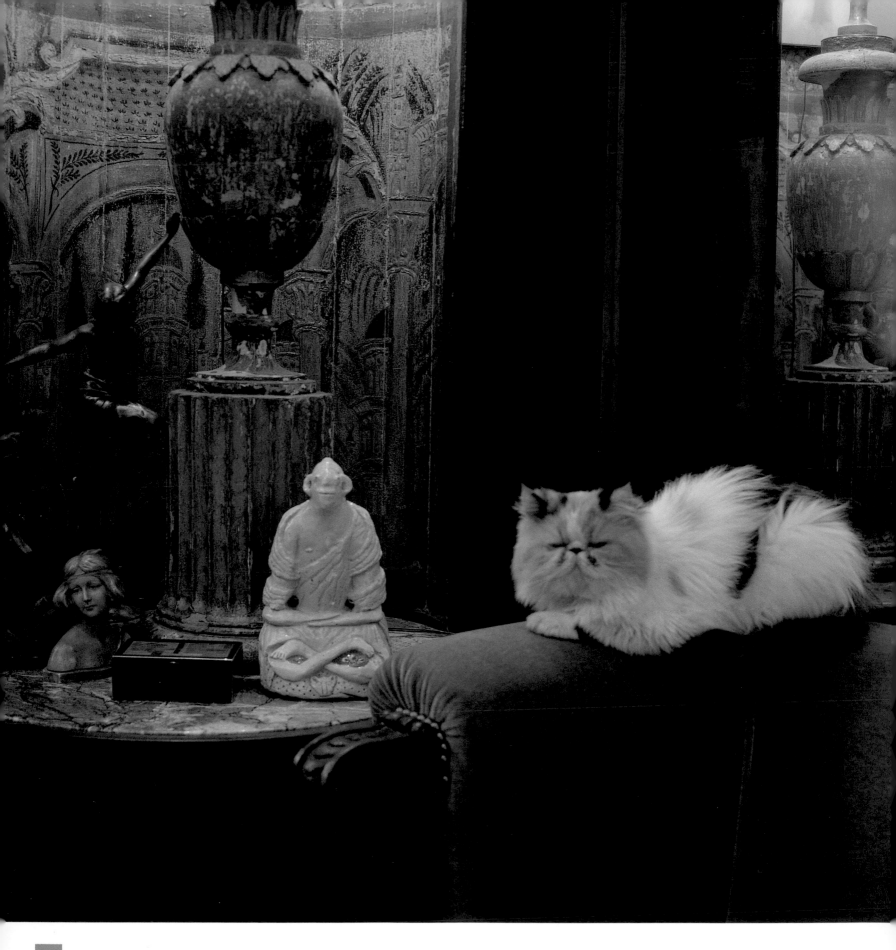

tastes. Hakan, by contrast, loves to create theatrical effects by using large pieces of dark furniture as a foil for finer objects, playing with sources of light to emphasize different layers within the same space and conjuring infinite perspectives with mirrors.

He is inspired by people with a flair for complexity – he is relieved, he says, that even the French design gurus Christian Liaigre and Philippe Starck are now 'less edgy'. Whenever he is in Copenhagen, Hakan visits the boutique of the flamboyant horticultural artist and sculptor Tage Andersen, but he also finds inspiration closer to home. He remembers being struck by the contrast of the severe stonemasonry with the elaborately carved wooden doors of his grandparents' courtyard house in Antakya when he saw it for the first time in his teens. And he recalls the marvellous studio of a couple, both artists, who were cousins of his mother's: 'It was full to the brim with their work and objects – shards, kilim fragments, broken tiles, bits of skeleton, driftwood and pebbles they had picked up in Anatolia.'

For years Hakan has been loyal to his own style, which he calls 'contemporary baroque'. It may seem extravagant, but he has strict principles. He favours custom-made rather than imported furniture,

commissioning local craftsmen and artisans, helping to revive old arts and crafts, using natural materials that are recyclable. Above all, he avoids if at all possible designing commercial interiors. 'Because,' he says, 'they are redesigned frequently with each passing vogue or when they change hands, which I find wasteful as well as environmentally polluting.' He is an idealist and an artist, but he is also a craftsman himself, able to turn his hand to carpentry, goldsmithing, ironwork, painting or sculpture. 'To achieve the results you wish, you have to experiment yourself and be able to demonstrate what you are after,' he adds.

Hakan's cat Tesbih, or Worrybead, sits next to 'African Buddha' by the artist Hylton Nel (opposite).

A dark, potentially gloomy corridor in the apartment was transformed using clever paintwork and ceiling lighting into an airy gallery for paintings and more treasured objets (above). A fine pair of ladies' riding boots from the 1900s, bought in Cambridge, have found a new home in the hall (left).

The scrolling Art Nouveau pattern of a hand-embroidered textile
fragment, arranged by Hakan with matching materials to create an
impressive bedhead (above). The large canvas *The Man and his Dog*
in the dining room (opposite) is by the flamboyant Turkish painter
Mehmet Güleryüz. The latticework over the windows is from the
Far East, but has been installed in such a way that it resembles the
screens of old houses in the Levant.

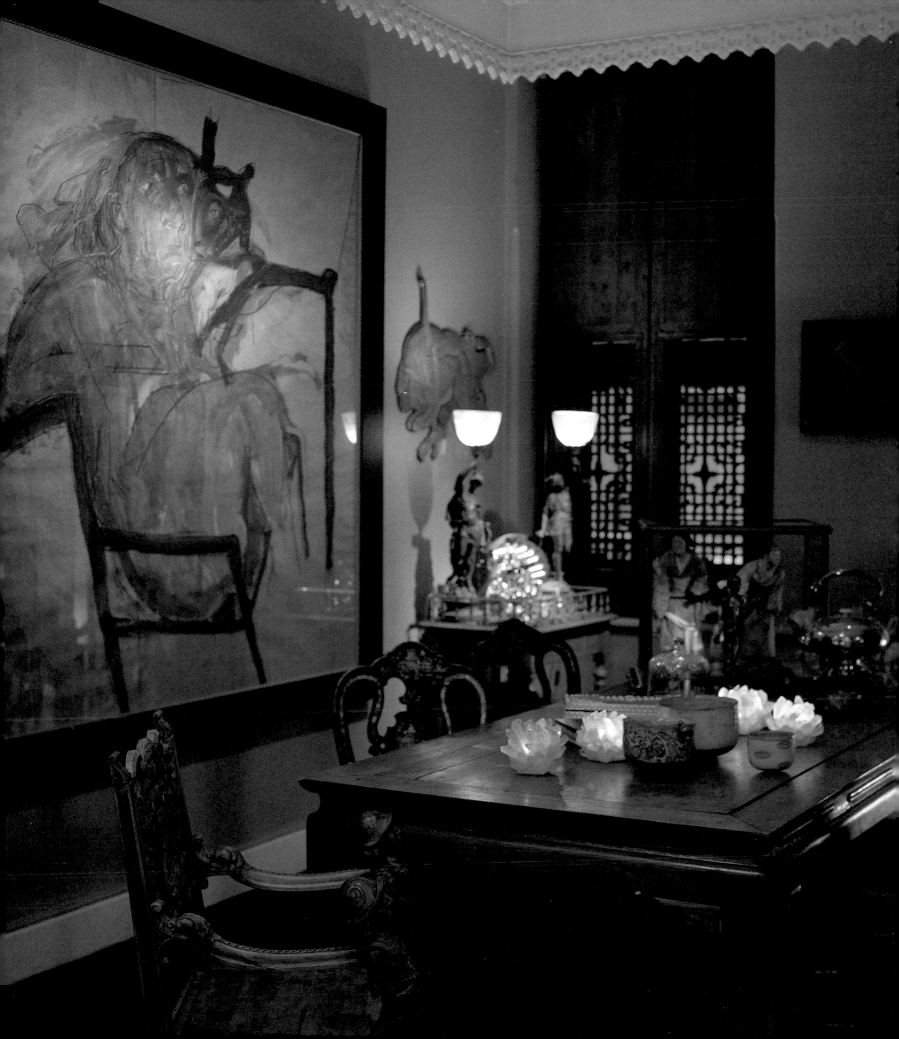

winter

High above the Black Sea, self-sufficient log houses sit against the mountain slopes, safe from the floods and storms of the lower valleys, dormant for long months under a blanket of snow.

During the day, snow-clad peaks dominate the landscape and the slopes come alive with a rainbow of young skiers. But at night, whether in a modest log cabin or an elegant ski resort, the focus is always on crackling fires.

Meanwhile, in the cities the scent of roasting chestnuts lingers in the streets and traffic grinds to a standstill. Everyone complains, but no one really minds. As the nights draw in and the weather grows ever more temperamental, icy winds sweep down from the north, bringing fierce blizzards, often followed by a grey, wet drizzle which will melt the settling snow, disappointing all the children.

Winter months are the time for creativity — new exhibitions, fresh shows, memorable concerts. It is a time for studying, reading and contemplation, when the inner world comes to life. New projects are dreamt up in every walk of life, new vineyards are plotted, new business ventures are schemed, new horizons are sought. Music is composed, furniture designed, fashion styled, and, far from the madding crowd, the new prize-winning novel is written.

Kemal Torun

A RUSTIC WOODEN chalet
in veliköy, şavşat

Şavşat is a gently rolling plateau in northeast Turkey, high above the towns of Ardahan and Artvin, some 100 miles from the Georgian border. Woods of beech and oak, fir, pine and spruce line the hillsides. In contrast to the wealthy landowners of the lower Black Sea valleys, who built grand *konaks*, the people of Şavşat constructed humble log houses. They are well-built, functional and pleasing.

Kemal Torun, a retired teacher, was born in one of these log houses. In the old days, he explains, newlyweds would build their own. His father built his with help from his brother, and in turn lent his brother a hand in constructing his house. 'Elderly members of the family only move when they become unable to look after themselves, choosing the most prosperous child so as to be the least burden,' says Kemal, 'though of course the other children always help out.'

The village of Veliköy has about 150 log houses built according to the traditional floor plan, with a large central hall and a room in each corner. The usual stonemasonry of Black Sea mansions is replaced with solid trunks of pine from the surrounding forest. The logs are left whole, the bark is stripped off and they are stacked to form a barn-like ground floor with separate stables for cattle and sheep. Next to it is a spacious winter room with a huge hearth, which provides warmth and light on winter nights.

Everything is crafted from timber without the use of metal nails. External wooden stairs lead up to the balcony on the first floor. The walls are built of broad pine planks. Solid timber columns support the joists and roof beams. In older houses even the roof tiles

The foothills of the Black Sea Mountains (above), where the log houses are snow-covered for months in winter. The *köşk*, or loggia, in the Şavşat house (right and opposite). Every house has a *köşk* perched where the view is best. A pair of ewers from Artvin stand on the balustrade at the far end of the balcony. In the old days, when unmarried girls went to fetch water, their village could be identified from the shape of their ewers. At night solid shutters lock out the storms and blizzards.

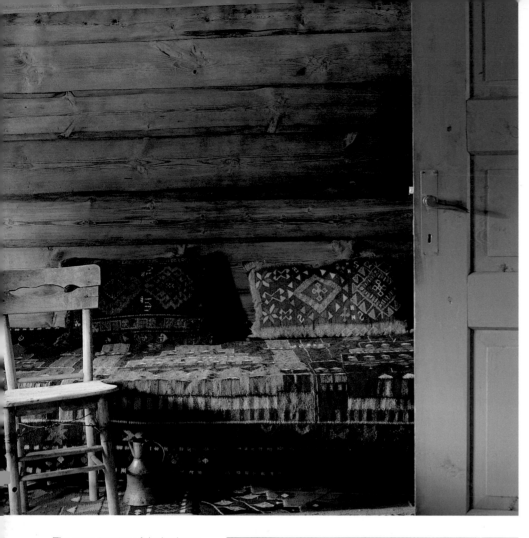

The warm interior of the log house. The honey-hued fir of the walls contrasts with the indigo paint of the doors and shutters (above). Shoes are removed and left on the doorstep before the house is entered (right).

The wood-burning stove (opposite) is used to bake bread, cook food and heat water, as well as warm the house. Printed cotton cushions and a checked cloth make delightfully simple furnishings for the seating area.

were wooden, sliced from fir in wedges three fingers thick and weighted down with flat stones against the frequent storms. Kemal's house has a corrugated iron roof, the favoured material since the 1920s. Heavily overhanging eaves give maximum shelter from the almost constant rain.

Inevitably, families are moving away from the remote valley and the old way of life is vanishing as a result. But Kemal continues to life there with his family, in his home hidden high in the forest, 1,450 metres above sea level.

He looks back with a certain nostalgia on the customs of his youth. When he was a child, he recalls, he used to walk over two miles to school every morning. In winter, the snow was knee-deep for several months. Every spring the family would move 500 metres higher up the mountain to graze their animals on richer pastures. As the snows melted on the higher plateaux, so they climbed higher still to the summer pastures. There they made cheese, butter and yoghurt, dried pulses and corn, and prepared all the winter staples. No one in the village worked for money: they all helped each other. In autumn the family would pick the fruit from their orchards and take it down to Ardahan, exchanging it for wheat, which was needed for the bread baked by Kemal's mother.

The balcony that runs round three sides of the house serves as a living room in warmer months. Here family and friends gather, runners are woven, garments are knitted, food is prepared and meals are eaten. The best view is always from the köşk built out from the balcony. In the simplest log houses, the köşk's carved balustrade is the only embellishment on the entire structure. Inside the köşk, a raised platform lined with cushions and pillows can comfortably seat two people leaning against the balustrade. The köşk is secluded but still part of the rest of the balcony, somewhere to sit and watch the sun set over the snow-capped mountains.

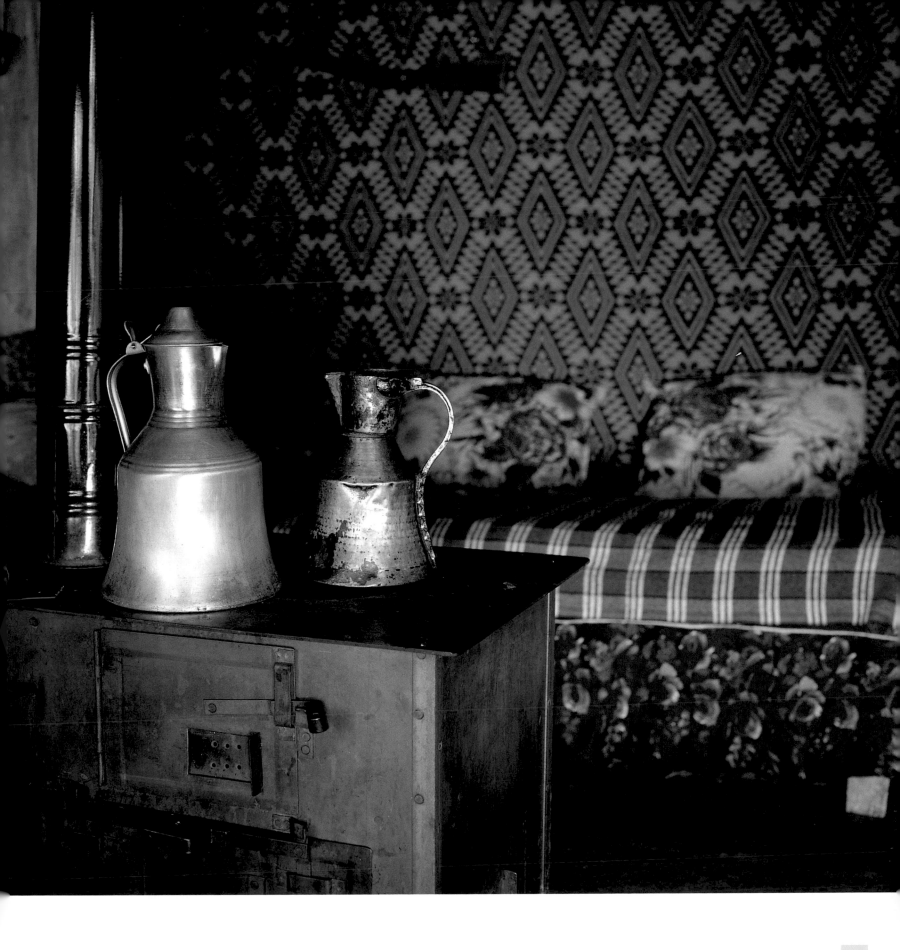

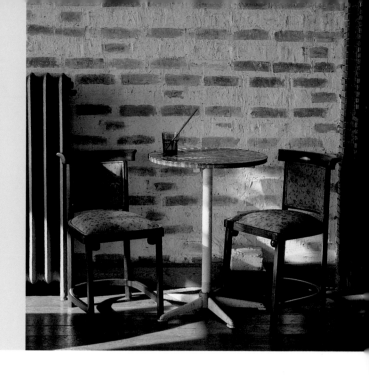

Rıfat Edin
A bohemian apartment
in ortaköy
on the bosphorus

The view from the balcony (above, left) is of the 19th-century Ortaköy mosque which, like Rıfat Edin's apartment block, was built by the Balyan family. Every week as the Sultan arrived by sea for the Friday service, the imperial band would strike up with marches composed and conducted by Donizetti Pasha, brother of the famous opera composer Gaetano Donizetti. The elegant dining chairs look like doll's furniture next to a tall table and an industrial radiator (above, right). The sort of decanter that every household would have had before fridges became commonplace (right).

The vaulting structure (opposite) is like the hull of a boat. This studio-cum-salon is where Rıfat paints, plays the piano and entertains. It leads onto a balcony with spectacular Bosphorus views.

Rıfat Edin, now in his fifties, and his three siblings were born in a villa built by his grandfather in the 1940s in Erenköy, a leafy suburb by the Sea of Marmara on the Asian side of Istanbul. He played cowboys and Indians with his brothers and sisters and the children of the neighbourhood. 'We were the Red Indians of course, with our hide-out in an abandoned old water cistern.' This was the happiest period of his life.

His hide-out today is the neo-classical Simon Kalfa Apartments on the European side of the Bosphorus in Ortaköy, built at the end of the 19th century for the Balyan family, the dynasty of imperial architects and contractors. What he loves about this six-storey apartment block, which now belongs to his family, is its decaying grandeur. 'Think of the lives spent in these rooms! I am always drawn to things with a past. They are like relics. Objects gain a patina of life. The Balyans,' he continues, 'used the leftover materials given to them by the Sultan after they finished building Beylerbeyi Palace on the opposite shore and the Çırağan Palace next door.' The building, its façade stripped of years of accumulated paint, is now a Habsburg yellow.

The ground floor and basement are occupied by a smart café chain very much in tune with the faded grandeur of the building. Each of the upper floors has two flats with the classic floor plan: rooms with tall, handsome oak-framed windows and stunning views over the Bosphorus radiating off a central hall. The attic, once reserved for servants, with a terrace to dry the laundry, is today Rıfat's favourite place. Here he has stripped the paint and the plaster, exposing the

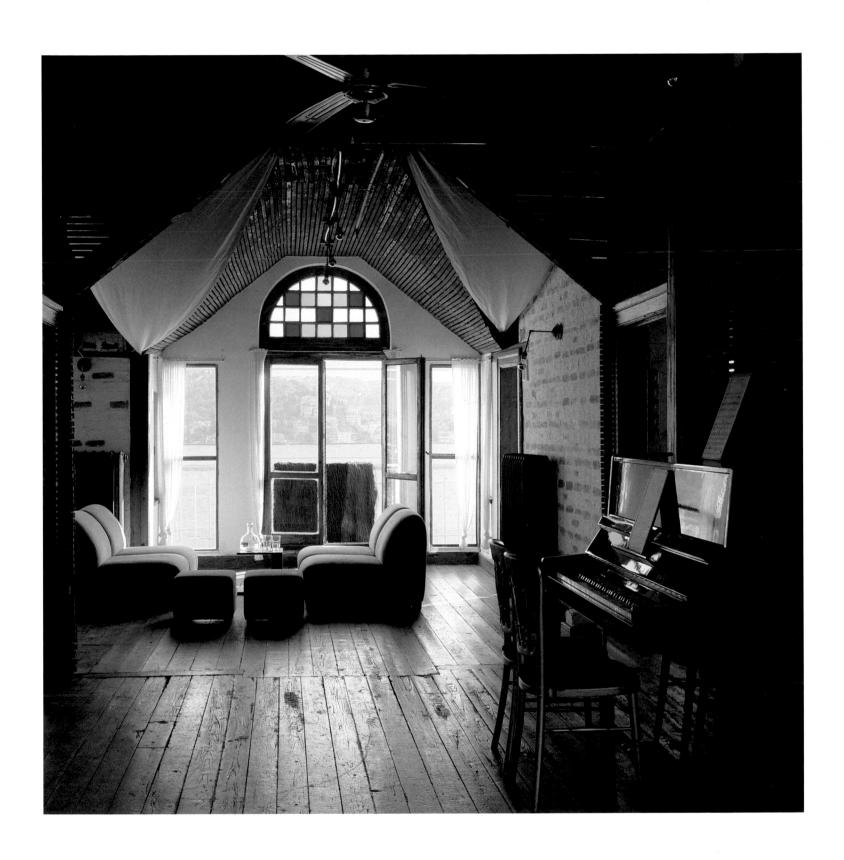

laths of the old structure. He has also removed the partition walls that divided up the servants' quarters so as to create an open space, his studio-cum-salon, where he practises the piano, paints occasionally and gives parties. The bare beams of the ceiling are like a ship's hull and inspired him in his passion for boats: he builds and races exquisite replicas of wooden dinghies dating from before the First World War. The bedrooms are downstairs and have threadbare furniture and salvaged objects found in the neighbourhood. The old kitchens still have the hooded chimneys that were used with wood-burning stoves; Rıfat is trying to convert them into bathrooms with log-burning fireplaces. 'I am stimulated by the architecture,' he says with a mischievous smile.

Rıfat might approach things playfully, and he might take a childlike pleasure in them, but he is an idealist with quite remarkable achievements. It is in large part thanks to him that the village of Ortaköy was kept out of the hands of developers intent on high-rise blocks and shopping centres. The Balyans' apartments

at one end of the pretty waterside square are mirrored at the other end by the small wooden house where Rıfat first lived – he converted it some years ago into Sedir, a hip café. The entire quarter, with its magnificent baroque mosque, is now under a preservation order, and the old narrow lanes, mostly of two- or three-storey buildings still owned by residents of modest means, have been saved and are full of life. Café tables also line the square, and between the handsome marble fountain and the boat station are benches shaded by plane trees.

His passion for the sea and all that floats on it is shaping Rıfat's other big project. He collects traditional boats of all kinds, which he keeps on the shores of the Marmara. Among them are the traditional wooden boats with curving bows and prows known as *kancabaş*, or 'hook-heads' – very much part of the Bosphorus seascape in old photographs. Rıfat collected three of the last remaining examples and plans to commission reproductions of these historic vessels to fulfil a dream: a race on the Golden Horn between the *kancabaş* of Istanbul and the gondolas of Venice, a revival of the races that took place in Ottoman times, three centuries ago.

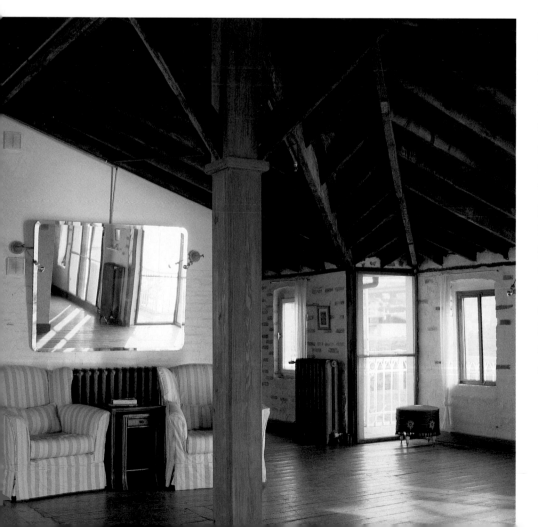

A sepia photograph from the 1920s of a gathering of gentlemen in formal dress (opposite, above). It was left behind in a taxi and given to Rıfat by the driver. When the plasterboard of the ceiling was removed, these handsome beams and the whole wooden structure supporting the roof were revealed (opposite, below).

The attic (right), like a captain's bridge, is where Rıfat practises the piano, cooled on summer days by a colonial fan. 'I feel as if I am at sea, which is where I feel most peaceful and healthy,' he says. All the partitions were removed in the attic, which has stripped walls, to create a spacious loft (below, right). Here a door frame has been left free-standing.

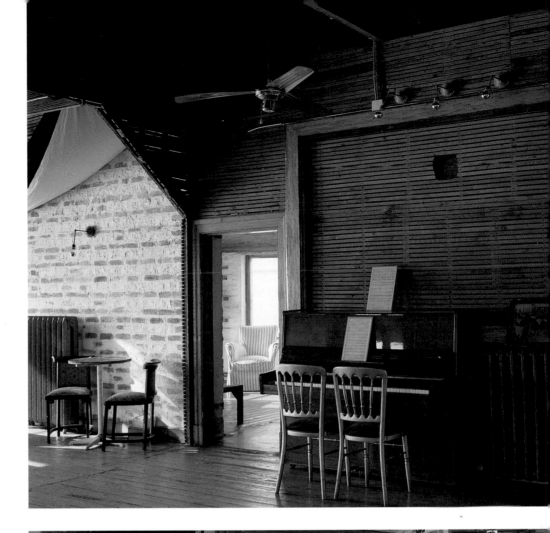

An Art Deco dressing table (right),
from Rıfat's childhood home, set
against a concrete wall. This
painting (below, left) was a friend's
thank-you present for Rıfat's
hospitality. A rusty coal-burning
stove (below, centre): one of Rıfat's
interests is collecting heating
devices. Wooden garden chairs
in front of a peeling blue wall next
to an orange buoy (below, right).

A quiet corner with a coal-burning
stove, or *soba*, and an improbably
ornate table (opposite).

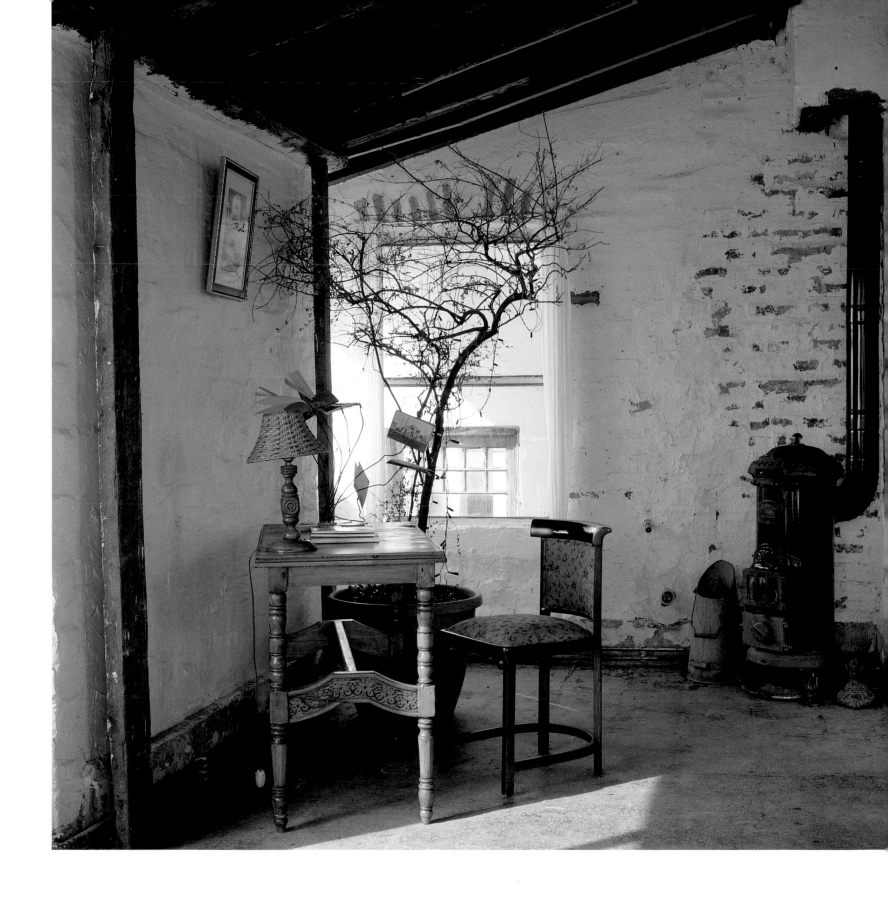

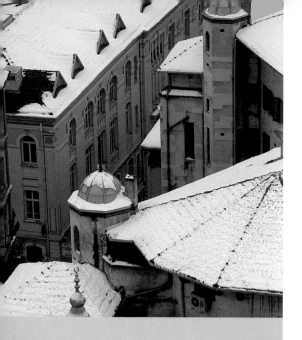

Zeki and Catherine Özdoğan
A painterly pied-à-terre in Galata

A bird's-eye view of the old snow-covered rooftops of the French Lycée St Benoît (above, left). The vintage telephone on the hall table still rings (centre, left). The Galata Tower (below, left), built by the Genoese in the 14th century, seen from the bay window of the master bedroom. You can step out from the sitting room (right) onto a narrow balcony and take in a sweeping panorama. The loose-covered sofas and the glass coffee table, made by a metalworker from industrial spare parts, were designed by Catherine Özdoğan. The painting, dated 2003, is by Irfan Ömürme.

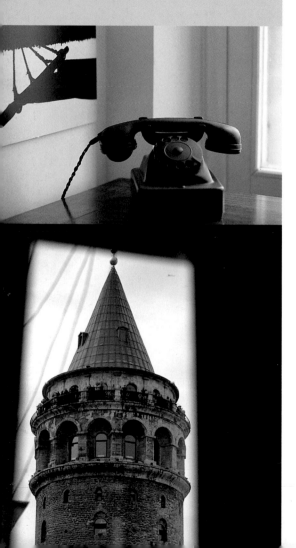

Zeki and Catherine Özdoğan met in England when they were both students. After they married, they returned to Istanbul. Catherine has been living happily in Turkey for 25 years now, perfectly adapted to her new world, judging by her mannerisms and her fluent Turkish, which is full of local idioms and proverbs. When they returned to Turkey, Zeki joined the family business started by his father. Today their company manufactures and exports textiles to the four corners of the world.

Catherine describes their flat as a pied-à-terre 'in the navel of Istanbul'. 'It could not be more convenient,' she says. They live in a modern log house on the edge of the Belgrade Forest outside Istanbul most of the time, but they love this apartment – its views, its practicality, its dimensions, its simplicity. Their many friends and Catherine's family stay whenever they visit the city.

When they found the flat in 2002, the owner of the apartment block was living in it. It is not very spacious but because it is on the top floor, just below the attic, it has a view to die for from almost every window. It was built at the beginning of the 20th century, and the original resident, a shipowner who traded with Russia, was said to watch his cargo ships passing up the Bosphorus from the window.

One could almost be in a lighthouse: at one end of the panoramic view are Seraglio Point, the Topkapı Palace and the skyline of the old city with its silhouettes of domes and minarets; at the other, the Çamlıca hills above Üsküdar on the far shore of the straits. On a clear day even the Princes Islands in the Sea of Marmara are visible on the horizon.

The block is located at the foot of the Galata Tower, one of Istanbul's iconic landmarks, and – happily for the jazz-loving Özdoğans – not far from Nardis, the

work called, he parked his bike, dealt with it, and went back to continue where he had left off.'

The rectangular sitting room has a narrow cast-iron balcony and two tall French windows. Like the rest of the house, this space is understated and minimally designed by Catherine and Zeki, which focuses one's attention on the view. Long white sofas merge with the white walls, so that you can sit back in utter comfort absorbing the scenery undistracted. The large, low glass coffee table, transparent so as not to divert the eye, was designed by the mistress of the house. White Venetian blinds, a few abstract paintings and sparingly used kilims complete the mood.

On display in the hall are colour photographs taken by Zeki Özdoğan on his travels (left). A kitchen with an unrivalled view (below). The painting on the wall is from Zanzibar. The small oil of a tea glass and a packet of cigarettes by an Istanbul street painter, Sadık, was found in a frame shop. The table, by the young designer Tardu Kuman, has a salvaged wooden top and metal legs.

The breezy interior of the master bedroom (opposite, above); the bedspread of warm earthy colours is from southeastern Anatolia and was originally a nomad's tent curtain. The kilim on the floor is from the same region.

city's most famous jazz bar. It is built of brick and mortar and the façade is decorated with neo-classical features characteristic of the period – fluted pilasters with Corinthian capitals, pediments, palmettes and garlands. Four flights of marble stairs lead up to the narrow flat, which is flooded with light from the many windows. The living room, kitchen and master bedroom all face a wonderful panorama of Istanbul.

Catherine stripped the plaster from the vaulted ceilings to expose the herringbone brickwork, which, like the smooth plastered walls, is painted white. The existing wooden floorboards were sanded and sealed. Graphic black and white encaustic tiles were laid on the floor in the hall, corridor and bathroom, creating a Bridget Riley optical effect. The contrast with the white walls and the warm timber floorboards of the other rooms has a painterly quality. The corridor serves as a gallery for Zeki's colour photographs from his travels, mainly landscapes and seascapes. Some are of distant places, others closer to home. Rather as Paul Theroux did in Britain, Zeki followed the entire coast of the Turkish peninsula. 'But unlike Theroux, he did it on his motorbike,' Catherine says. 'When

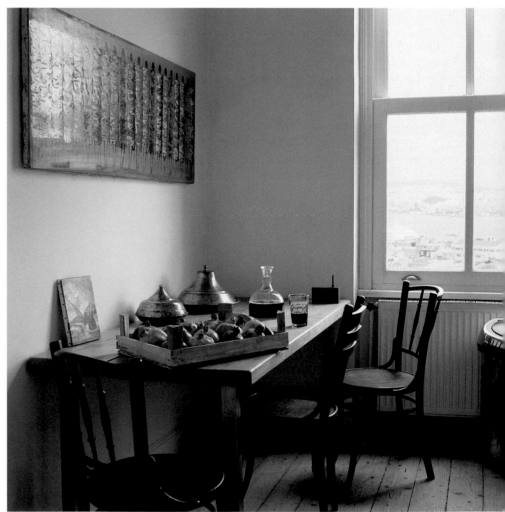

The kitchen next door was planned by Catherine. 'I am interested in cooking,' she says, 'and spend a lot of time in the kitchen.' She talks proudly of how she was trained by her mother-in-law, originally from Ottoman Salonika, to cook traditional recipes. She determined the height of the work surfaces and chose the local Marmara marble tops. The well-proportioned table next to the window serves as a dining-cum-working table and is by the young designer Tardu Kuman, a neighbour, who uses salvaged solid timbers in his work.

The small shower room is plain and whitewashed, setting off the delicately carved marble washbasin and contrasting ultra-modern taps. Not antique, but nonetheless old, such a washbasin would have been standard ware in an Ottoman house until a century or so ago. Catherine picked it up in Çukurcuma, the district of Istanbul's antique dealers.

Off the hall is a spare bedroom, with an adjoining dressing area, and the master bedroom. This room again has a beautiful view of the Bosphorus from a window directly opposite the bed, as well as a tall bay window with an altogether different vista – of the huge medieval Galata Tower, captured as if in a single, perfectly composed exposure.

In a way, the whole flat is like a series of frames for astonishing vistas, designed to capture the wonderful greyish-blue panorama of sky and water.

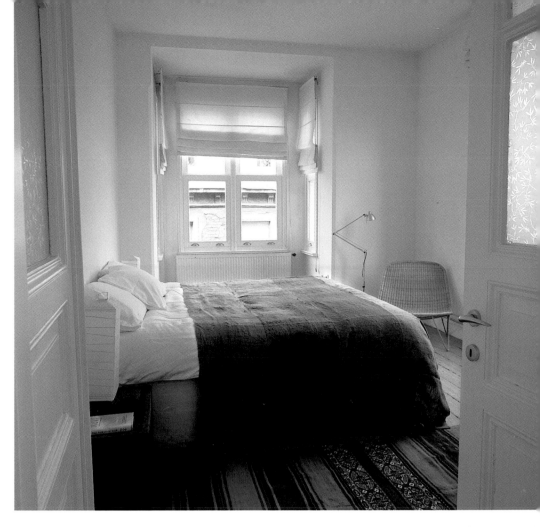

A flatweave from Malatya (above, left). It is hand-woven in narrow strips, dyed with plants and roots – saffron for golden yellow, madder for red – then stitched together. Originally it would have been a curtain to divide the communal interior of the tent for privacy.

Detail of a woollen *çuval* from Central Anatolia (above, right). These sacks or bags are used by nomads for storing grain or clothes.

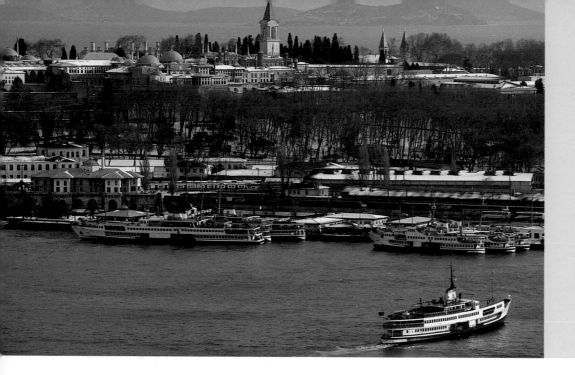

The snow-dusted domes and towers of the Topkapı Palace (above), seen from the balcony of Orhan Pamuk's apartment in Cihangir, with the purple hills of Asia beyond. A side table holds a clutter of curiosities, including several sets of false teeth (right).

The desk, where most of his seven novels were written (opposite), and pen. 'I need solitary hours at a desk with good paper and fountain pen like some people need a pill for their health,' he says. The family wing chair is for the occasional visitor.

Looking up from the ferry as you cross the Bosphorus towards the trailing waters of the Golden Horn, the seven hills of Istanbul are piled with houses and apartment blocks, all facing out to sea. Countless windows peer down on the waters, like millions of anonymous eyes. Yet each eye is a world in itself, independent, a hideaway oblivious to all the others, conscious only of the great blue expanse of water in front. Behind one of these windows, Orhan Pamuk, author of many books and winner of the Nobel Prize in Literature, writes his novels.

'I've always lived on hills overlooking the Bosphorus – if only from a distance,' Orhan writes in *Istanbul: Memories and the City*. 'To be able to see the Bosphorus, even from afar – for Istanbullus this is a matter of spiritual import which may explain why windows looking out onto the sea are like the *mihrabs* in mosques, the altars in Christian churches, and the tevans in synagogues, and why all the chairs, sofas, dining tables in our Bosphorus-facing sitting rooms are arranged to face the view.'

When Orhan was eleven his family moved into a small flat in an apartment block belonging to his grandfather facing the Bosphorus in Cihangir, one of the hills

overlooking Seraglio Point. Fifty years on, he is back in the same neighbourhood, even if not in the same building. Here, every day, the author toils away for long, solitary hours, looking out of the window at the Bosphorus 'shimmering like a silken scarf' to soothe his eyes as well as his soul.

The author's flat is modest, furnished with a few remnants of family furniture from the 1940s and 1950s,

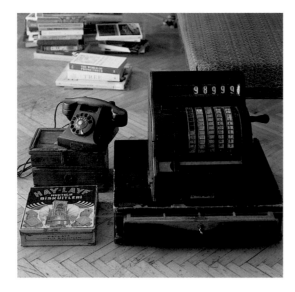

and housing his collections of curiosities – faded postcards, childhood magazines, used tram tickets, a Bakelite telephone, old directories, and a vintage cash register – all objects he has found meaningful or interesting since his early student days. The flat also harbours thousands of books, some neatly filling the bookcases, cabinets and shelves, some precariously piled in stacks of different heights on the parquet floor. 'It's not the rooms of a house that matter to me, or the beauty of the things inside it,' he writes in the chapter of *Istanbul*, devoted to his Cihangir flat. 'Then as now, home served as a centre for the world in my mind – as an escape, in both the positive and negative sense of the word.'

Alone at his desk facing the balcony window and overlooking a hazy panorama of old Istanbul, Orhan writes his finely woven novels in longhand with a fountain pen. He is committed to rituals. 'I am happy when I'm alone in a room and inventing.'

Orhan writes eloquently of his attachment to Istanbul in his book of essays, *Other Colours*: 'For me the centre of the world is Istanbul. This is not just because I have lived there all my life, but because for the last thirty-three years I have been narrating its streets, its bridges, its people, its dogs, its houses, its mosques, its fountains, its strange heroes, its shops, its famous characters, its dark spots, its days and its nights, making them part of me, embracing them all.'

The books in his library (opposite) are, Orhan says, what compel him to take his work seriously; among them are perhaps 10 or 15 he truly loves.

A Bakelite telephone and an old heavy cash register (above), both designs familiar from the writer's childhood. A collection of 1970s ladies' shoes and handbags (below), a reminder of lives past.

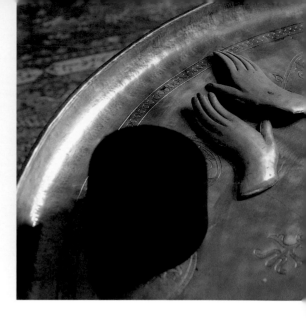

Serdar Gülgün
AN OTTOMAN-STYLE APARTMENT
in TEŞVIKIYE

A rare Ottoman calligraphy of a Koranic verse in Serdar Gülgün's hallway (above, left). Each delicate letter on the ruby-coloured velvet background is cut from a paper-thin sheet of wood. The crystal chandelier is French. A large gilded copper tray (above, right) holds a fez made in Vienna for the Ottoman market. The gilded icon hands are from Greece. A cup of tea and a pumpkin sugar bowl on a silver tray (right).

A velvet wall hanging in the drawing room (opposite) is embroidered in metal thread with rays of light, an imperial motif known as Nur-u Osman (Light of Osman). With his theatrical eye, Serdar has used it as a backdrop for a portrait of Sultan Abdülmecid believed to be by the Italian artist Rubino.

In the heyday of café society, the elegant 19th-century Gözüm Apartments in Teşvikiye, today Istanbul's most expensive shopping district, would have been a magnet to high society, diplomats and royalty. The setting suits the young Ottomanist Serdar Gülgün handsomely. Widely travelled and well educated, he is like a gentleman in one of Pierre Loti's novels: instantly attentive and utterly hospitable as he offers his visitors delicious home-made Turkish biscuits with tea. The choice of objects, the furniture and especially the calligraphic panels, about which Serdar is particularly knowledgeable, are so much of the period that visiting him is like stepping back in time. It could easily be 1900.

Serdar's apartment is painted in deep, dark colours that create a dramatic foil for his extensive collections of calligraphy, textiles and objets d'art. The *sedirs* and divans are covered with luxurious velvets, satins and brocades of vibrant colours, piled high with cushions of yet more brilliant colours, many of his own design. A corridor papered in broad burgundy and cream stripes that remind one of a Regency artist's studio leads from the hall and drawing room at the front of the apartment to the jet-black dining room and the master bedroom overlooking the garden.

Double windows and thick, lavish curtains create a distance from the outside world. 'I can spend all day here, all week even. I lie and read in every corner, entertain friends, work, draw and think,' Serdar says. Numerous lamps with smart lampshades create pools of light in the dark interior. Corners perfect for soirées are arranged around a delicately hand-painted Damascus arch, or a circle of deep divans, or throne-like sofas. The choice of opulent candelabras, Baccarat crystal, Venetian mirrors, Ottoman candlesticks and celadon dishes is eclectic, but they are all put together harmoniously and flatteringly lit

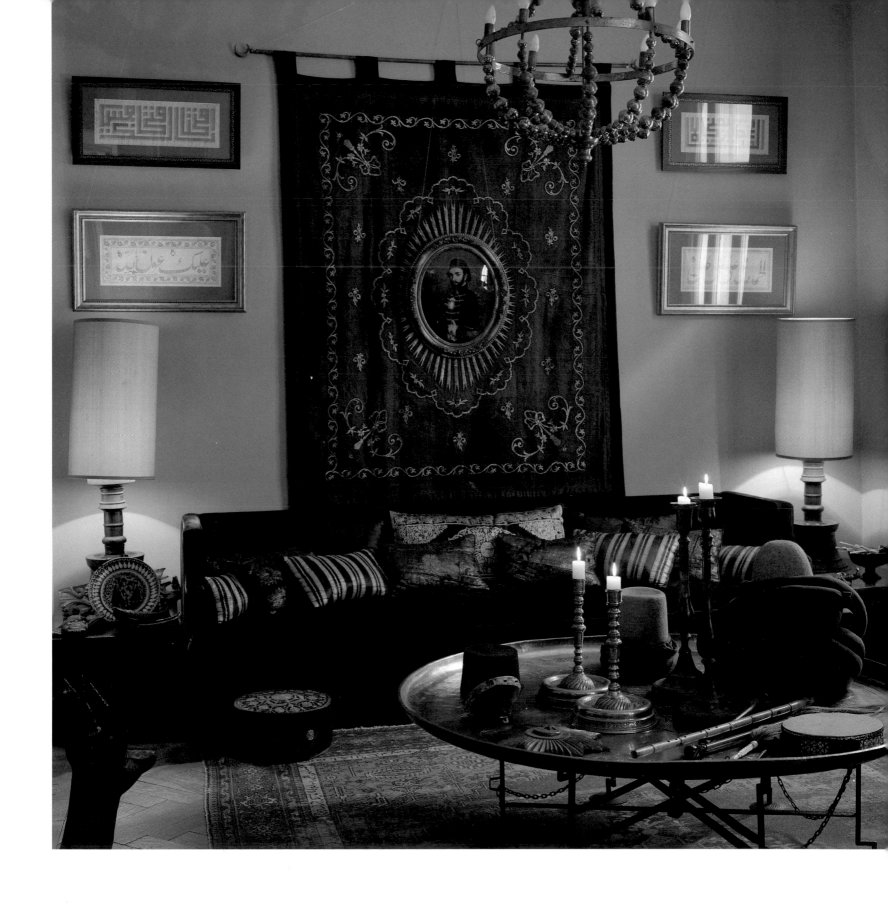

On a fin-de-siècle table (right) stands a wooden finial carved from a solid piece of wood. It depicts the letter 'vav' and its mirror image and was possibly from a dervish lodge. The rug is Persian. A corner of the drawing room (below) decorated with part of an 18th-century Timurid-style collar arch from Damascus. It is gilded and has delicate miniature-like illustrations of houses, trees and mosques. The melancholy figure in the turban may be a doomed 16th-century prince. On either side are 19th-century cartoons by Spy of Ottoman figures from *Vanity Fair* magazine.

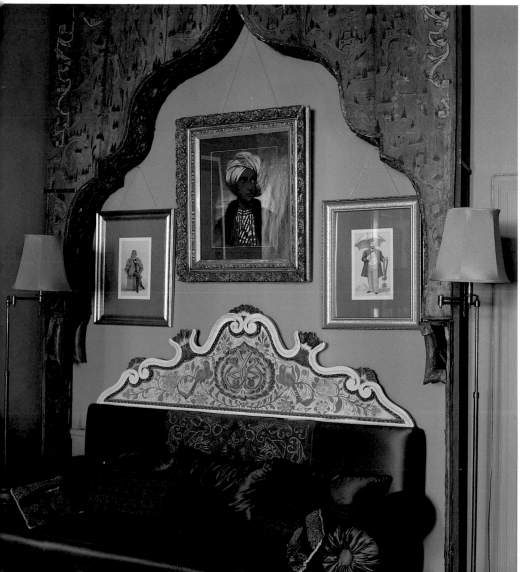

with an eye for colour. The effect is theatrical yet comfortable and relaxed. Serdar, in his early forties, gives talks in Istanbul museums and at the British Museum in London on calligraphy, textiles and table manners in the Ottoman era. He also advises auction houses and has lately been busy restoring a fine 19th-century mansion that once belonged to a Hungarian pasha in Çengelköy, on the Asian side of the Bosphorus. But he has no plans to move; he will keep both this apartment and the house, living on both shores of Istanbul.

Serdar tells how his mother once gave him a fine porcelain Russian tea set inherited from a great aunt – a tea set kept for three generations in a vitrine and consequently in mint condition. He decided to use it. Inevitably, piece by piece, it gradually vanished, down to the last couple of saucers. 'There is only one lifetime,' he sighs. 'Things should be enjoyed. If I'd kept it as my family did, unused and unloved, it would have been such a waste.' He adds: 'In auction rooms and antique dealers' warehouses, I've seen

so many precious objects which have been jealously treasured, some still in their original packaging, never having seen the light of day.' Serdar believes that houses, like objects, should be lived in and enjoyed to the full.

Born in Istanbul, 'of Republican parents' as he puts it, he went to the French Lycée St Benoît and studied economics at Istanbul University. It was assumed he would go into on his father's business. But as a young boy, he became curious about the Arabic letters of the Ottoman script, the so-called *hat*. He was intrigued by the powerful graphic effect of the interlaced lines and fine glittering illuminations. 'They were magical,' he recalls. 'I started to collect small pieces, such as the old calligraphic exercise sheets known as *karalama*. They were affordable then, even for a child.' Later he started to decipher the letters and to enter their enigmatic world. He quickly decided that business life was not for him, and with his father's blessing, set off to London to study Islamic art at the School of Oriental and African Studies.

On his return to Turkey, Istanbul was launching its first serious art and antiques fairs and discovering 'Ottomania'. Serdar's expertise and eye were in instant demand. By the time the famous Hungarian porcelain manufacturer Herend commissioned him to prepare designs for their exquisite hand-painted tableware in 2000, Serdar's drapery and furnishing fabric designs for one of Turkey's most prestigious fashion and textile firms were already renowned. Inspired by Ottoman courtly motifs, they had instantly become sought-after by stylish clients and top-ranking interior designers. Many examples are on display in his home.

A collection of 18th- and 19th-century calligraphy (above). The centrepiece is of walnut carved and then painted and gilded. The celadon dishes on the altar table behind the deep divan date from the 17th century: next to them are a pair of Ottoman mosque lamps bought in Syria. A gilt coffee set, or *stil* (left). Such beak-spouted pots and cups were used to serve coffee with all the flourish of the Japanese tea ceremony.

In the master bedroom (opposite), the bedspread and hangings are made from a fabric of Serdar's own design: it has a bold crescent moon motif inspired by sultans' kaftans. The sumptuous Damascus wardrobe, inlaid with bone, tortoiseshell and mother of pearl, is a souvenir from a visit to Aleppo.

Beyond the door is the spacious balcony (right). The black and white tiles are original. The grand building behind the magnolia tree was intended to be the Italian Embassy, but became a school when the capital moved to Ankara. The park benches are from a secondhand shop on the Golden Horn and the bronze candleholder next to the bench is late Ottoman.

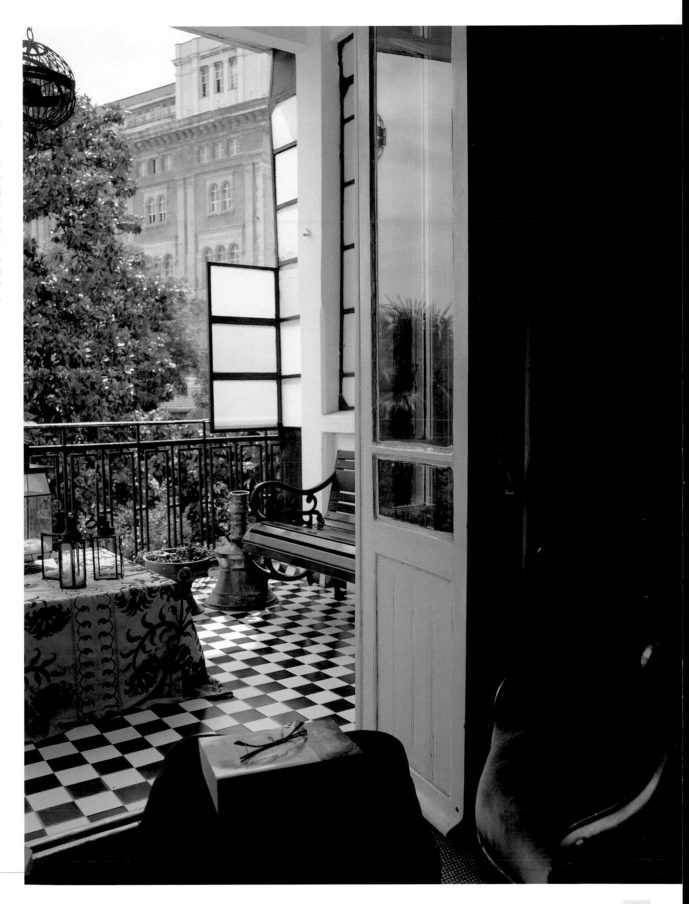

A splendid 24-branched Baccarat chandelier bought in India crowns the dining table (right). The pair of Venetian mirrors on the black walls are from Tangier. The domes on the table that look like helmets are tinned copper dish covers from Central Asia. A blue still-life (below, left): next to the pair of satin silver embroidered Ottoman slippers stands a turquoise-glazed Çanakkale bowl. It contains traditional spoons of mother-of-pearl, coconut or tortoiseshell. The textiles on the gilded Louis XV armchair (below, right) were made in France for the Ottoman market – they are just a few of Serdar's large collection of 17th- and 18th-century textiles.

The chinoiserie library-cum-spare bedroom (opposite): a porcelain creature – on an Ottoman turban stand – was brought back by a diplomat serving in China. The cushions on the mahogany *lit bateau* are made from a material bought in Java which contrasts dramatically with the deep blue of the walls.

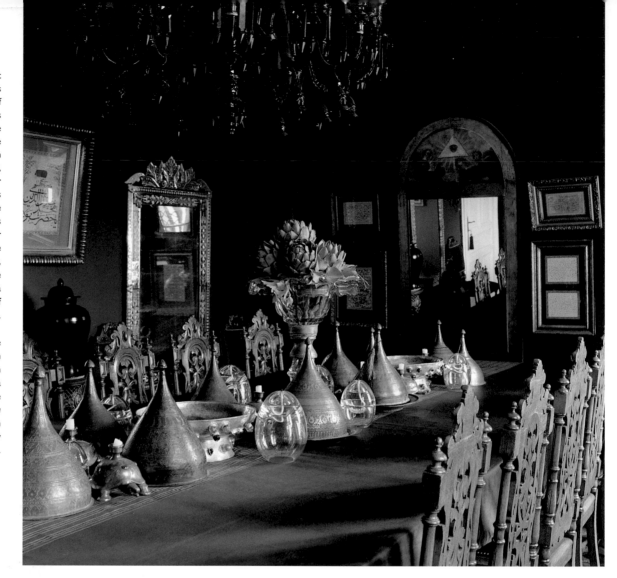

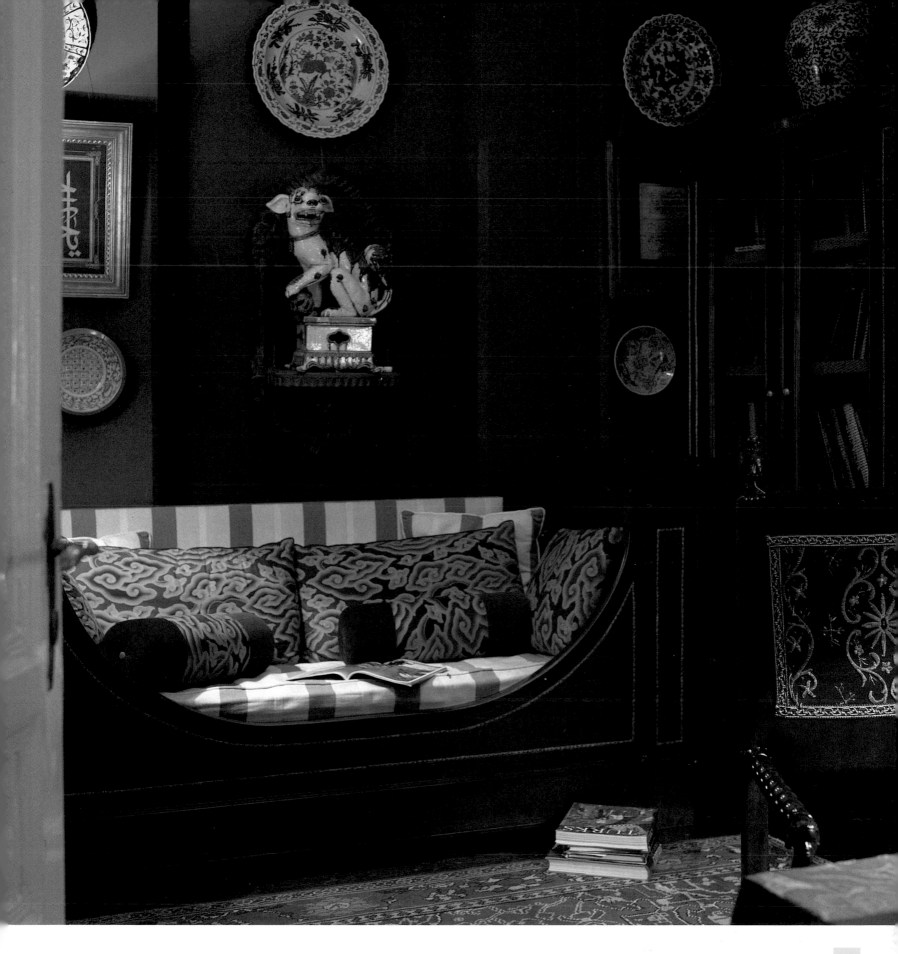

contact details

Jacques Avizou
Les Maisons de Cappadoce
info@cappadoce.com
www.cappadoce.com

İlkay and Mihda Bilgişin
Göksu Caddesi, 27
Kandilli, Üsküdar
Istanbul
ilkay@vitsan.com.tr

Sefer Çağlar
Autoban Gallery
Meşrutiyet Caddesi, 64A
Tünel
34430 Istanbul
info@autoban212.com
press@autoban212.com

Rıfat Edin
rıfatedin@hotmail.com

Selden Emre
Cami Sokak, 15
Taksim
34425 Istanbul
seldenemre@gmail.com

Mica Ertegün
Mac II Interior Design
125 East 81 Street
New York NY 10028

Hakan Ezer
Faik Paşa Yokuşu, 5
Çukurcuma, Beyoğlu
Istanbul
hakan@hakanezer.com

Serdar Gülgün
Kalantor Sokak, 5
Macar Fevzi Paşa Köşkü
Çengelköy
34684 Istanbul
serdargulgun@hotmail.com

Hakan and Nilgün Kavur
Borokav
İkitelli Organize Sanayi Bölgesi
İpkas Koop,16 Blok no. 54–56
İkitelli
34603 Istanbul
hakank@borokav.com.tr

Mustafa and Caroline Koç
Haremlique
Şair Nedim Caddesi, 11
Beşiktaş, Istanbul
info@haremlique.com

Rahmi M. Koç
Koç Holding A.Ş.
Nakkaştepe, Azizbey Sokak, no. 1
Kuzguncuk, 34674 Istanbul
maxinei@.com.tr denizg@koc.com.tr

Halis and Alev Komili
alevkomili@komili.com.tr

Emel Kurhan
workingemel@gmail.com
www.yazbukey.com

Sema Menteşeoğlu
PK.31
48800 Köyceğiz
Muğla
pasakonak@hotmail.com
cagla@caglabaykal.com

Mehmet and Emine Öğün
emogun@ttmail.com

Rifat Özbek and Erdal Karaman
Port Bodrum, Yalıkavak Marina
Çökertme Caddesi, 22
Bodrum, Muğla
info@yastikbyrifatozbek.com
www.yastikbyrifatozbek.com

Zeki and Catherine Özdoğan
Ceylan Giyim San.ve Tic. A.Ş.
Eski Hadımköy Yolu
1ci Cadde, 1ci Sokak, 32
Büyükçekmece,
Istanbul
zeki@ceylan.com.tr

Zeynep Öziş
Alaçatı Taş Otel
Kemal Paşa Caddesi, 132
Alaçatı, Izmir
zeynep@tasotel.com
www. tasotel.com

Zeynelabidin Öztürk
karanfil.1975@hotmail.com

Gönül Paksoy
Atiye Sokak,1 / 3
Teşvikiye
Istanbul
gonulpaksoy@gmail.com

Erdal and Betül Sayıl
erdal@teosinsaat.com.tr

Reşit and Şebnem Soley
Corvus Vineyards
Tuzburnu
Bozcaada, Çanakkale
info@corvus.com.tr

Ramazan Üren
crowist@hotmail.com

Özlem Urgancıoğlu
Gökçüoğlu Konağı
Bağlarbaşı Mahallesi
Değirmenbaşı Sokak, 13
Bağlar
Safranbolu – Karabük
ozlem@allseasonstour.com.tr
ozlem1976@superonline.com
www.astasturizm.com
www.allseasonstour.com.tr

acknowledgments

First of all I would like to thank Talu Worldwide, my partners in
this venture, for their enthusiasm for the project from its beginnings,
and their generous support throughout. I would also like to thank
all the homeowners whose houses I photographed for the warmth
and friendliness with which I was received. This generosity remains
my lasting impression of Turkey. With thanks to Serap Afan, Tüsiad;
Erkal Aksoy, A la Turca; Hülya Baraz; Engin Demirkol, Hazal Kilim;
Zafer Güngüt; Cihangir Karabay; Bahar Siber, İletişim Yayınları; Alev
Ebüzziya Siesbye; and Ayşe Veryeri, Lin Tekstil.

Solvi dos Santos

Photographs © 2008 Solvi dos Santos
© 2008 Thames & Hudson Ltd, London

First published in 2008 in hardcover in the United States of America by
Thames & Hudson Inc., 500 Fifth Avenue, New York, New York 10110

thamesandhudsonusa.com

Library of Congress Catalog Card Number 2007910203

ISBN 978-0-500-51424-5

Printed and bound in China by C&C Offset Printing Co. Ltd